KU-224-490

CHALLENGING THE BIG BRANDS

GLOUCESTER MASSACHUSETTS

CHALLENGING THE BIG BRANDS

How New Brands Win Market Share with Innovative Design

Judith Evans Cheryl Dangel Cullen

ROCKPORT PUBLISHERS

LEARNING RESOURCES
CENTRE

Havering College
of Further and Higher education

658.827 HL 162772

© 2003 by Rockport Publishers, Inc.

All rights reserved. No part of this book may be reproduced in any form without written permission of the copyright owners. All images in this book have been reproduced with the knowledge and prior consent of the artists concerned, and no responsibility is accepted by producer, publisher, or printer for any infringement of copyright or otherwise, arising from the contents of this publication. Every effort has been made to ensure that credits accurately comply with information supplied.

First published in the United States of America by
Rockport Publishers, Inc.
33 Commercial Street
Gloucester, Massachusetts 01930-5089
Telephone > (978) 282-9590
Fax > (978) 283-2742
www.rockpub.com

Library of Congress Cataloging-in-Publication Data

Evans, Judith, 1964-
 Challenging the big brands : how new brands win market share with innovative design / Judith Evans and Cheryl Dangel Cullen.
 p. cm.
 ISBN 1-56496-905-3 (hardcover)
 1. Trademarks–Design. 2. Logos (Symbols)–Design. I. Cullen, Cheryl Dangel. II. Title.
 NC1003 .E83 2003
 659'.022—dc21 2002014942

ISBN 1-56496-905-3

10 9 8 7 6 5 4 3 2 1

Design > John Hall Design Group > www.printlives.com
Cover Design > Tim Nihoff
Copyeditor > Pamela Hunt
Proofreader > Stacey Ann Follin

Printed in China

To my friends and family for their unwavering support during this project—most notably from Vernice Gamble and Patricia Evans.

—Judith Evans

To my ever changing, ever growing source of inspiration. My son.

—Cheryl Dangel Cullen

Dedication

> Contents

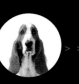

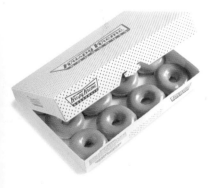

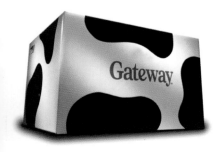

Introduction

It's conventional wisdom that all an entrepreneur needs to start a new business is a great idea. Investors will flock to finance the venture so that companies can be hired to manufacture and distribute the product. Best of all, the reasoning goes, consumers will eagerly participate by purchasing whatever is the latest gizmo on the market. Although that's true to a degree, such an argument fails to appreciate the complexity of what is often called in business parlance "the challenger brand."

Launching, establishing, and growing a new product in a market already dominated by a strong leader can be tough work. Not only do companies need a good idea and the financing to bring it to market, they also need the brand identity and advertising muscle to differentiate the product from the competition and establish relevance among consumers. Some of the most successful challenger brands—from Krispy Kreme and Virgin Atlantic Airlines to Priceline.com and SoBe—have discovered that a dynamic and unforgettable marketing campaign is critical in sparking awareness among consumers and driving sales.

"You really have to communicate to consumers how good your idea is for the target audience," says Michael Lucas, executive director of brand packaging of Interbrand, a New York–based company that offers a variety of brand management services to corporations. "If you don't, [the product] is a failure. There have been a lot of great ideas that didn't fly because the message was improperly communicated or failed to register with consumers."

Challenging the Big Brands sets out to explore the ways in which 28 companies have used graphic design and advertising to establish or increase their market position in an industry. The companies profiled here use a myriad of mechanisms in the media to communicate with the buying public. Some develop eye-catching packaging and logos to get their points across. Others use humor or tug-at-the-heartstrings tales in television and print ads.

No matter what the medium, the bottom line is a crisp and well-focused brand identity and message are essential for challenger brands. Hayes Roth, vice president of marketing for Landor Associates, says brand identity for challenger brands hinges on four principals: differentiation, relevance, esteem, and knowledge.

"It's like building a holograph around the brand," Roth says. "Once a brand hits the button of what elements distinguish it from another, then you start to build on relevance, knowledge, and esteem."

According to Roth, the most critical principal for challenger brands is differentiation. He describes it as a process in which corporate executives deconstruct the product to determine the elements that set the

product apart from its competitors. At the end, a phrase or statement is created for the product that can be carried through a marketing plan. For instance, Roth recalls working with the New York Stock Exchange to refresh its brand identity. The collaboration resulted in the tag line, *A Portal to the Global Marketplace.*

"If you're an investor, you want to have access to the exchange" Roth notes. "And even more important, if you're an investor, you want access to exchange that generates the most significant volume of trades."

Challenger brands have a way of presenting consumers with a different way to approach buying a product. Consumers buy Starbucks coffee not only to get their caffeine fix, but also to have the experience of sitting down in oversized chairs and letting their minds wander. Priceline.com challenged the traditional way consumers purchase airline tickets by using the Internet to find the cheapest fares more efficiently.

Challenger brands can also be products that have languished behind market leaders or have lost touch with the demands of a new generation. As Advil and Alleve hit the market, Tylenol realized it needed to strengthen its bond with consumers. Interbrand sought to reinject the brand's message by emphasizing Tylenol's benefits, which involve more than just curing headaches. Through highly emotive ads, the company showed people that taking Tylenol was about safety, security, and regaining control of their lives.

A year ago, when Krispy Kreme doughnuts went public, the company used part of the proceeds to expand its retail outlets nationally. More than seven decades ago, the Winston-Salem, North Carolina, company had shaped the way consumers purchased fresh doughnuts in the South by illuminating a sign atop its stores to alert the public when the product had just popped out of the oven. The company now figures it can transplant the concept around the country and go up against competitors like Dunkin' Donuts.

Advertising simply serves as the vehicle for driving brand awareness. "Advertising is television, radio, print, flyers, in-store displays, and whatever," Lucas says. "It tells all about the product. It communicates an image and identity. You can't have one without the other."

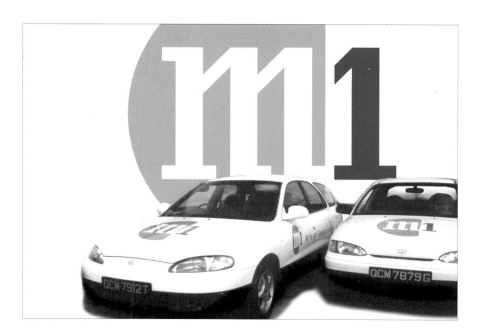

^

FedEx > Appealing to the
International Market

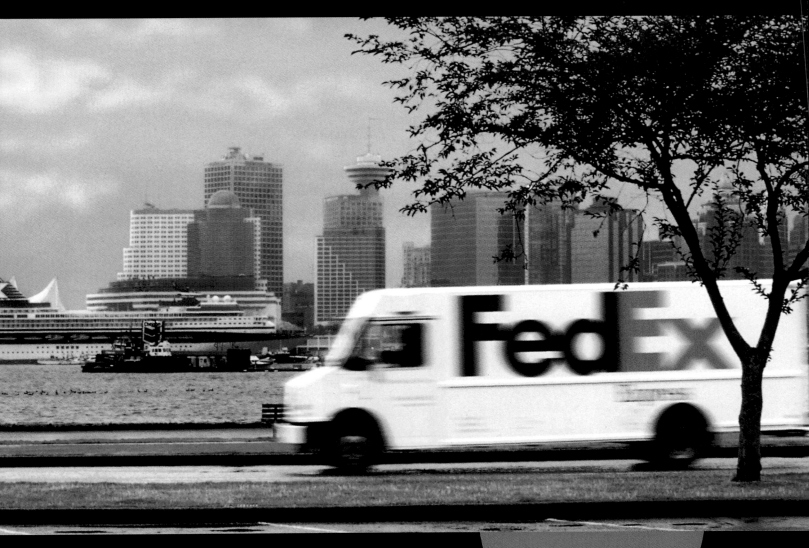

The name Federal Express
did not translate well in
some countries, so the
company shortened the
name to FedEx, as many
consumers had already
begun to refer to it.

Agency > BBDO
Creative Director > Mike Campbell
Copywriter > Janet Lyons

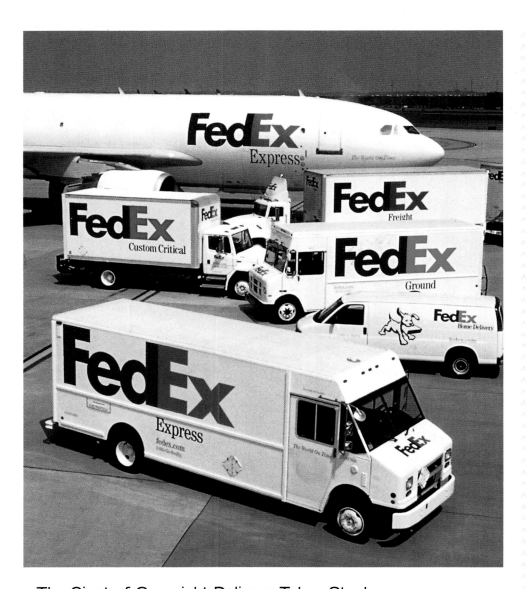

[LEFT] The task to change the company's name was a massive undertaking that involved replacing the logo on a wide variety of products, ranging from its truck and airplane fleets to corporate stationery.

[BELOW] The company's old logo incorporated its entire name, Federal Express, in a typeface that appears more like cursive writing than the new logo. The colors are not as vibrant as the current ones.

> The Giant of Overnight Delivery Takes Stock

Nearly two decades after creating the overnight delivery industry, Federal Express founder and CEO Frederick W. Smith and management discovered the Memphis-based company in the unorthodox position of the hunted rather than the hunter. The line separating Federal Express from its rivals—United Parcel Service, Inc, and DHL Worldwide Express—had been blurring, and efforts to expand overseas suffered under interpretations of the name.

Like many other established brands, Federal Express realized change was needed to ensure future growth. In 1994, the company took that step in one of the most secretive and closely researched image changes in corporate history. FedEx would no longer be just the nickname that people used to refer to the company; it would become the way the company would officially refer to itself and what it does.

Courtesy of FedEx

> Simplicity Drives the Makeover

The idea appeared simple enough, but the decision proved more difficult amid internal concerns over tampering with what was already a popular corporate symbol. "Federal Express had created this industry, and for a long time we were the only player," says Gayle Christensen, managing director of global brand management. "As several other companies entered the marketplace, if you looked at Federal Express, it wasn't working hard enough for us."

In 1992, Federal Express hired Landor Associates, a venerable San Francisco–based design firm, to make over the traditional purple and orange symbol. Over many months, Federal Express managers and Landor embarked on a series of sessions to determine what the company wanted to achieve and how to execute a change without abandoning what already existed.

"It was a massive project, because we have so many applications," Christensen says. "It does seem like a no-brainer, yet our brand is our most important asset. We wanted to make sure a change looked like what we are."

> Bold Colors Brighten Logo

The company selected its current FedEx logo from the five designs that Landor presented. It is a bold design, using the company's trademark colors, purple and orange. The colors were tweaked slightly for a more electric orange and stronger purple to reflect a more modern and dynamic company.

Initially, the company decided to keep the name Federal Express just under the brand, but it disappeared once customers got used to the new look.

The size of the letters was equally important. The combination of uppercase and lowercase letters is meant to present the company's accessibility and friendliness toward its customers. "You can present the logo in a really big way, but it still comes across as friendly," Christensen explains. "It really changed us but kept the elements of our personality."

Smith added in a 1994 interview, "FedEx is practically a verb. We're trying to capitalize on our identity, taking advantage of the phrase 'FedEx' meaning express mail." Smith also said the new name was capable of becoming one of those corporate and product names that represent an industry, like Xerox for photocopies and Kleenex for tissues.

[BELOW] At the time of the name change, FedEx was launching some new services and wanted to differentiate them. As a result, the company designed logos that designate specific divisions of FedEx.

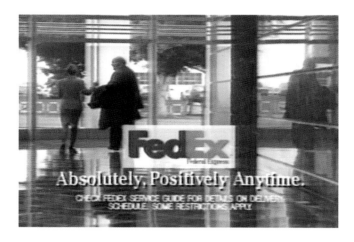

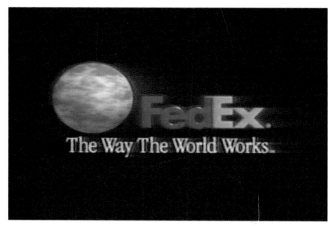

> Reaching New Markets

The new symbol with the forward-pointing arrow nestled between the *e* and *x* would take on a marketing function as the company moved to paint it on hundreds of aircraft and install new decals on its thousands of vans. For instance, FedEx Express would promote its overnight air service as trucks rolled through the street. FedEx Ground would serve a similar function in touting the company's small-package ground service.

The new logo also featured a new tag line, *The World on Time*, in an effort to show the company's commitment to serving customers internationally. At the time of the name change, FedEx was experiencing difficulties gaining acceptance in some international markets. Research showed that one hurdle was the company's name, particularly the word *Federal*.

In Latin America, the police are known as the *federales*—not usually a respected part of the local government. Asians had trouble pronouncing the word, particularly the *r* and the *l*. "People had a hard time saying the name in some countries," Christensen says. "It sounded very governmental to customers in other countries. We were really starting to expand internationally, and the timing to make the change was perfect."

Soon after, the company embarked on a new advertising campaign aimed at promoting its new identity. The marketing would not only serve to reintroduce the brand to consumers but would also provide exposure to a wide array of new services that FedEx was launching at the time.

"The advertising can be tactical to market any products," Christensen says. "The campaign still has to look at the personality of FedEx. It can't look different than what they [the consumers] see on the street. You can't have a different personality."

[ABOVE LEFT] In 1992, as competitors began making inroads in the express delivery business, market leader Federal Express underwent its own makeover with a new name and marketing campaign to mark its launch into international markets.

[ABOVE RIGHT] FedEx introduced a new slogan to reinforce in consumers' minds that the market leader could deliver packages anywhere in the world at anytime.

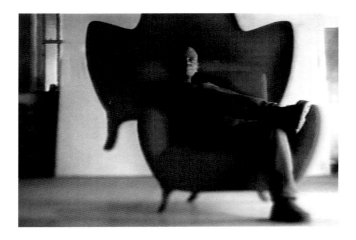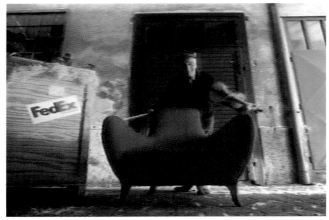

[ABOVE LEFT] As part of its rebranding, FedEx wanted to show small-business owners that its services could benefit them. In this television ad, the company shows an interior designer in one of his products.

[ABOVE RIGHT] The final shot of the interior design commercial shows that the owner used FedEx to ship the product to a consumer in a European village.

> "Absolutely, Positively, Anytime"

FedEx's "The Way the World Works" campaign set out to tout the company's same-day delivery service (arrival by 8:00 a.m. the following morning) by depicting personalities with which consumers could relate. Customers could relate to a harried executive assistant named Gloria whose reply to her boss's incessant questioning about when packages will arrive at their destination is "Next morning." The company's tag line on this series of ads was *Absolutely, Positively, Anytime.*

The company underscored that premise with its "Red Chair" campaign, in which a designer is pictured sitting in the red chair that he has designed in his studio. Several frames later, the viewer sees the red chair next to a FedEx box in the streets of an unknown European destination. Standing over the chair is an old man with a violin. The bottom line: FedEx is capable of delivering packages anywhere in the world.

Throughout the campaign, FedEx also delivered a subtler message to consumers about how its services could help them manage their businesses more cost-efficiently. The theme was explored in a spot where the initial scene shows an empty warehouse. The view then pans to workers surrounded by parts and other materials delivered by FedEx, in a nod to a popular management tool at the time called just-in-time manufacturing. The company linked its ability to deliver packages quickly to the manufacturing practice in which companies can contain warehousing costs by keeping only the inventory that is necessary.

What the company learned is that brand identity is an ever-evolving process. For a long time, FedEx used its advertising to establish a message of reliability. But the company has realized that as its services expand, the message needs to follow.

Christensen points out that the process may be complex, but the central idea need not be. "One of the things that we learned is that the best solutions are the natural ones," she says. "We used what we had but made it better. It was the biggest project that I ever have done. It's not something that I would want to do every five years. But it was amazing to see that the changes provided a boost for the company among its customers. It also gave employees a shot in the arm."

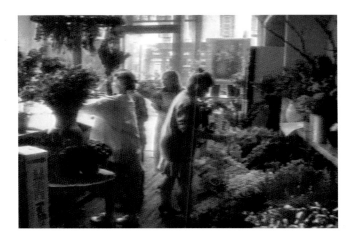

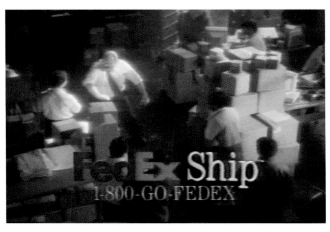

[ABOVE LEFT] As part of its television advertising, FedEx aired commercials that showed how it was possible for the company to deliver products to small businesses before they even opened their doors to customers.

[ABOVE RIGHT] This spot shows a once-empty warehouse, now full of employees who are laboring to fill orders.

[CENTER] In another spot, FedEx shows it is a company that can handle the shipping needs of business owners with the most complicated and delicate shipping orders.

[BOTTOM] In its marketing, FedEx always had tried to establish the relationship that develops between its delivery personnel and customers.

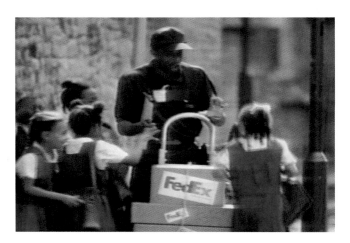

∧

Adidas > Pioneer Adds New Twist to Sportswear

EVERY adidas HAS A STORY

'83-C' Track Top

Exact remake of a jacket found in an LA thrift shop. Features the original owner's personally embroidered signature and team number. See the whole collection at adidas.com/originals

IF YOU'RE OUT THERE J MANO, GET IN TOUCH.

I BET YOU NEVER THOUGHT YOU'D BE FAMOUS—

AND CERTAINLY NOT FOR EMBROIDERY.

Communication Manager > Jennifer Harmon, Adidas
Agency > Burrell Communications (print)
Creatives > Perry Fair
Producer > Bob Sayles
Photographer > Matt Gunther
On-line Agency > SBI (internet)
Internet Communication Manager >
Deanna Schindler-Ord, Adidas

> Pioneer Sportswear Maker Retrenches

Since it was founded in 1920, the Adidas brand had grown with a strong marketing alliance with the Olympic games. The first Adidas tracksuits, with the familiar horizontal stripes running down the sides of the pants and jacket sleeves, appeared on the market in 1962. Ten years later, the company introduced the three-leaf clover design, known as the trefoil, for the Munich games. As the official sponsor of the games, the sportswear maker designed the trefoil as a symbol of the Olympic spirit.

But by the early 1990s, the company's products had lost their luster. In dire financial straits, Adidas asked Robert Louis-Dreyfus, a famed turnaround artist of troubled companies, to step in. He took control by persuading banks to invest $100 million in capital to resuscitate the brand.

Dreyfus immediately pumped money into the company's marketing budget, which had dwindled substantially as Adidas struggled through its fiscal crisis. The marketing budget had slipped to only six percent of sales in 1993. Now, a decade later, Adidas is the nation's second-largest sporting-goods maker behind Nike, largely through a rejuvenated advertising campaign that has revived the company's image as a top-rated athletic performance brand.

"Adidas really truly was the first sports company. They really blew it in the '70s and '80s," says Christopher Jenkins, director of brand marketing for Adidas American. "Adidas hadn't done a good job of marketing itself. It's been a huge resurgence. A lot of it was we hit a time when everybody loved the three-striped products. The athletic market was looking for something, and Adidas provided it. We're in a position now where we have products that compete with Nike and an image that competes with Nike."

[ABOVE] Adidas has tweaked its logos to give them a more contemporary look. The striped logo that appears mostly on footwear has been shortened for a more streamlined look.

[LEFT] Adidas owes much of its resurgence to celebrities who began appearing at award shows and in music videos with clothing emblazoned with the label. That success led the company to launch an Originals brand, which sells replicas of the company's earlier lines of footwear and gear. The Italia shoe is a replica of the shoe worn by track stars during the Rome Olympics.

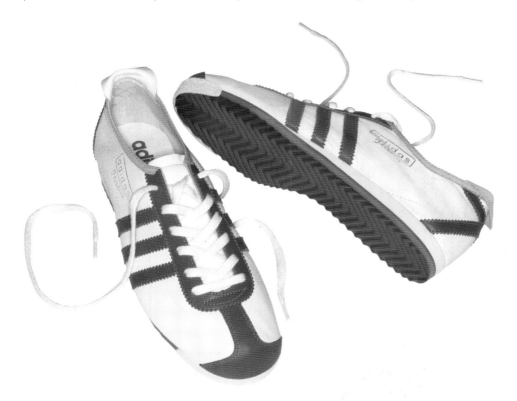

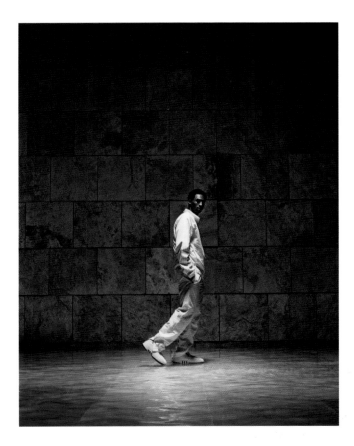

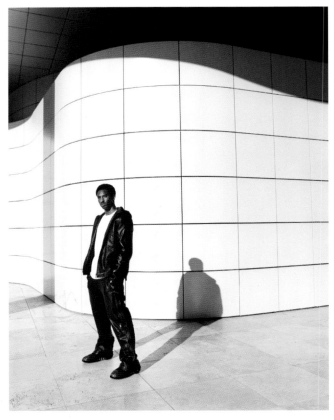

[ABOVE] Adidas also signed Los Angeles Lakers guard Kobe Bryant. The company carved out an upscale image for Bryant, who lived in Italy with his family until high school and speaks Italian fluently.

adidas, the Trefoil logo and the 3 stripe mark are registered trademarks of the adidas-Saloman group, used with permission

> Celebrities Go Retro

Adidas owes much of its revitalized popularity to celebrities and hip-hop artists who began sporting its products during the early '90s. Run DMC, a popular rap group, fashioned their entire persona on red Adidas sweatsuits with three white stripes running down the legs and white sneakers with black stripes. Pop star Madonna appeared at a Hollywood event wearing a gown made from an old Adidas tracksuit.

Adidas quickly released a line of shoes called the Originals. The concept was expanded when the company created two divisions in which to sell its products—the Originals division to promote the fashion apparel and the Performance line for its athletic items. "We didn't want to get too caught up in the whims of the pop culture movement that had helped resuscitate the brand," Jenkins says. "The performance footwear adds credibility. We're trying to reestablish brand identity as an authentic sports brand that makes good products that are not particularly flashy."

Still, the Originals line of shoes and apparel has provided a boost to the bottom line for Adidas. The shoes and apparel are marketed with the tag line, *Every Adidas Has a Story*. The company rereleased the Italia shoes—a popular track shoe worn by several Olympians in the 1960 games in Rome. The replica shoe, which sells for $180, features a white leather upper with green stripes across the middle and green soles.

Among other retro brands the company is promoting are a sweatsuit from the '60s that an employee found in a thrift shop embroidered with the name J. Mano. The tracksuit features the original Adidas logo of an oblong circle with vertical three stripes and a rough version of the trefoil. The company ran a campaign picturing the original suit with the tag line, *Hey, J. Mano, tell us your story and we'll send you your jacket*. The products can also be purchased online through the Adidas store at www.adidas.com, which features an Originals store with the tag line, *Once Innovative. Now Classic. Always Authentic.*

"We've been around since 1948," Jenkins says. "The beautiful thing about the Originals line is that we have such a rich line of products because of our heritage. We can pull something from those years and make it exactly like it was or reinterpret it. These products wouldn't fit the competitive athlete of today, but they satisfy the Prada and Armani consumer."

> Luring Back Amateur Athletes

The Adidas Performance line has turned its attention to developing new products that appeal to the competitive amateur athlete. Two years ago, the company unveiled an advertising campaign called "Long Live Sport," in which the company used amateur athletes to reestablish the company's long history—it was founded in 1948 by Bavarian shoe designer Adi Dassler—and its commitment and passion for sports.

One ad shows a women competing in a running event. As she finishes the race, the camera pans to her legs, revealing prosthetic devices. "It was a beautiful campaign—just the regular two- or three-sport athlete," Jenkins recalls. "It definitely hit the core mainstream consumer. We needed to hit that consumer before we could really start being specific in our advertising."

Once the buzz began about Adidas, the company executed some clever marketing through its Web site in an effort to sustain it. The company developed an e-card competition in which the winners would receive

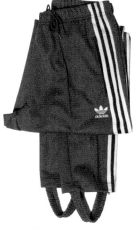

[ABOVE] These Adidas stirrup sweatpants from the '70s reflect the nostalgia of the brand with the distinctive three stripes down the leg and the trefoil logo just below the pocket.

[BELOW] Adidas management was intent on reestablishing its reputation as a premier sports manufacturer with products that appeal to all types of recreational athletes.

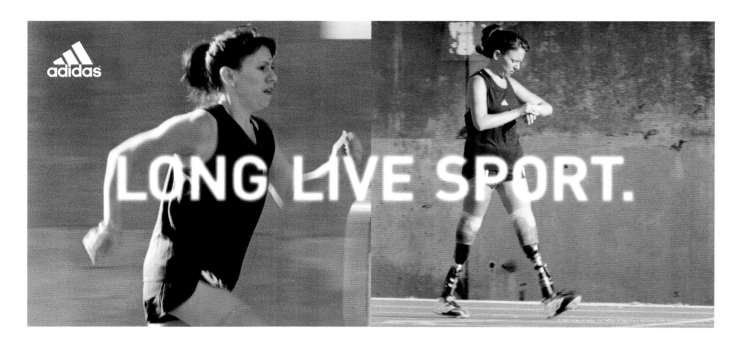

[ABOVE] **The Adidas "Long Live Sport" campaign was geared to show consumers that the company understood the triumphs and trials that young athletes experience while participating in sports. The ads, which ran in a variety of print publications, also reflect the broad range of products beyond the company's roots.**

[OPPOSITE] **As an official sponsor of the Women's World Cup in 1999, Adidas sought to highlight its long relationship with girls who play soccer. Adidas clothing and footwear has long been favored among men and women soccer players. But sporting companies have learned over the years that it must reach young players to build its brand awareness so that as consumers age, they continue to buy Adidas for all their athletic needs.**

new Adidas equipment. Contest entrants developed computer-generated postcards featuring celebrities, such as tennis player Martina Hingis and golf sensation Sergio Garcia, around the theme of "Be Better." One winner pictured Hingis with arms pointed toward the sky, which was filled with gold stars and tennis balls. The tag line reads, *Do Whatever. Dream Whatever. The World Is Yours.*

> NBA Pitches New Products

Since then, Adidas advertising has focused on new products. The company didn't have to look too far for a professional athlete to launch its new basketball shoes after signing two of the game's brightest stars— Los Angeles Lakers guard Kobe Bryant and Orlando Magic forward Tracy McGrady. Adidas signed Bryant to a contract in 1996, when he became, at the time, the youngest player to enter the NBA.

After the Lakers won their second consecutive championship and Bryant emerged as a popular player, Adidas launched the KobeTwo shoe. For the advertising, the company wanted to focus on Bryant as one of the preeminent players in the league with a series of television commercials that showed him executing a series of extraordinary dunks.

"The problem with Kobe is that he relates to inner-city kids about as much as I do," Jenkins says. "But what we can do is talk to the kids about what they relate to him—his basketball skills and money."

With the print campaign, Adidas took a different tack in reaching consumers, picturing Bryant in a bare setting, with the focus on the clothes and shoes he is wearing. Bryant, who spent several years of his youth living in Italy and speaks the language fluently, is seen standing before a brown concrete wall in a white sweatsuit and white sneakers.

Recently, Adidas ran a series of ads with McGrady after his breakout season last year, featuring his new shoe called the T-Mac. McGrady, whose skills Jenkins describes as more gritty and raw than Bryant's, allows the company to promote him more to inner-city kids. One ad features McGrady playing in a three-on-three pick-up basketball game in the evening in a back-alley setting. He rips off his shirt to look like the Incredible Hulk. The tag line is *If they appear near, appear distant.*

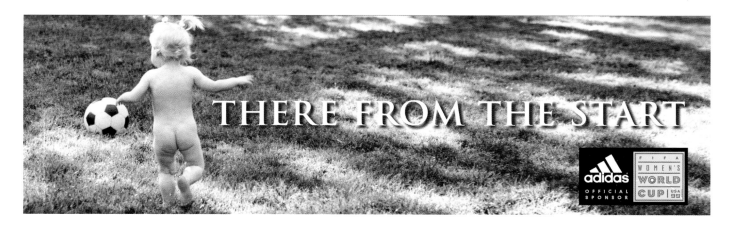

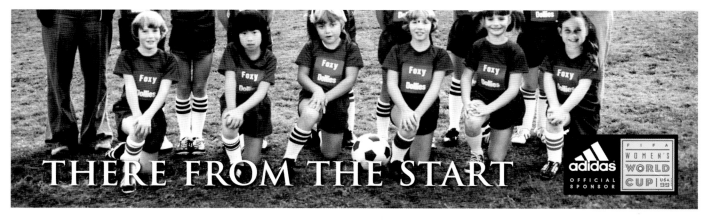

In this case, when on a basketball court, McGrady is defending and wants to give the appearance that he can steal the pass. He does so and shows that he is a great defender, team player, and scoring threat. "With McGrady, we can hit a fairly core, urban source with ads in *Vibe*, *Source*, and *Slam* magazines," Jenkins says.

The result: "I think we've really sort of grown up, but we're not there yet in the marketing," admits Jenkins. "We're turning the corner where when we do focus groups, consumers are happy to see great design, and they're surprised we make such good shoes. The message we need to establish in the consumers' minds is that Adidas is truly a great brand."

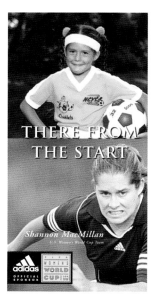

/\

Hush Puppies > Puttin' on the Dog

Hush Puppies' packaging was completely overhauled in the redesign. Gone were the flimsy boxes, often torn from being taken down from store shelves. Instead, Fitch developed a highly innovative—and much imitated—design that specifies a longer lip for strength and the addition of a finger hole for easy gripping from a full or high shelf.

When Fitch began working with Hush Puppies, the brand was perceived as tired. Although it enjoyed high awareness, its popularity had waned from its heyday in the 1950s and '60s, when it was America's most popular brand. With an aging market and little or no appeal to younger consumers, Hush Puppies was looking at a dim future and asked Fitch to completely reposition the line to appeal to a broader, younger, and more fashion-conscious audience.

After months of research, Fitch implemented a plan to relaunch the brand in 1993—up against Bass, Hush Puppies' primary competitor in both the men's and women's footwear categories. The plan focused on aligning Hush Puppies with lifestyle aspirations and attitudes, "capitalizing on characteristics inherent in the new Hush Puppies positioning—style, fun, comfort, genuine—to make it meaningful and attractive to the target consumer," says Dr. Nita Rollins at Fitch. A positioning statement was crafted as an underlying philosophy and attitude for the whole brand, and for the whole company: *Hush Puppies are about people,*

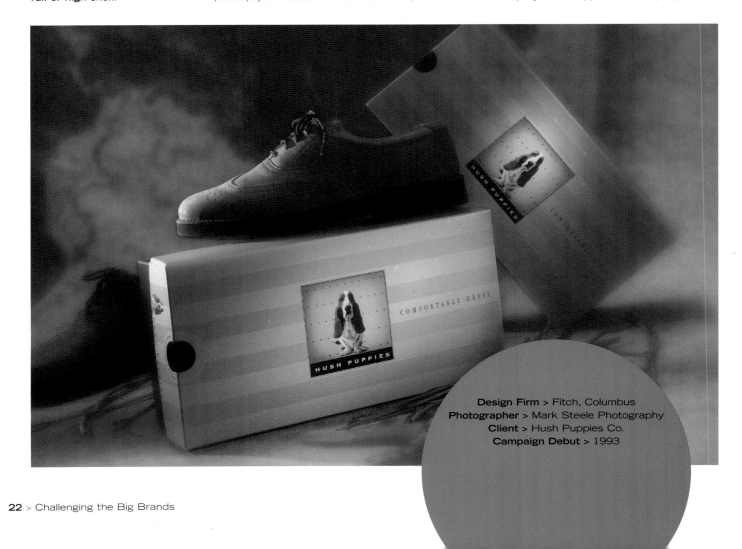

Design Firm > Fitch, Columbus
Photographer > Mark Steele Photography
Client > Hush Puppies Co.
Campaign Debut > 1993

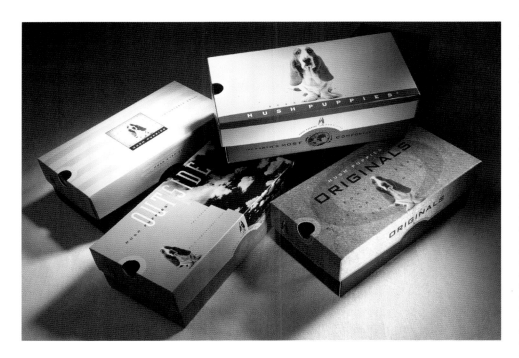

[LEFT] The entire Hush Puppies product line was restyled and segmented into four categories: Outside, Originals, Comfortable Dress, and Casuals.

[BELOW] The redesign extended to Hush Puppies' company-owned retail stores, which feature a prominent display of the kids' line.

emotion, and energy. About walking. And all walks of life. Shoes that are quality. Styles that are honest. True to current attitudes about basics and simplicity. Hush Puppies. The Earth's most comfortable shoes.

> An Icon with Equity Deserves Another Chance

To support the new brand positioning and distinguish Hush Puppies from the competition, all communications materials—including packaging, sales tools, labeling, and merchandise materials—were given a new look. "Over the years, Hush Puppies had changed the graphic treatment of the famous basset hound numerous times, to the point where there was no longer one consistent recognizable symbol used throughout the brand," Rollins explains.

At the same time, Fitch realized that the hound appealed to consumers and had built-in equity with retailers as well, so team members kept the basset as part of the new brand identity. "Typically, a marketing image declines along with the product it represents, but this was not the case with Hush Puppies. The sad-faced basset hound turned out to be an image so powerful that people remembered and liked it, even though they hadn't noticed the product in 20 to 30 years," adds Rollins. "The new identity captured the appeal of a 'real' dog through the use of sharp, close-up photography. One image would now be used for all purposes, replacing all previous incarnations."

A new tag line—*The Earth's Most Comfortable Shoes*—complemented the new graphics. The product line was segmented into four categories—Outside, Originals, Comfortable Dress, and Casual—to reflect the preferences of the new target consumer who is young; style-, value-, and quality-conscious; and comfort-oriented. Packaging for each category communicates an individual personality but is linked to the new image through enhanced identity elements, such as color, texture, form, and the dog icon. The inside of the box tops carries each line's personality statement.

Courtesy of Hush Puppies

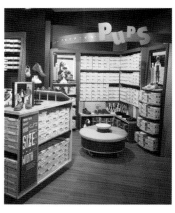

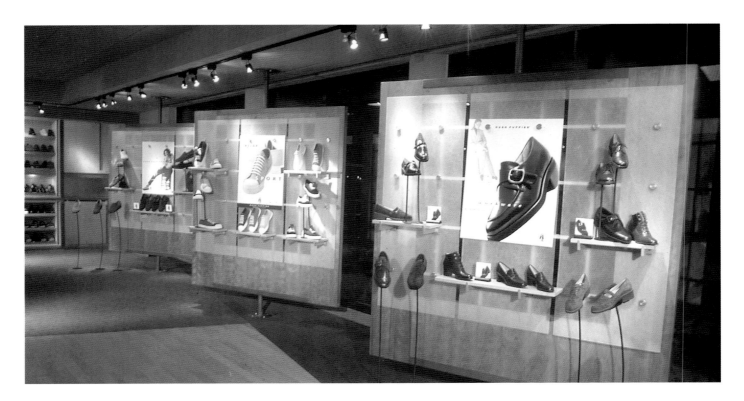

[ABOVE] Fitch developed a Hush Puppies "brand room" at Wolverine World Wide corporate headquarters, Hush Puppies' parent company, to present the brand's products and new image.

> Give Them What They Want

"We discovered in discussions with retailers that Hush Puppies' shoe boxes needed to be more functional and durable for stocking and inventory maintenance. Boxes suffered repeated pulling on the top lid as sales personnel removed them from the storeroom, and customers often received their purchase in a shabby, damaged box. To remedy this, we developed a highly innovative—and now much imitated—design that includes a longer lip for strength and the addition of a finger hole for easy gripping from a full or high shelf," Rollins explains.

Once positioning for the adult line was established, Hush Puppies extended the new brand identity to kids' products, packaging, and merchandising. Key brand messages, including *The Earth's Most Comfortable Shoes*, were translated into a format that would speak to kids—*The Most Comfortable Stuff in the Whole Wide World*.

> And the Dog's a Winner

"Since 1993, Hush Puppies has gone from a dying brand with slumping sales and an extremely limited customer base to a leader in its category, enjoying record sales and popularity. Since the introduction of the new brand positioning and identity strategy, Hush Puppies has attracted a large base of youthful consumers who have grown to identify Hush Puppies with the lifestyle aspirations they hold," says Rollins.

Moreover, Hush Puppies was able to expand into a greater number and range of retail channels. Having broadened its appeal beyond its original, aging core customer base, the footwear company secured buy-in

[TOP LEFT] This seasonal print advertising campaign targets retailers and coordinates with the Hush Puppies Web site.

[BOTTOM LEFT] When Hush Puppies launched its Web site—long after the 1993 image overhaul—it followed suit in promoting the new design language Fitch established for the brand that appealed to younger consumers.

at major middle-market retailers, independent mall retailers, and high-end department stores, as well as its own outlet stores.

"The Hush Puppies brand repositioning was very well received by the retail trade and consumers alike. Wolverine World Wide, parent company of Hush Puppies Co., marked four straight years of record sales and earnings following the launch of the new brand identity, and their stock price rose over 250 percent. With the new positioning of the children's line, Hush Puppies' business in the category tripled in the first year," reports Rollins.

While Hush Puppies sales soared, its competitor stood by its image that communicates tradition, dependable quality, and classical styling in a simplistic, conservative style. "Hush Puppies' new positioning expresses similar attributes—gentle comfort, excellent fit, superior quality, and value—[but] it's more lighthearted and fun with the famous basset hound lending a touch of nostalgia," Rollins adds.

∧

sarabanda > "Il Futuro è Adesso":
The Future Is Now

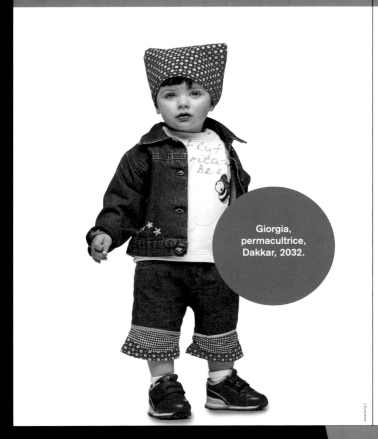

sarabanda
Il futuro è adesso

Giorgia,
permacultrice,
Dakkar, 2032.

sarabanda
Il futuro è adesso

Tommaso,
Direttore del Teatro
Nazionale,
Lisbona, 2026.

sarabanda ads are color-
coded, with orange being
sarabanda's corporate
color, blue designating tod-
dler clothing, and green
denoting clothing for older
kids, like Tommaso, the
future director of national
theater in Lisbon in 2026.

Design Firm > Hand Made Group
Art Directors/Designers > Alessandro Esteri, Giona Maiarelli
Photographer > Alessandro Esteri
Client > Miniconf
Software > Adobe Photoshop, Quark Xpress

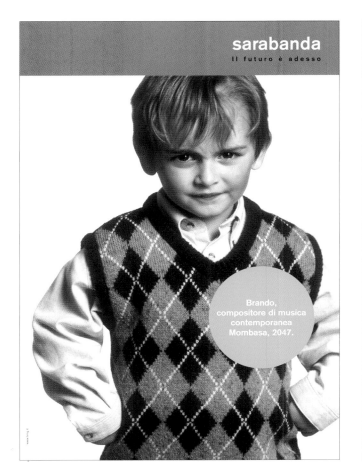

sarabanda
Il futuro è adesso

Brando,
compositore di musica
contemporanea
Mombasa, 2047.

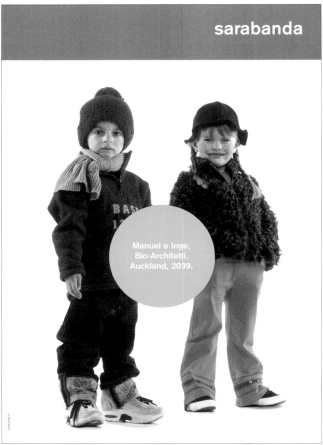

sarabanda

Manuel e Inge,
Bio-Architetti.
Auckland, 2039.

> A David versus Goliath Story

Remember the "Colors of Benetton," featuring children and young people from around the world in a consciousness-raising campaign that sold hip-colored clothing to consumers in the 1980s? Well, it was against this formidable entity—notable for their striking corporate green and multicolored advertising palette—that sarabanda chose to compete.

sarabanda is the most visible brand within Miniconf, a large manufacturer of children's clothing in Italy. Although it is Miniconf's most prominent brand, it wasn't the most visible or recognized brand in Italy, where Benetton continued to reign. Benetton had a long-standing tradition in Italy; it was a time-honored brand. Conversely, sarabanda was created in the late 1990s, and although it was distributed through its own chain of stores, it wasn't well known. Despite its newcomer status, it set out to compete head-on with the number-one manufacturer and retailer— specifically, Benetton's 012 line.

[ABOVE] Rather than raise awareness by focusing on the negative aspects of society, Hand Made Group took the opposite tack and focused on the future and what's good and promising in our children—like Brando, a contemporary music composer from Mombasa, 2047, and Manuel and Inge, bio-architects from Auckland, 2039.

Courtesy of sarabanda

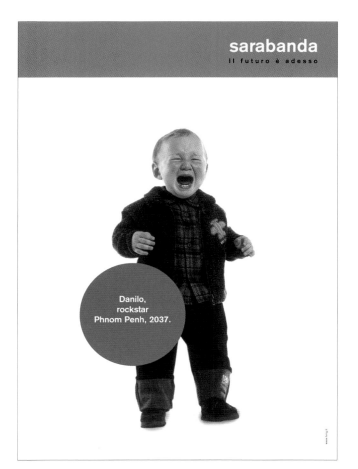

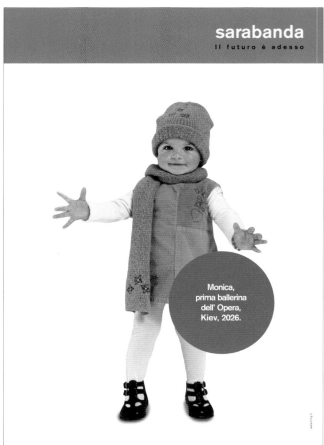

[ABOVE] Photographer Alessandro Esteri pur- posely stayed away from children who were beautiful by conventional standards, and instead cast children in the ads who emitted a real quality, chock full of personality.

> Positive Messages Pack a Punch

The job to raise visibility and increase awareness fell to the Hand Made Group, which embarked on the task of creating a print advertising campaign. The strategy was simple. "While Benetton, at least on an institutional level, presents negative aspects of our society with the intent of raising awareness, we set out on the opposite path—present the future in a positive light," says Giona Maiarelli, co-art director and designer on the project.

They did so by proposing that they photograph children wearing sarabanda clothing against a plain white background. The copy would be minimal. The goal was to focus on the hard-to-resist and memorable faces of today's youth. "Our future is today's children. The text on the images introduces the children and their future occupations in a borderless world," explains Maiarelli.

The ads feature one child—sometimes two—and personalizes the kids for the reader. One feels as if they are meeting Maddalena and Carlo, commanders of interplanetary station Syr, in 2037, or Antonio, a rising star on the L.A. Lakers in 2010, in family snapshots.

"Their future occupations speak of a bright future for them and for humanity in general. We are looking at this future right now. They are in front of our eyes," says Maiarelli, pointing to the tag line, *The future is now.*

> Colors Bring Organization

Visually, the campaign is crisp, clean, and youthful—as evidenced by its use of bright colors. A clean white background is juxtaposed against a palette of lively colors, which identifies the campaign with sarabanda. The white background enhances the visibility of the clothes but doesn't interfere with the powerful message. The ads also feature a color-coded palette that designates the product to its age-appropriate group. Orange is sarabanda's corporate color. Blue is the color used for toddler clothing, and green is used to designate clothing for older kids.

"The colors are part of a color code we have devised for the brand and carried out in all their graphics, from in-store graphics to packaging, labels, and posters," explains Maiarelli.

[BELOW] **A white background was chosen for the ad series so that it would not detract from the colorful clothing.**

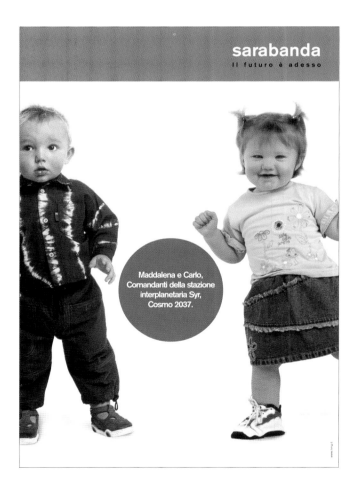

sarabanda
Il futuro è adesso

Maddalena e Carlo, Comandanti della stazione interplanetaria Syr, Cosmo 2037.

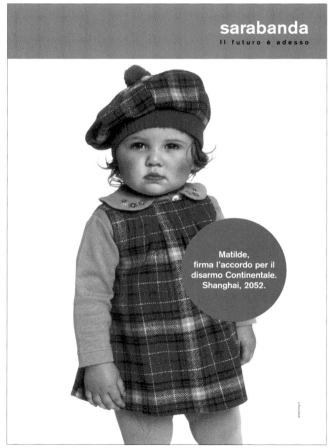

sarabanda
Il futuro è adesso

Matilde, firma l'accordo per il disarmo Continentale. Shanghai, 2052.

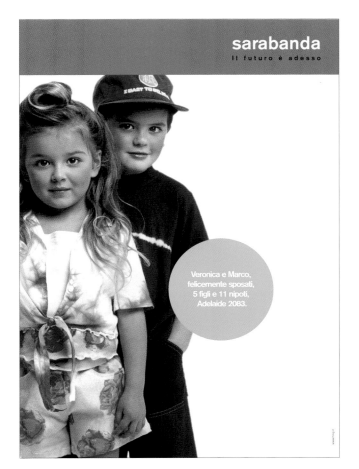
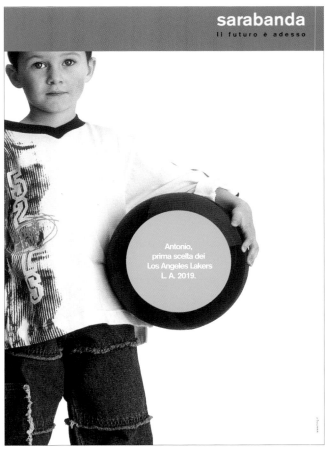

> Never Work with Kids and Animals

Hand Made Group cast aside all cautions about working with kids and animals when they embarked on this campaign and hosted a casting call that recruited 1,500 children from all across the Tuscany region of Italy.

"The children selected were not the most beautiful in the typical advertising sense, but had the most interesting personalities," says Maiarelli. "The overall image achieved is that of a series of real children."

Alessandro Esteri, the photographer and creative director, specifically requested that the children had to be living in the countryside, as opposed to urban centers where castings are usually made, because he believes children living in the country look more real and less stressed.

[ABOVE] **Photo shoots for each child lasted only about ten minutes. After that amount of time, Esteri believes that most children lose their spontaneity.**

[BELOW] **Esteri asked that children applying for the casting call live in the country, because he believes they look more like kids and appear less stressed.**

The photo shoot was done at Esteri's house and studio, an ancient renovated wool mill in the hills of Tuscany, which serves as the headquarters for Hand Made Group. Each child was photographed in about ten minutes, because Esteri believes that after that time, most children lose their spontaneity.

> Ten Minutes and It's a Wrap

In those brief ten minutes, Esteri managed to capture enough magic that when the photographs were combined with the personal stories the team created, the clothing advertisements grabbed the attention of consumers throughout Italy. Buyers who would have gone to Benetton as well as to local stores "that carry multiple brands were ready to switch to a more dynamic mono-brand store in Benetton's vein," says Maiarelli.

Numbers are hard to come by, but some say that the sarabanda campaign grew sales by as much as 60 percent. In fact, the campaign was so successful that the company created a new brand for newborns, minibanda, and is opening new stores all across Italy.

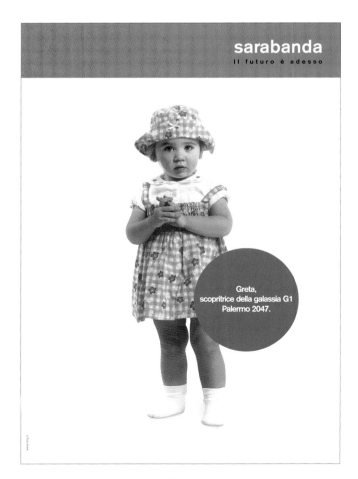

sarabanda
Il futuro è adesso

Greta,
scopritrice della galassia G1
Palermo 2047.

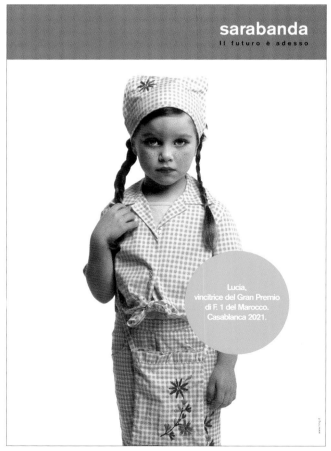

sarabanda
Il futuro è adesso

Lucia,
vincitrice del Gran Premio
di F. 1 del Marocco.
Casablanca 2021.

∧

JetBlue > Low-Cost Flying in Style

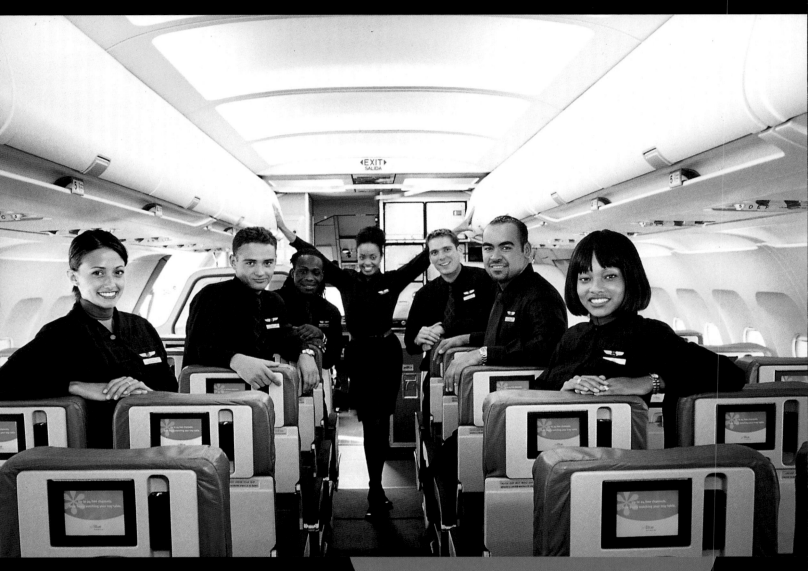

JetBlue set out to create a low-fare airline that didn't look cheap. Each plane's interior has leather seats and television sets that broadcast several stations.

Agency > The Ad Store
Creative Director > Paul Cappelli
Art Director > Victor Anselmi
Photographers > Roger Moenks and Laurent Alfieri
Copywriter > Brian Flatow

Somebody up there likes you.℠

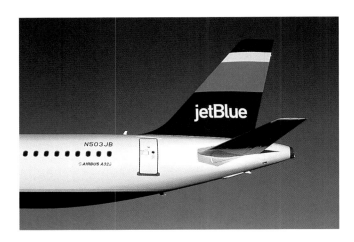

> Birth of the Low-Fare Carrier

The adage goes that anybody who does any research would never launch an airline. The start-up costs alone are astronomical, considering the expense for planes, fuel, and labor. Three years ago, JetBlue bet it could defy the odds if it could convince skeptical New York travelers that low-fare air travel doesn't necessarily translate into an unpleasant experience.

"JetBlue executives were keenly aware that the image of the airline needed to reflect the 'minimalist chic' service that it was trying to provide," says Amy Curtis-McIntyre, the company's vice president of marketing. "I'm a lifetime New Yorker. I knew that for New Yorkers, there would need to be something that would marry low-fare with something that had some style. We knew from the beginning that we wanted to come off as minimalist chic."

Three years later, JetBlue offers flights out of New York's John F. Kennedy Airport to 15 cities, including Seattle, New Orleans, and West Palm Beach. The airline has been hailed by Wall Street analysts as one of the most successful start-up airlines to emerge since Southwest started flying 30 years ago. Although JetBlue offers only one class and electronic ticketing, passengers are treated to satellite television with 24 live-channel feeds at every seat and leather seats in the airline's new fleet of Airbus A320 jets.

The company's first exercise was choosing a name for the airline. The words *Jet* and *Blue* were among 1,200 names tossed around in various branding exercises. But the process didn't yield any results until a

[ABOVE] JetBlue wanted to add a distinctive element to the tailfins of its fleet of planes, so Merkley Newman Harty came up with various designs in shades of blue. The design firm introduces a new one every year.

Courtesy of JetBlue Airways

week before the corporate name was to be unveiled to the media, when Curtis-McIntyre scrawled the combined words of *JetBlue* on a napkin.

"It says airline quickly, which is important," says Curtis-McIntyre. "You don't need to have people trying to figure out what you do. It was simple and new. The logo is very clean. It's really easy to remember."

JetBlue hired the design firm of Merkley Newman Harty in New York to create the logo. The airline settled on a logo in which *jet* is lowercased and set in a thin typeface, whereas the *Blue* is dominant, in thicker and larger letters. Curtis-McIntyre says the logo denotes the simplicity and approachability of the airline.

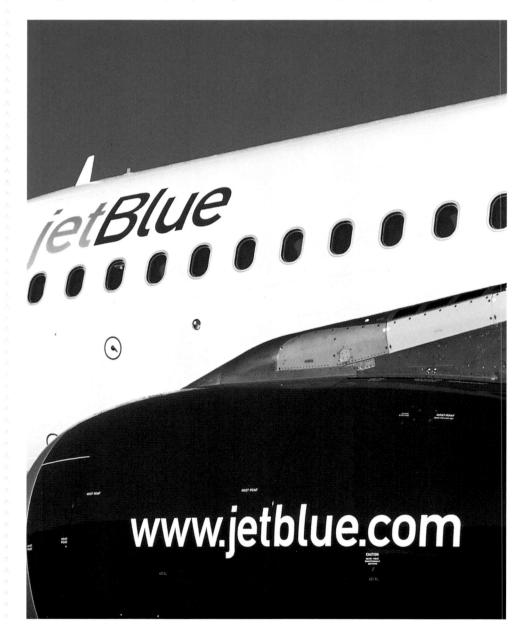

[RIGHT] **Management found that the tailfins set the airline apart from competitors when spotted at the gates of major U.S. airports. The airline also had its Web address imprinted on the side of its aircraft in an attempt to push consumers toward the convenience of booking online.**

> Trolling Chinatown for Ideas

The next challenge was to extend the new logo throughout the airline, from its cocktail napkins to the aircraft tailfins. Designer Carol Zimmerman walked into JetBlue's executive boardroom one day after a shopping trip on Canal Street and proceeded to pull out sunglasses, scarves, and bedsheets in various shades of blue.

When asked which shade of blue she planned to use for the tailfin design, Zimmerman is said to have replied, "All of them." She developed three different design patterns for the planes, using a variety of blue-on-blue themes.

"Our greatest fear is that we would get stuck with a baby blue or powder blue or a conservative navy blue," says JetBlue spokesman Gareth Edmondson-Jones. "We didn't want the obvious or the tired. We wanted it to have an edge and quirkiness. It was like, 'Eureka, she's got it!'"

The concept of using various shades of blue extended from the interior of the plane to the flight attendant uniforms. The airline had begun to design its uniforms before it had settled on a name for the airline. The company originally wanted black uniforms, but the idea was scrapped after the name was chosen. Still, designer Stan Herman came up with stylish midnight blue togs.

[ABOVE] Fashion designer Stan Herman was hired by JetBlue to provide style to the flight attendants' uniforms. The design conveys a casual yet contemporary style that mirrors the brand identity the airline has established.

IT DIDN'T TAKE A ROCKET SCIENTIST
TO CREATE AN AIRLINE LIKE THIS.
ANY ONE OF YOU WOULD HAVE DONE IT.

Only JetBlue Airways delivers up to 24 channels of DIRECTV® at every big leather seat – absolutely free. See what over 5 million passengers nationwide have already discovered – with new planes, low fares and a refreshing attitude, JetBlue isn't the only way to fly. But it should be.

florida
FROM $79* EACH WAY

jfk to	internet fares from* (each way)	jfk to	internet fares from* (each way)
burlington, vt	$44	west palm beach	$79
buffalo	$44	new orleans	$79
rochester	$44	denver	$114
syracuse	$44	salt lake city	$114
ft. lauderdale	$79	seattle	$124
ft. myers	$79	los angeles (long beach & ontario)	$134
orlando	$79	san francisco (oakland)	$144
tampa	$79		

Introducing service to San Juan, Puerto Rico starting May 30th from $124 each way.*

All fares reflect a $5.00 savings per one-way trip only when booked online at www.jetblue.com. All reservations made by calling 1.800.jetblue will not reflect $5.00 savings.

1.800.jetblue jetblue.com

jetBlue AIRWAYS®

NOTHING OLD. EVERYTHING NEW.
NOTHING BORROWED.
BLAH, BLAH, BLAH, JETBLUE.

What happens when you marry new planes, free DIRECTV® at every big leather seat and super low fares? You get JetBlue Airways. A better kind of airline, committed to treating you right at super low prices. See what 5 million passengers have already discovered. JetBlue. It's not the only way to fly. But it should be.

nonstop from oakland
new york city (jfk) 4 times daily*
new service:
washington, d.c. (dulles) 2 times daily

1.800.jetblue jetblue.com

*Fourth daily nonstop starts May 8th

jetBlue AIRWAYS®

[TOP LEFT] As intended, the JetBlue ads serve as a visual tour of the high-level amenities consumers can expect from the low-cost carrier.

[TOP RIGHT] The typical whimsy of JetBlue ads is delivered in this message where even newlyweds would consider saving money by flying with the airline.

"We wanted to say that we were different from other airlines and suggest to the passengers that the experience was going to be different," Curtis-McIntyre says. "There was going to be a commitment to style, even if you're flying for $59. By taking design and style seriously, we combated the skepticism that a low-fare airline couldn't work. Only people with confidence and conviction would come out with such aesthetics. People got that right away. It never felt cheap even though the whole design was inexpensive to execute."

> Tapping into Consumer Angst

JetBlue initiated its marketing with a print advertising campaign in which the airline used wit to tap into New Yorkers' hostility toward flying. In a series of ads, Merkley Newman Harty used stock photographs of angry faces and sarcastic tag lines. For example, in one ad, the tag line reads, *Low fares and TV. Sure, I'm the Queen of Sheba.* In another, *New planes and low fares. What am I? An Idiot?*

Over time, though, Curtis-McIntyre says the airline realized that the theme of the spots was too aggressive and simply fed into consumer resentment toward airlines, including JetBlue. "We needed to talk more about ourselves, more than we thought we did," she says. "We had to prove to our customers that we were improving the coach travel experience."

Although the new marketing campaign focuses more on JetBlue as an airline, the humor in the ads has not been lost. Developed by the Ad Store of New York, the ads focus on the features that differentiate JetBlue from its competitors, such as satellite television, comfortable leather seats, and slightly more upscale meals.

Because it was launched after the September 11 attacks, art director Victor Anselmi said the challenge was striking a tone in which JetBlue appears sensitive to consumers' fear of flying, while still encouraging potential passengers that air travel is safe. "It's been tough," he says. "If you do something that is insensitive or in poor taste, it could hurt the airline's sales."

get better reception at long beach.

real tv at every seat to nyc jetblue.com jetBlue AIRWAYS

long beach. short lines.

fly easy from long beach jetblue.com jetBlue AIRWAYS

One approach Anselmi took was to use a blue jet stream as part of an outdoor campaign. The company ran two billboards set up next to each other near Los Angeles International Airport. All that appears in the ad are the words *blue jet stream* and *Long Lines Suck. Fly easy from Long Beach.*

The word *lines* has 17 *l*s spread across both billboards to appear like a group of people standing in a long queue. The jet stream serves two purposes: to evoke the feeling of an airplane without actually depicting one and the comfort of the blue skies.

A print ad shows the interior of a JetBlue plane with the copy, *It didn't take a rocket scientist to create an airline like this. Any one of you would have done it.* In another spot, a young couple is carrying his bride down the aisle of the plane. The tag line reads, *Nothing old. Everything new. Nothing borrowed. Blah, blah, blah JetBlue.*

"It's something to say that they've got tons to offer that frankly a lot of different airlines don't," Anselmi says.

[TOP] In an outdoor ad, JetBlue combines promotion of its airline features—in this case, its television services—with its new service launch from Long Beach, California, to New York City. The ad includes not only JetBlue's logo but also its Web address.

[BOTTOM] JetBlue prides itself on providing consumers with the most convenient and inexpensive way to fly, as depicted in the message of this campaign about flights and fares from Long Beach to New York City.

Virgin Atlantic Airways

> Keeping It Light

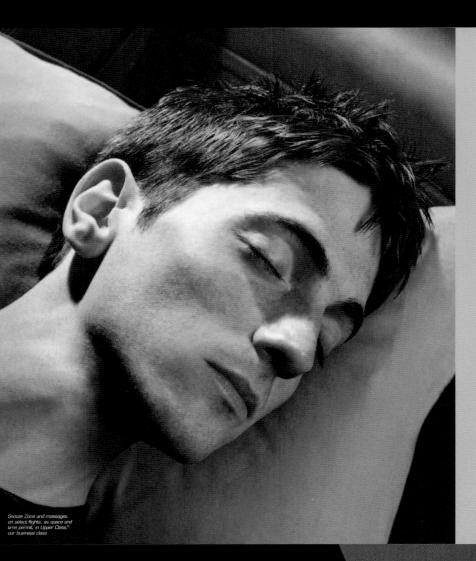

THE CRUST IN YOUR EYES. THE DROOL IN
THE CORNER OF YOUR MOUTH. THE MESSY HAIR.
SLEEP. IT'S A BEAUTIFUL THING.

Arriving wide-awake and ready for business. That's the true beauty of Upper Class.

Maybe it's our new seat that's doing the trick, offering you over 6 feet of sleeping

space. Or our private Snooze Zone, a designated area where you'll never be disturbed

by a rattling food cart, a chatty passenger, or anyone clicking away at their computer.

And when it comes to helping you go out like a light, what more could you ask for?

Well, how about a real pillow and comfy duvet? Complimentary cotton pajamas? Or

maybe a soothing on-board massage? In the end, you'll get a sleep that leaves you

feeling great and looking, well, let's just say there's a salon in our Revivals Lounge.

Business Class to London
1-800-862-8621
virgin.com

virgin atlantic

Snooze Zone and massages
on select flights, as space and
time permit, in Upper Class,
our business class

Virgin's ads rely on edgy
and humorous copy, written
to appeal to busy travelers.

Design Firm > CMG Communications
Creative Director > Vinny Tulley, Mark D'Arcy, and Dave Berger
Senior Art Director > Tim Shaw
Senior Copywriter > Yvonne Lavosa

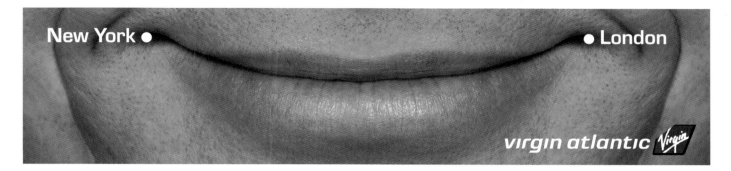

New York ● ● London

virgin atlantic *Virgin*

> Recreating the Way We Think About Flying

When Virgin Atlantic Airways launched its first flight in 1984, founder Richard Branson knew that the airline needed to establish a strong profile in a competitive market. Another no-frills transatlantic airline had declared bankruptcy just two years earlier after competitors like British Airways cut their fares and drove the smaller company out of business.

"The key to building the brand would be to establish Virgin and its London destination within the travel industry," says Michael Glavin, a partner at CMG Communications. "We wanted to establish fun, innovation, and value for money as pillars to the brand. People will fly once for the price, and they'll remember everything but the price."

Part of the marketing plan hinged on the product itself—a fleet of airplanes offering passengers reclining sleeper seats, stand-up bars, and in-flight beauty therapists. Yet, the advertising team needed to develop an innovative print, television, and radio campaign that captivated the imagination of consumers.

> Strength of the Unexpected

Glavin, who then worked for Korey, Kay & Partners, thought one way to establish the airline was through the name itself. Initially, the airline was to be called British Atlantic Airways. But the company's executives changed the name to Virgin as a way to leverage the name of Branson's record label founded in 1973. By the 1980s, Virgin Records was one of the hippest music labels with a stable of established recording artists such as Janet Jackson and Genesis.

Korey, Kay & Partners worked to establish Virgin among consumers before a flight ever took off. Aviation regulations prohibited the airline from advertising its fares until it received proper certification, so Glavin and his team focused on piquing consumer interest.

Virgin teased the market by hiring five skywriting planes to fly over Central Park and deliver a message: *Look Out for an English Virgin. The New York Post* ran a front-page story about the incident in the newspaper the following day. The article explained that the message was about a new airline that would offer low-fare service on a route between the Gatwick and Newark airports.

Radio commercials followed the skywriting campaign. One of them involved a conversation between a husband and his wife discussing an upcoming business trip to London. At one point he tells her that he's flying to London with an English virgin, but by the end of the spot, it's clear that he's talking about the airline.

[ABOVE] The "Smile" billboard set out to raise awareness among customers who were familiar with Virgin Atlantic Airlines. CMG research discovered travelers didn't know which airports the flights originated from.

Courtesy of Virgin Atlantic Airways

[ABOVE] The success behind the Virgin ads has led CMG to emblazon the promotions on T-shirts and hats as another method of increasing the visibility of the brand.

[RIGHT] Virgin Atlantic Airways founder Richard Branson attracted attention to the fledgling airline in its early years with his daredevil stunts, which included setting several world records by hot-air ballooning across various parts of the globe. CMG Communications uses Branson occasionally in advertising, as seen here to advertise the alliance that developed between Virgin and Continental.

"It was a way of introducing the name to the public and travel trade," Glavin recalls. "It was a seat-of-the-pants operation. Every penny was spent on making the airline happen as opposed to planning and researching it."

With little advertising money, Virgin and its creative staff were willing to break new ground in an effort to differentiate the airline from other low-fare carriers such as Peoples Express and Continental.

> Capitalizing on the Virgin Family's Assets

"Richard had access to the celebrities, and we didn't have the money," Glavin states. "We asked ourselves, 'Why aren't we working more closely with the record company?'"

Virgin Records struck deals with a few of its recording artists, offering revenue for doing commercials for the airline. At the height of its popularity, Genesis, with lead singer Phil Collins, produced several radio commercials for Virgin. At the end of one spot, a band member utters the tag line, *What kind of airline would call itself Virgin anyway?*

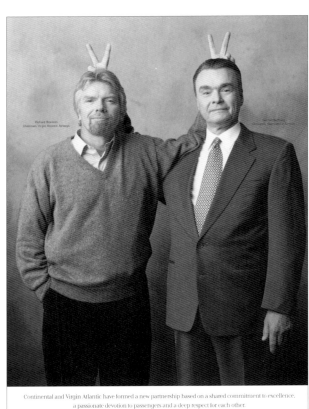

Continental and Virgin Atlantic have formed a new partnership based on a shared commitment to excellence, a passionate devotion to passengers and a deep respect for each other.

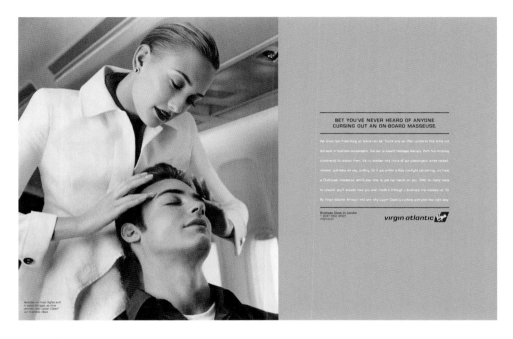

BET YOU'VE NEVER HEARD OF ANYONE
CURSING OUT AN ON-BOARD MASSEUSE.

virgin atlantic

[LEFT] In-flight beauty therapists help passengers relax and rejuvenate at 35,000 feet. Massages, manicures, and aromatherapy are available in a dedicated area of the upper-class cabin.

Virgin's use of celebrities expanded. The airline hired actress/comedian Tracey Ullman as a spokesperson because she is British and had established a reputation for developing edgy yet funny characters. For Virgin, she created such characters as a single career woman and an Italian businessman. In the radio spots, the characters ranted in hyperkinetic speech about what a great trip they had on Virgin.

Although research indicated that consumers identified with the Ullman spots, the spots didn't translate into increased sales. By 1990, Glavin and Virgin executives recognized that the airline industry was entering a new phase that focused more on business travelers. Virgin was now competing head-on with American Airlines and British Airways, and its marketing campaign would have to reflect that.

"Anyone can be successful for a few years by coming out with low prices," Glavin relates. "But the big boys will prevail. It was a different marketplace and the [advertising] plan had to use the personality of the airline to grow. The question was how to grow up without growing old."

> Refining the Focus

Advertising moved away from focusing exclusively on fare prices and toward the differences between Virgin and other airlines. When Virgin inaugurated service to Washington, D.C., in the mid-1990s, Glavin developed a hip video for corporate travel agents featuring shots of the planes and imagery of London and Washington with background music by Jimi Hendrix.

A television spot followed, in which an American businessman walks into a British pub. The owner lavishes the man with free beer and food, and a patron offers to drive him to Heathrow airport after he asks for directions. Over a shot of Big Ben, the voice-over says, "England isn't really like this; that's why Virgin Atlantic is."

NOW YOU CAN TAKE CARE OF THE THREE S's
RIGHT AT THE AIRPORT.
Y'KNOW, SHOWER, SHAVE, AND SHOESHINE.

In our Upper Class Clubhouse, you can take care of everything from A to Z. Relax in our Virgin Touch Salon with a complimentary massage, manicure, or haircut. Lose yourself in one of our private music rooms. Or, better yet, find yourself curled up with a book from our library. When you're ready to get down to business, there's our state-of-the-art business facility, with computer stations and Internet access. Passengers arriving at Heathrow can retreat to our Revivals Lounge for a shower, a bite to eat, or just to put their feet up. And as for that other "S" you were thinking of. Yes, you can still play on the Ski Machine in our Clubhouse.

Business Class to London
1-800-862-8621
virgin.com

virgin atlantic

[TOP] Virgin discovered that female business travelers want the same services that men expect on flights—even shoe shines. The airline was one of the first to reach out to female business travelers and gay travelers.

[BOTTOM] One drawback of transatlantic air travel is the countless hours stuck in a seat. Virgin developed a bar on its planes to show travelers that passengers need not be confined to their seats.

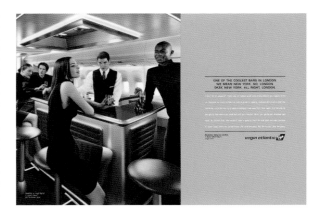

ONE OF THE COOLEST BARS IN LONDON.
WE MEAN NEW YORK. NO, LONDON.
OKAY, NEW YORK. ALL RIGHT, LONDON.

virgin atlantic

"Consumers had misconceptions about the quality of the products," Glavin states. "The free limos, great lounges, stand-up bars, and sleeper seats really weren't for them. It was the favorite airline that they never flew."

Virgin tried to distill the hesitancy on the part of consumers. One advertisement featured a business-woman sitting in the plane's lounge with the tag line, *You have a place to get up and go*. The airline then launched a series of similar print ads that appeared in *Forbes, Fortune, Wired,* and *Golf Digest* in an

effort to appeal to highly educated readers with strong disposable income. Virgin was one of the first airlines to advertise in the gay publication *Out*.

> An Ultra-Mod Spokesperson Seals the Deal

When Virgin launched a route from Boston to London in 1991, Glavin turned to a new type of ad: billboard advertising. Located near the Fleet Center (formerly the Boston Garden and home of the Celtics), the billboard featured former Celtics player Larry Bird and was emblazoned with the phrase, *There is a new bird in town.* Other spots featured images of Cambridge and Boston's compact Back Bay neighborhood with the tag line, *We would have been here sooner, but we couldn't find a parking space.*

The humor continued, but the graphics made a stronger link between London and the city from which Virgin Atlantic Airways originated. In many respects, the Boston billboard campaign—and subsequent ones that ran in New York City featuring Austin Powers—elevated the airline and its advertising message to cult status.

Several of the Boston slogans were eventually printed on T-shirts and stickers that the airline handed out to passengers for free. The airline also designed wobbly salt- and pepper shakers with a message on the bottom—*Pinched from Virgin Atlantic.* Glavin notes, "It was free advertising that the airline could never have afforded to buy."

Having learned a lesson with the Ullman campaign, Glavin was sensitive to not allowing the celebrity to overpower the brand in the Austin Powers commercials. One billboard campaign simply had the Virgin Atlantic logo and the words *Virgin Shagatlantic* underneath it. The airline served martinis in a glass with an embossed picture of Austin Powers, and the passengers were given free T-shirts and hats.

"The association among travelers with Virgin and traveling to London doubled after those two campaigns," Glavin says. "Behind the fun was a serious message. We'd been able to get a lot of value for our money."

[ABOVE] The airline never runs out of places to establish its brand identity, including these salt- and pepper shakers that wobble. When turned over, they deliver the Virgin name, the insignia, and a message *Pinched from Virgin Atlantic.*

[LEFT] Travelers don't need to worry about packing a travel bag for their long flights—Virgin offers upper-class customers a convenient backpack filled with a toothbrush, an eye mask for sleeping, earplugs for silence, and socks for warmth.

[BELOW] Male business travelers also get their needs fulfilled with a kit containing socks, a toothbrush, earplugs, body gel, and moisturizing lotions.

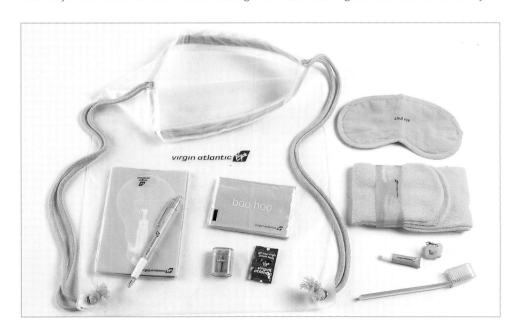

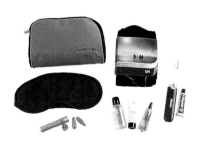

∧

Avis > Trying Harder to
 Connect with Consumers

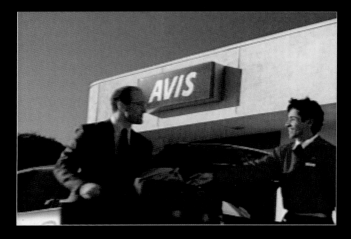
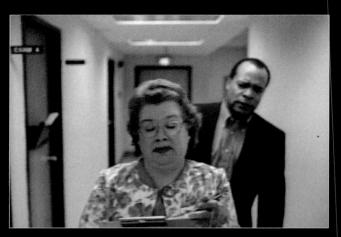
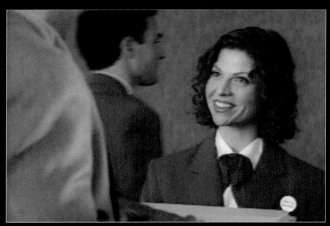

Agency > McCann-Erickson
Creative Director > Steve Ohler
Art Director > Chris Quillen
Copywriter > George Dewey

> Remaking an Image

Sometimes, even the most indelible and effective tag lines get worn around the edges. The message is no longer crisp and consistent with the company's market position. The words no longer convey what consumers want to feel or remember about the product.

Two years ago, Avis executives decided to tweak its illustrious *We Try Harder* slogan to make the campaign work a little harder for the company. The result was a new advertising campaign that attempted to stretch the meaning of the tag line beyond its original intent of challenging the nation's leading car rental company, Hertz.

"Our intent was to restore luster to one of America's greatest brands ever created," says Kevin Scher, senior vice president and group account director for McCann-Erickson, which handles the Avis account. "It was the original challenger brand. It defined what a challenger brand did and how it operated. We wanted to redefine the meaning of *We Try Harder*. Part of the challenge of *We Try Harder* was that it was a reference to Hertz. Avis was sick of being the number-two brand. The company wanted to recast it so that the message had a broader meaning."

We Try Harder is arguably one of the greatest tag lines ever created. The Avis "We're Number Two—We Try Harder" campaign was started in 1962 by Doyle Dane Bernbach. Bill Bernbach, the founder of DDB, took the campaign to the then chairman of Avis, Robert Townsend, despite it being panned by pretesting research. Townsend liked it so much he instructed the agency to run it, and a universally admired and respected advertising legend came into being. It even spawned a whole book.

"When that campaign began, it was pretty provocative," Scher says. "What brand would come out and say, 'We're number two'? These days, a company wouldn't. Back in the 1960s, it was a pretty dynamic statement to make. It tapped into the American desire to root for the underdogs, and that sentiment really hit home with Americans in a category that is about fun."

> Challenging the Leader

McCann-Erickson faced the difficult challenge of trying to rejuvenate the tag line, while not destroying the message that is synonymous with Avis. An effective tag line conveys something so important or real about

[OPPOSITE: TOP LEFT] In this campaign, Avis shows the warmth that develops between Avis and its customers through the use of more people and fewer cars.

[OPPOSITE: TOP RIGHT] Avis developed a campaign to tap into consumers' disgust over bad service from retailers by touting the services it offers to make renting a car efficient and convenient.

[OPPOSITE: BOTTOM] Avis employees are then shown offering efficient and friendly service to customers. They pose the rhetorical question, *Ever get the feeling some people just stopped trying?* because service is what distinguishes the company from its competitors.

[BOTTOM RIGHT] The Avis *We're Number Two— We Try Harder* campaign was launched in 1962 by Doyle Dane Bernbach. Bill Bernbach, the founder of DDB, created one of the most recognizable and endurable tag lines in advertising history.

Courtesy of Avis

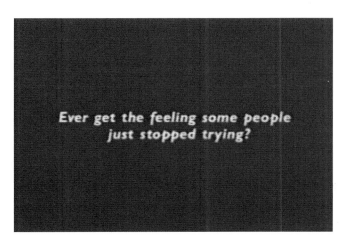

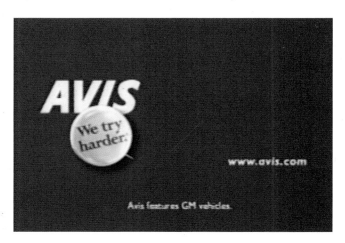

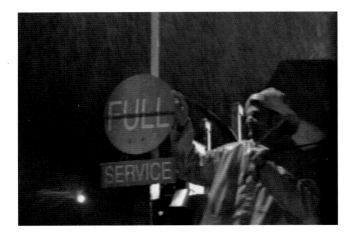

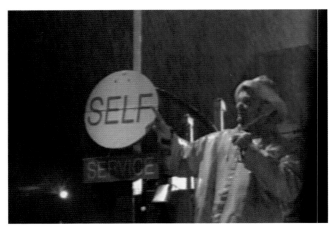

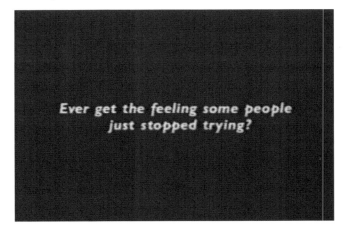

Ever get the feeling some people
just stopped trying?

[TOP ROW AND BOTTOM LEFT] The latest marketing campaign for Avis attempts to focus on the superior service that the company offers when compared to competitors. The company's "Pain in the Gas" commercial shows how Avis shops go to extraordinary lengths to meet the needs of consumers.

[BOTTOM RIGHT] Each of Avis's latest commercials features a single shot of the *Ever get the feeling some people just stopped trying?* tag line to reinforce that the company cares more about service than its competitors.

a company that it sticks in customers' minds. You don't even need to mention the company's name. Most recently, Nike has followed with the *Just Do It!* tag line. McDonald's has *You deserve a break today*, and Coke has *It's the real thing*.

After much research, McCann-Erickson discovered that the Avis tag line needed to break away from its number-two mentality. Scher says the company's creative directors wanted to use the slogan as a foil for all that was wrong in the service industry, not just a reflection of its competition with Hertz. The process produced some 50 campaigns, which were then whittled down to three—including the one chosen—which were pretested among consumers.

> Focusing on Service

McCann-Erickson wanted the outstanding service that Avis employees provided to become the standard for which the company would distinguish itself, not only from others in the rental-car business, but also from other companies in service-oriented industries like fast-food restaurants, banks, and hotels. In the ads, the visual images changed from being dominated with photographs of cars to shots of people in warm, caring moments.

"This message had so much buzz and a breakthrough ability to get the company back on the map and rede-fine itself as the leader in service among car-rental companies," Scher says. "It was hard to come up with an idea that the company finally loved. But once they [the executives] pulled the trigger, it was a pleasure. You could understand them being cautious. You don't want drastic change, but you want to stay current."

One of Scher's favorite spots that embodied the new message involved a driver pulling his car into a full-service gas station on a rainy night. The driver is seen waiting for an attendant for what seems to be an extended period of time. Eventually, a 20-something kid comes out and changes the sign from "Full Service" to "Self Service." Then comes the voice-over: "Ever get the feeling that some people just stopped trying? At Avis, we take a novel approach—We try harder."

"It was an untapped opportunity to reach consumers with a different message, a different look, and the feeling of a bigger brand, like it wasn't," Scher says. "What we were doing was showing shots of con-sumers walking into stores that showed humanity with a message. It was all designed to portray a warm,

[TOP ROW LEFT] Avis cre-ated the "Uncle Clown" character that doesn't seem interested in his job when he shows up at a children's birthday party and performs haphazardly.

[TOP ROW RIGHT] "Uncle Clown" can't remember the name of the birthday boy or create animals out of balloons, making the party a disappointment for everybody involved.

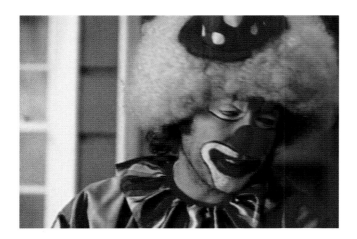

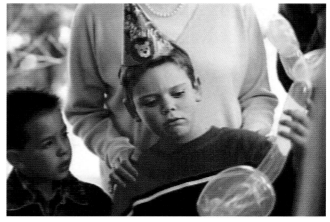

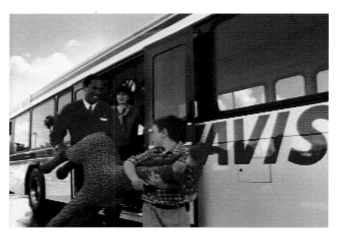

[BOTTOM] Avis does everything it can to help families, especially those with kids, to meet their car-rental needs, even when the task is cumbersome.

[ABOVE] McCann-Erickson executives eliminated references to Avis being ranked the second-largest car company in its logo. The agency wanted the logo to reflect the company's focus on customer service.

[RIGHT] The print ads for Avis echo the theme established with its television spots and use the copy to explain the services that Avis offers to make life easier for customers.

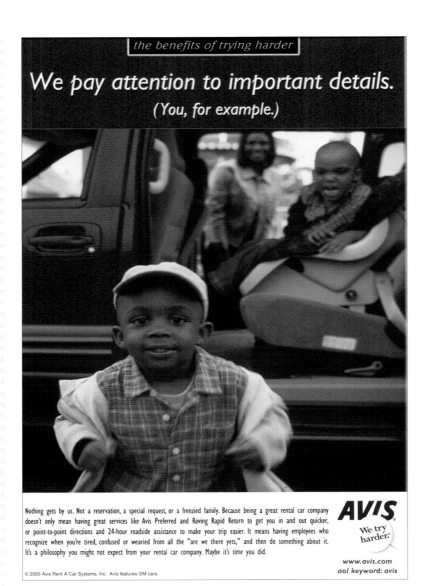

caring package. Hertz is very big and professional. Enterprise has the deal where it will pick you up. Avis is about caring employees that treat consumers right and treat them like human beings."

McCann-Erickson also wanted to invoke more humor in the campaign, something that had been lacking in the Avis marketing effort. One ad that prompts laughter features a clown entertaining a bunch of nine-year-old kids at a birthday party. However, the kiddie clown isn't much interested in his role—he forgets the birthday boy's name and tries to entertain the partygoers with grossly distorted balloon animals.

The end of the ad shows an Avis employee helping a family—led by its young son whose hands are filled with an oversized stuffed giraffe—out of the airport bus and into a rental car. Then, a blank, red panel appears with the Avis logo and button on which *We Try Harder* is emblazoned.

One thing that McCann-Erickson didn't do is fiddle with the Avis logo or the button. "Those elements," Scher says, "are permanently affixed to the company's image." The button serves several purposes, reinforcing the message to consumers and the employees that wear them. He says it is a symbol whose message hasn't diminished since its introduction, and it continues to resonate some four decades later.

Scher says the company has made a concerted effort to make sure its new approach is filtered throughout its various advertising media, ranging from television to newspapers. In most cases, Avis runs print ads to promote new services or specials, yet the company's dedication to service always remains a focal point. This can be seen in an ad touting its lower rental costs. The rate of $29 is prominently displayed in white letters in the middle of a red background, but underneath in parentheses are the words, *It would've have been $31.50, but we tried a little harder.*

In another ad about the Avis Preferred and Roving Rapid Return services, the headline above a picture of a young boy in front of an open minivan door with his infant brother and mother looking on says, *We pay attention to important details. (You, for example.)* The copy goes onto explain that service isn't what makes Avis a superior car-rental company, rather its employees do. *It means having employees who recognize when you're tired, confused or wearied from all the "are we there yets," and then do something about it.*

"Avis really defines service and always has. That's what the brand is about. We tried to bring some of that back with a sense of humor and a message that goes right to the heart of consumers so that they pick Avis first," adds Scher.

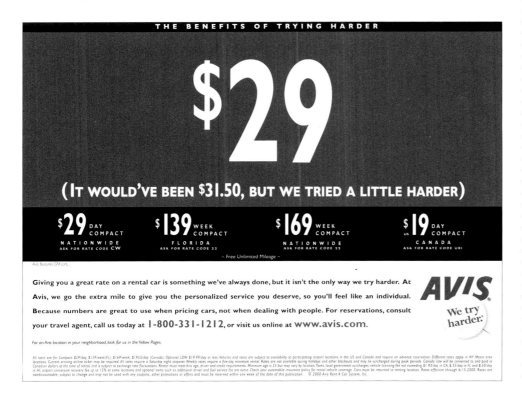

[LEFT] The print ads are used as a vehicle for car-rental promotions, but they still make reference to the company's willingness to try harder.

∧

Gateway > Taking a Completely
Different Tack

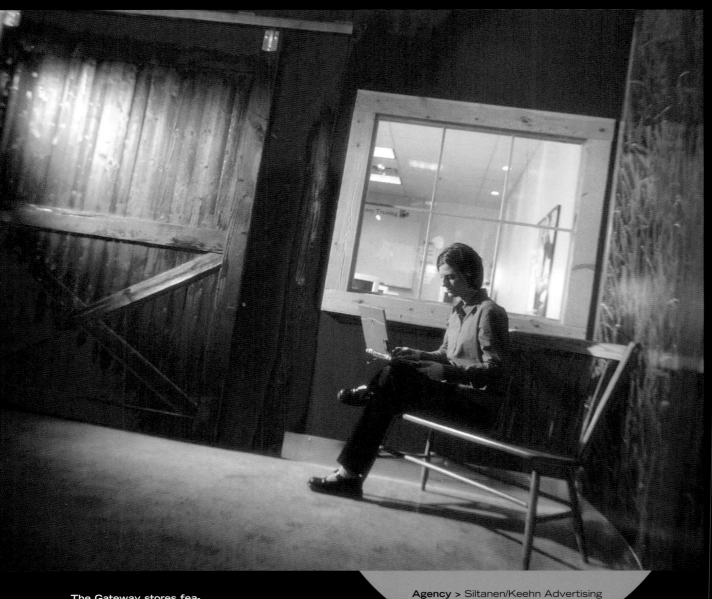

The Gateway stores fea-
ture replicas of barn doors
and wooden benches
where consumers can feel
comfortable exploring the
company's products.

Agency > Siltanen/Keehn Advertising

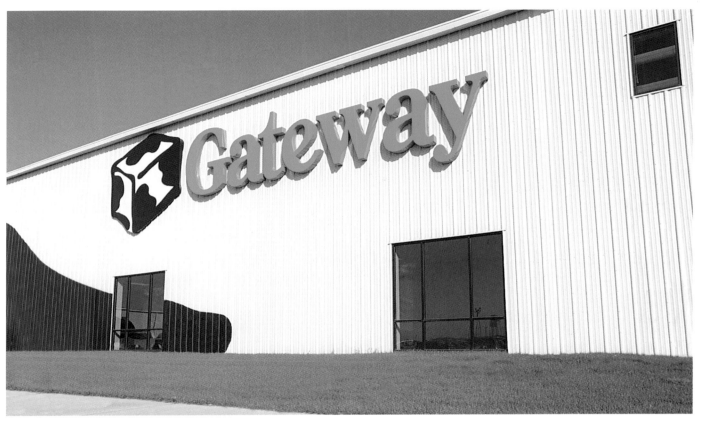

> Cows Selling Computers?

By the time the black-and-white cowhide-motif boxes began arriving at the homes of consumers, Gateway had established itself as one of the nation's largest direct sellers of personal computers. Marketing has been essential in Gateway's efforts to influence—and, in effect, change—consumers' computer-purchasing habits.

At age 22, Ted Waitt started Gateway 2000 (as it was then called) in a barn on his parents' cattle farm outside Sioux City, South Dakota. His strategy was to manufacture personal computers and sell directly to consumers. By doing so, he could keep overhead low and offer high-quality PCs at the best possible prices.

Waitt, a University of Iowa dropout, quickly moved to market the company's computers to enthusiasts through advertisements in trade publications. The early ads served as the incubator for building a corporate image whose foundation was firmly rooted in the company's farmland heritage. The images behind Gateway's marketing campaign have changed little over the past 17 years. What has changed is their efforts to reach consumers through more commercial vehicles, like television, mainstream magazines, and newspapers.

"The basis was the latest technology and the biggest bang for the buck," says Luanne Flickkema, Gateway's director of customer insight and relationship marketing. "The basis hasn't changed much. When selling products, we're still talking about the value and the approachability that we offer consumers in an area that many find intimidating. We may go about showing it in a different way."

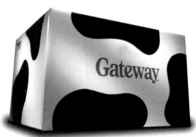

[ABOVE] The black-and-white cow-motif boxes in which Gateway computers are delivered were pivotal in establishing the company's brand among consumers.

[TOP] The exterior of the Gateway National Sales Center reflects the company's original design with its motif of black-and-white cow spots.

Courtesy of Gateway

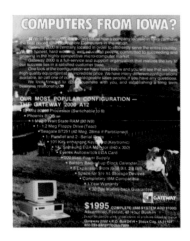

[ABOVE] In its earliest ads, which usually ran in trade publications, Gateway used its Midwestern roots to lure potential buyers.

> Creating a Following

With a small advertising budget, Gateway focused its early advertising on trade publications, where computer enthusiasts turned for the latest information on technology, and used its headquarters in South Dakota as a means for attracting attention. One ad featured a banner headline proclaiming, *Computers from Iowa?* The copy that followed (sometimes 8- to 10-page spreads) went into a lot of detail on various configurations that only computer aficionados would be able to comprehend. As the buzz about the company began to build, Waitt and his employees started popping up in their advertisements. The ads caused Gateway to develop a cultlike following with its earliest buyers. Flickkema says that Waitt believed the ads featuring him and his employees reinforced Gateway's attempt to show consumers that Gateway was an accessible computer maker.

One ad featured a scene in an Iowa diner in which Waitt was seen leaning through a window dressed as a short-order cook. The copy asked viewers to point out which person was the founder of Gateway. The tag line (assuming the viewer chose correctly) read, *You're part of the in-cows.*

> Reaching for a Wider Audience

Despite its early success, Gateway management realized it couldn't grow as a company by simply hawking its products to a small niche of educated computer buyers. Flickkema notes that enthusiasts made up only 8 to 12 percent of the market.

In 1995, the company launched its first full-scale marketing campaign, with television as the main outlet for its message. "We knew that most consumers didn't read trade publications," Flickkema says. "We had to talk to them in a different way. TV seemed to be the perfect medium. There was a general lack of understanding on the part of the consumers as to why they would want to buy directly from Gateway."

Convenience served as one reason to buy from Gateway, a theme that would ultimately filter throughout its advertising. Gateway ran a series of ads called "Suzy Souvenir." The ad portrayed "Suzy," a local resident, trying to sell souvenirs to the line of traffic waiting to purchase computers outside the gates of the company's headquarters in South Dakota. The ad went on to explain that Gateway computers are sold over the phone by customer service representatives who could create a system that would fit every customer's needs. This theme was further borne out in an ad in which a truck is delivering pizza and not far behind it is a United Parcel Service truck. The camera then pans to the company's trademark black-and-white boxes sitting at the front door of a consumer. "Technology fresh to the door," Flickkema says about the ad's intent. "Consumers can order whatever they want in a computer system as easily as different toppings on a pizza."

> Making the Act of Buying Easy

Gateway began to see how the growth of the Internet as a forum for buying and selling goods could further entrench the brand in the minds of consumers. In 1996, the company became one of the first computer manufacturers to sell its products over the Internet by placing its Web address on every piece of advertising.

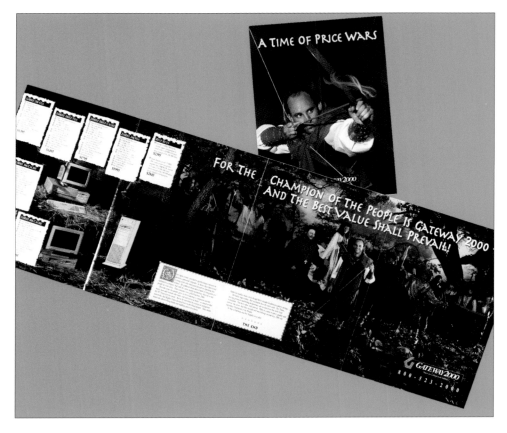

[LEFT] Gateway created a series of ads in which it posed a question for consumers and then cleverly answered it with a reference to the company and its mascot, the cow.

[BELOW] Gateway has always promoted itself as the computer maker with the highest quality products and affordable prices.

"It generally became a mantra in our advertising: Call, click, or both. We really wanted folks to know they had many chances to reach us," Flickkema says. "Web sales are huge for Gateway. It's a large percentage of the business that we do."

About the same time, Gateway discovered another mechanism to help consumers buy computers. After quite a bit of research, the company decided to open retail outlets called Country Stores. Research had shown that consumers wanted the ability to shop in a hassle-free environment where they could see and touch the products. In fact, after consumers' experiment with the products, they are free to go home and purchase them over the Internet or by telephone. At first, no products were available through the stores, but eventually a limited number of models could be purchased.

To create a nonthreatening sales environment, the interior design of the stores harkened to the company's Midwestern work ethic and family values. The store colors are gold, green, and bright red. In some stores, an actual silo was installed, and chairs were fashioned after tractor seats.

In 2000, Gateway kicked off its grassroots "People Rule" campaign in its national ad campaign and at all of its store locations. The campaign was built around company research showing 69 percent of personal computer owners do not know the full potential of their computers. The company offered weekly free training courses at all of its Gateway retail stores. The ad campaign depicts clueless store customers baffled by fast-talking salespeople.

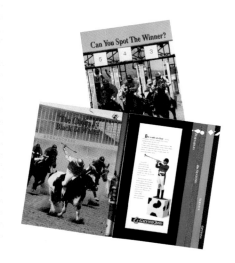

[TOP RIGHT] The design of the store interiors reflects the Midwestern roots of Gateway and its founder Ted Waitt. In some stores, the seats for customers are replicas of those found on vintage tractors.

[BOTTOM RIGHT] Gateway opened retail outlets, dubbed Gateway Country, to create a non-pressure sales environment in which consumers could purchase its products.

[BELOW] At many Gateway stores, employees offer free classes to consumers. Gateway hopes that these consumers will eventually purchase their products.

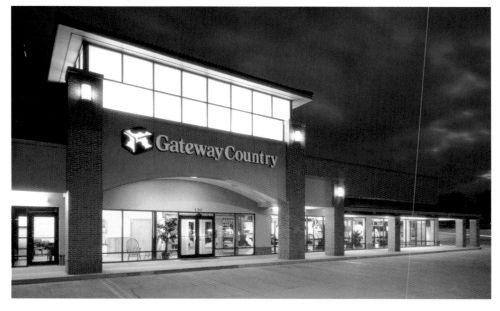

> Pulling Off the Ultimate Challenge

Most recently, in perhaps its biggest exposure on a national stage, Gateway served as an official sponsor of the Winter Olympics. The company provided all the hardware and service for the games, ranging from venue operations to security. Flickkema says the opportunity illustrated "that Gateway can take on one of the biggest technology jobs and pull it off." That has been invaluable as the company attempts to sell more computers to corporations and small businesses. At the same time, the platform allowed Gateway to build on its relationship with individual users.

For the Olympics, Siltanen/Keehn Advertising developed a series of commercials featuring a talking cow and Waitt. In one ad, promoting the release of a new operating system, Waitt is seated in his office when he receives a call from the cow asking to meet with him. Later, in a barn, the cow says, "Remember

when I told you to build all those stores and staff them with computer experts?" Waitt replies, "Yeah." The cow says, "Now is when we look like geniuses. Where's the best place to learn how to use it [the operating system]?" Waitt says, "Our stores." "Bingo," says the cow.

However, the most common ad showed the cow and Wait watching the ski jump competition on television, with the cow wishing he could give it a try. The next several shots show the cow flying off the jump and gliding through the air. The shot then moves to a hole in the shape of his body's outline where he landed. The ad cuts back to Waitt and the cow, who says, "Supplying computers and service is cool enough." I guess cows *can* sell computers.

[TOP] **As the official sponsor of the Olympic Winter games computer hardware, Gateway developed an advertising spot in which a talking cow dreams about competing in the ski jump.**

[BOTTOM] **Gateway shows in this television spot that its cow, which reflects its products, cannot be blown away by the competition in price or quality.**

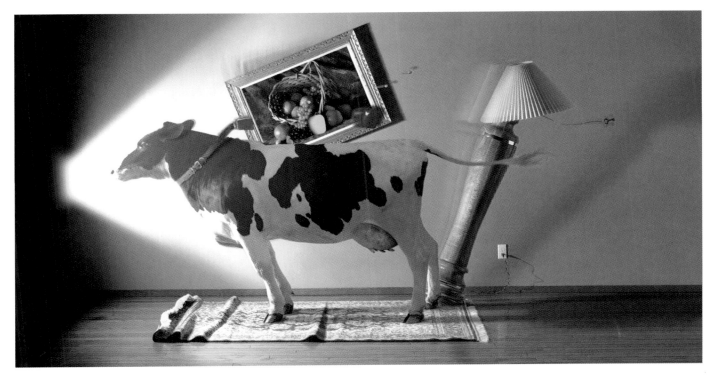

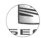

^
Seat > *Hasta la Vista*, Baby!

In the late 1990s, Seat S.A., an automobile brand owned by Fiat and manufactured in Spain, was suffering from a dismal reputation, according to graphic designer Mike Salisbury. Enter Volkswagen to the rescue. The powerful German company bought the brand, and because labor was cheap in Spain, the automobile manufacturer figured it could offer the brand as a price-point vehicle in Europe. The strategy was simple—Seat would be a cost alternative to VW and would compete in the Fiat class with VW attributes.

Right, that's it. It had to happen, and it's happened. I don't think I'll be able to resist something like this for long. A car I like as much as my motor-bike.

THE NEW (S5) FROM THE NEW SEAT

Design Firm > Mike Salisbury, LLC
Art Director/Designer > Mike Salisbury
Client > Seat S.A.
Software > Quark Xpress, Adobe Pagemaker, Adobe Photoshop, Adobe Illustrator
Campaign Run > 1997-2000

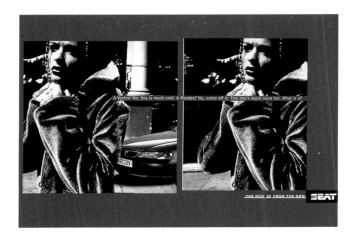

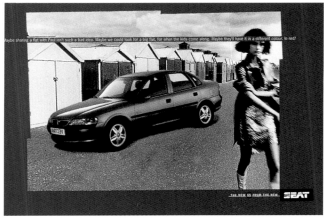

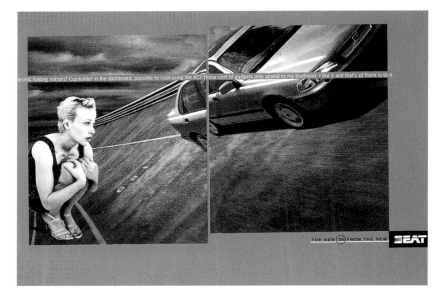

[THIS PAGE AND OPPO-SITE] **Black-and-white photography juxtaposed with minimal copy that steered clear of car hype set the stage for the print advertising that featured hip, young people proclaiming their reasons for buying a Seat.**

For its strategy to materialize, VW knew it needed to rejuvenate the brand's reputation and retained Los Angeles–based Mike Salisbury, L.L.C., to develop a campaign that would allow Seat to compete head-on with Fiat and Peugot. The objective was unequivocal—make the brand irresistible to young, first-time car buyers in the 18-year-old-plus market who are looking for something economical with good gas mileage.

> The Strategy: Don't Talk Cars

"The people interested in a price-point car are not car nuts, so we decided to create a campaign that didn't talk cars," says Salisbury of the campaign that would have confused most clients… "What? Not sell cars in car advertising?"

Courtesy of Seat

"For the most part, all cars are similar, not distinct and different," Salisbury explains. "They all sell features and benefits. So, we decided, 'Let's not do cars—at this price point, who cares?'" It was a trusting client that gave the go-ahead, confident that Salisbury knew what he was talking about.

Moreover, although the campaign avoided techy car talk, Salisbury admits that the design team could not totally ignore the performance engineering built into the car and somehow had to infuse a graphic element into the ads that spoke to the car's resurgence of German quality. The two seemingly opposite objectives made the project a challenge.

The result was a campaign that, while hyping a price-point car, offered an air of sophistication. Black-and-white photography showed hip, young people walking around familiar sights in Europe was its identifying characteristic.

> Sell Cool and Sell Cars

They got the job done through "careful design that we hoped had a sort of Teutonic simplicity that was well designed. And we made the ads cool—very subtly with no color and hip-looking models and non-pushy copy totally without car hype, yet still selling features and benefits," adds Salisbury. To infuse the

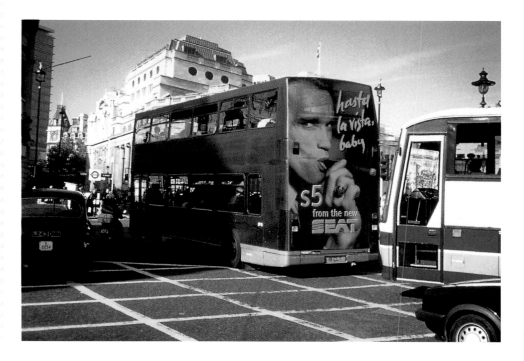

[RIGHT] To lend additional personality to the campaign, Salisbury borrowed the famous line from *The Terminator—Hasta la vista, baby—*and plastered it and Arnold Schwarzenegger's image onto mass transit and other advertising throughout Europe.

[LEFT] Despite the lack of car talk in the advertising, Salisbury was mindful that he needed to inject a graphic element that spoke to the resurgence of German quality inherent in the new Seat.

car with a Latin touch—for added personality—oversized billboards, mass transit advertising, and promotional items feature the familiar line uttered by Arnold Schwarzenegger in the film, *The Terminator*: "*Hasta la vista*, baby."

The copy, like the imagery, is minimal, and yes, distinctly different from most automobile advertising. *Those sort of gadgets only appeal to my boyfriend. I like it and that's what counts,* reads the copy in one of the ads. The tag line is equally simplistic and memorable: *The new S5 from the new Seat.*

The advertising campaign ran throughout Europe but was targeted to Germany, Scandinavia, and Spain. Was the campaign successful? Yes. Although Salisbury doesn't have actual sales figures, the car is now selling well in Germany and France, where it hadn't before. How did it fare against the big brands? Very well. In fact, the competition improved their collateral marketing materials as a direct result of this campaign, according to Salisbury.

∧

Egg > The Simplicity of
Banking Online

In its newest ads, the campaign juxtaposes a fictitious company called Brilliant Industries and their ludicrous inventions to make money with Egg's realistic and simple alternatives.

Original advertising art
Agency > Howel Henry Chaldcot Lury and Partners
Creative Director > Steven Henry
Art Director > Ian Williamson
Copywriter > Jon Burley

New art
Agency > Mother
Creative Director > Robert Saville
Art Directors > Sam Walker and Luke Williamson
Copywriters > Joe de Souza and Luke Williamson

> Hatching an Online Financial Services Company

Although Egg plc is the online financial services unit of Prudential plc, one of the United Kingdom's largest insurers, the company doesn't act like a typical banker. With its quirky name and edgy advertising, Egg broke free from the conservatism of traditional banking and in the process convinced consumers to embrace an alternative for handling their finances.

Launched in the fall of 1998, Egg became one of the first Internet bankers in the country after company executives discovered that they could make higher profits by providing financial services at a lower cost and offering consumers better rates on their savings.

"In the U.K., banks have a history of not being trusted by the customer," says Tony Williams, Egg's marketing communications director. "There are lots of hidden charges and such. We wanted to establish ourselves as an open and honest brand that could save consumers costs."

Egg initially offered consumers the ability to set up a savings account that paid 8 percent interest, a substantial increase over the 6.5 percent that most traditional banks were paying. Over the years, the company has expanded to offer customers access to financial products, such as mortgages, personal loans, travel insurance, and mutual funds. It also has a credit card that pays cash back on retail products available on the Egg Web site.

"We had looked at the success of brands like eBay and E*TRADE who had a huge first-move advantage and a stock that was well valued," Williams says. "We wanted to capitalize on our first-move status to use the functionality of the Web and offer consumers something that would be different and something that they could use."

Management worked with a company that helped it come up with 80 to 100 different names, ranging from *360 degrees* to *popcorn*. According to Williams, *Egg* was chosen for no other reason than it was short, funky, and memorable. "We were looking for something—although we offer financial services—that didn't sound or look like any of the other banks. It's part of the differential."

> Gaining the Trust of Consumers

Egg quickly set out to establish its identity with a series of television ads whose theme dwelled on consumers' mistrust of the country's banking industry. The company filmed several spots where it rigged celebrities to a lie detector that it bought from a dealer in the United States. Each celebrity was asked a series of personal questions, and if they lied, the detector would indicate so. The spots featured Radio 1's British disc jockey Zoe Ball and renowned sprinter Linford Christie.

In one spot, Christie is asked a series of personal questions, such as "Is there any particular body part that you're proud of?" and "Have you ever made love and regretted it?" "The message was about openness and honesty," Williams says.

To reinforce the message, Egg used its own employees in radio and print ads. The employees talked about their lives and ambitions in a conversational tone, reflecting the brand itself—helping consumers in their lives so that they can reach their aspirations.

Individual
Money
Matters

[ABOVE] Company executives sought a short and unusual name for the company in an effort to intrigue consumers who want more information.

When Prudential plc decided to launch an online financial services business, the company chose the unusual name Egg, simply because it is short and memorable.

[BELOW] The company's first series of television commercials sought to establish Egg's identity as much more honest and straightforward than traditional banks. In this spot, British disc jockey Zoe Ball is hooked up to a lie detector and asked a set of personal questions.

Courtesy of Egg

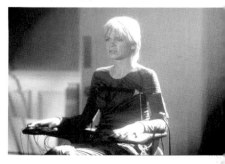

[TOP RIGHT] **The Egg credit card was the first designed for use on the Internet. Consumers can purchase products from participating retailers at the Egg Web site.**

[BOTTOM RIGHT] **Egg pokes fun at the stereotypes of conventional advertising with its TV spot to launch the EGG credit card.**

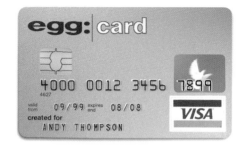

> Poking Fun at Competitors

In 1999, Egg launched its credit card, which featured a low interest rate and cash back on purchases made from participating retailers on its Web site. As part of the launch, Egg did a television commercial in which the company challenged the conventional notion of advertising by poking fun at the stereotypes.

The ad featured a strait-laced announcer holding up an oversized Egg credit card in front of a typical two-story suburban house. The announcer spoke about how Egg treats everyone as an individual, even though consumers do most of their banking in virtual anonymity.

"We're noted for our irreverence," Williams says. "We can be irreverent to the establishment. It's a bit like Virgin and what Richard Branson does."

As a pioneer in online banking, Egg also had to allay consumer fears over security when making purchases online. One way the company reassured consumers was to cover the costs of any items purchased

fraudulently through their accounts. Although this is a sensitive issue, the commercial poked fun at the stereotypes in most credit card companies' advertising.

The ad begins with a young announcer talking about the benefits of the Egg credit card. An old man cutting his hedges, a housewife, and a black man, at various points say that he or she should be the one talking about the credit card.

"The old man is like, 'I should be talking about this because this young guy knows nothing.' The woman says she should be talking about the credit card because she shops. Finally, the black guy says, 'I'm the token black.' It was quite funny," Williams says.

> Surviving Controversy

Sometimes the humor in Egg's advertising can create controversy. Two years ago, in an effort to show that Egg values customer service, the company launched a series of television ads that featured an overzealous employee named Rob. The employee goes through remarkable lengths to keep his customer, Stu, happy.

One spot shows Rob so willing to provide any services possible to Stu that the two are seen lying in bed together. "The point was to get across that we love our customers," Williams says. "Unfortunately, some saw it as a homosexual ad. We had some consumer backlash, but that's all right. The positives far outweighed any negatives. Gay groups asked for copies of the tape. It got notoriety."

[ABOVE] As part of its television advertising, Egg developed a series of commercials with an eager-to-please employee, Rob. The campaign created some controversy among viewers when one spot showed Rob in bed with his customer, Stu.

[ABOVE] **Egg** spent a considerable amount of time developing its **Web** site because it serves as the gateway through which consumers learn more about the company's services, products, and promotions.

[RIGHT] **Egg** uses everyday situations to appeal to consumers, as seen in this spot where a boyfriend grows tired of shopping with his girlfriend. The company uses the bags to deliver the message that shopping online could alleviate this problem.

To counter the gay theme, the series' next ad featured Stu's girlfriend, and the final spot featured Rob ironing for Stu and singing an English ditty. "This was brand advertising," Williams says. "It was about the emotion of the brand rather than the product. It registered highly. People noticed it."

The last brand advertising that Egg did was a television ad that showed an investigative reporter named Daisy Donovan traveling through Moscow. Donovan wants to buy a husband and is seen in the spot around 10 potential mates. She prepares to pay for the lucky one with her Egg card in an effort to show that consumers can purchase merchandise anywhere in the world.

Increasingly, as the brand has matured, Egg has focused more of its advertising on product promotions. Yet, the company manages to use humor to market even the most mundane topics. In touting its ability to check and manage finances through various sources, the company created a spot that shows a couple in the back of a limousine with the tag line, *Egg lets you be spontaneous.*

"We have aspirations to be a global brand," Williams says. "We're now putting a stake in France. As time has gone on, clearly we have more competition, so we have to continue being an innovator."

[TOP] **The magnetic boots developed by Brilliant Industries represent everything that Egg isn't in helping consumers deal with their mounting debts and other financial obligations.**

[ABOVE] **Egg's new advertising agency, Mother, developed the** *What's in it for me?* **tag line to draw consumer attention to the benefits of the Egg credit card.**

∧

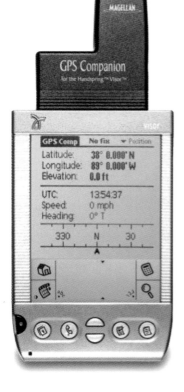

VIS**OR**
what you make it.

www.handspring.com

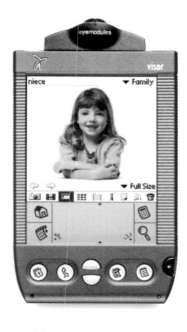

Modules sold separately.

The tag line, *What you make it,* has several meanings for Handspring and its products. It is an effort to appeal to a broader range of consumers, from business executives to students to stay-at-home moms. The slogan also points to the flexibility of the product, because it can be used for so many different purposes.

Agency > Leo Burnett Worldwide
Art Director > Mark Faulkner
Copywriter > Steffan Postaer
Account Director > Larry Bruck
Planning Director > John Greene

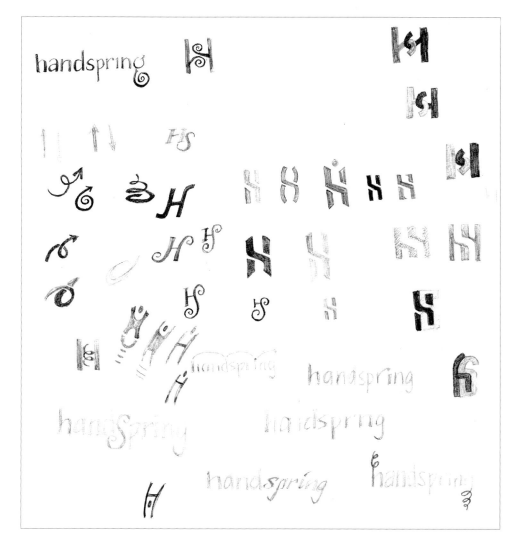

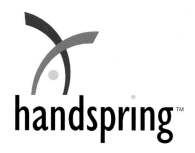

handspring™

[ABOVE] Handspring management sought a corporate logo that would set it apart from a crowded field of competitors—such as Sony, Palm, and Compaq—and would reflect its appeal to a broader base of consumers than just business professionals.

[LEFT] P.J. Nidecker produced a series of drawings that featured the letter *H* in various incarnations, mostly inside a box. Handspring encouraged Nidecker to be adventurous.

> Organizing the Masses

Jeff Hawkins had a front-row seat for the development and marketing of the original PalmPilot products as the founder and designer of Palm Computing. But he chucked it all four years ago to start over again, solely focused on taking on his former company with the launch of a new handheld wireless company called Handspring.

But Hawkins knew that he couldn't simply mimic the success of the Palm line, whose products, once unleashed, became *de rigueur* among the business elite. Instead, the new breed of Handspring handheld devices would be directly targeted at the mainstream consumer market—from business executives to the soccer moms.

"[Handhelds] had always been targeted at the mobile professional," says Claire Dean, Handspring's director of brand marketing. "It was all about what the business person needed to be organized. Our

Courtesy of Handspring

[ABOVE] Nidecker went back to the drawing board to come up with a design for Blazer, the company's software that allows its handheld devices to connect to the Internet.

approach was to enter the consumer market. People need to manage their lives. The whole premise was to keep it small, simple, affordable, and connected."

In many respects, the Handspring devices themselves would be crucial if the company wanted to challenge the brand leaders like Sony, Palm, and Compaq. With that in mind, the company designed handheld products called Visor, which are considered the most expandable among Palm OS computers on the market. Handspring handhelds can be transformed into an MP3 player, digital camera, or wireless Internet device with expansion modules called Springboards.

Still, to reach a broader consumer market, company executives would have to transform the Handspring name into an easily identifiable mark in a cluttered and competitive industry. Founder and chairman Hawkins, along with president and CEO Donna Dubinsky, started with the corporate name.

Dubinsky came up with the name Handspring in a series of brainstorming sessions with Hawkins and other key members of the executive team. The parameters for the name were quite simple: a combination of words that conjured up images of handheld devices and piqued the curiosity of consumers in a lighthearted manner.

With the name settled, the company turned to logo designer P.J. Nidecker, then of Mortensen Design, to create the visual identity. Nidecker, who now is art director for Handspring, began with a series of drawings using the form of the letter *H* that bounced around in different springlike movements.

> Piquing Consumer Curiosity

Out of our 100 different designs came the little "flip" guy that became the corporate logo. As Nidecker points out, the design began as the letter *H* in a box. But Handspring executives objected. "They didn't like it being in a block shape," she said. "They wanted it a little bit more free-form. We took it out of that shape."

The color scheme for the logo was a far simpler task. Nidecker laid out the shape of the little man doing a cartwheel on a variety of color boards, and the decision to go with darker shades of blue, green, and orange came down to what felt right to the company's management.

As Dean explains, "We wanted strong colors that stood out. It was unique enough to translate to consumers that this is a different company. We wanted to build the brand by hitting the mainstream in a fun way. From a brand-marketing perspective, this logo was a lot of fun—clean and crisp and visual."

Soon after, management began developing a logo for its modules. Nidecker got to work on what became Springboard—a free-form figure jumping off of a diving board. This logo would be used for all packaging and advertising related to the company's modules. She would undergo a similar exercise for Blazer, the software that allows its handheld devices to connect to the Internet.

"We looked at the modules as kind of game players," Dean says. "You know how you have PlayStations and the games that go with it. We actually felt that what differentiated us was the expansion slot [modules].

[ABOVE] The company wanted to set up a separate logo for the devices that allow Handspring handheld units to transform into a digital camera, MP3 player, or phone. Nidecker worked on logo designs that would reflect that these devices helped the Handspring "spring" into something else.

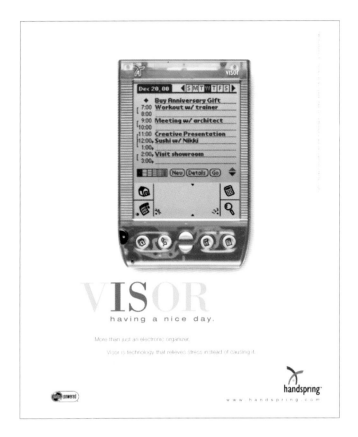

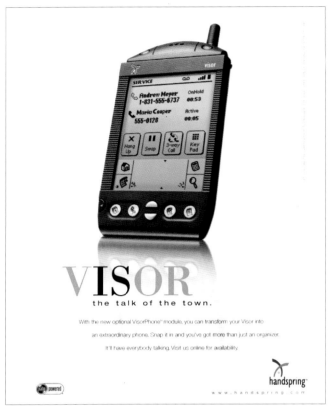

[ABOVE LEFT] **Handspring sought to distinguish itself from the other personal organizers by making the design and feel more approachable and fun.**

[ABOVE RIGHT] **Handspring promotes the fact that the Visor, with the use of a separately purchased module, can be turned into a telephone, allowing consumers to carry one product instead of two.**

It was an organizer. But if you added a module, it became a digital camera or an MP3 player. That was the emphasis of the ads."

The initial Handspring print advertising campaign focused on the flexibility of the Visor [the actual hand-held device] as a product that could help consumers balance different aspects of their lives. "We wanted to go into publications where people go when they're not thinking about work," Dean says.

For instance, the company placed ads in magazines such as *Golf Digest*, *Sailing*, *Runner's World*, *Cooking Light*, and *Architectural Digest*. The visual element of the ads focused on the application that was being marketed. To promote the Visor's calendar functions, the company used an image of a Visor with screen shots of daily activities, like sushi for lunch or an appointment at the day spa.

Similar ads appeared in *Rolling Stone* to tout the ability to transform the Visor into an MP3 player with the purchase of the Springboard module. The image featured a Visor with headphones. The tag line served as the unifying force in the ads: *Visor...What You Make It*.

> The Message Hinges on Flexibility and Design

The approach, Dean says, "was very strategic in entering the consumer market. We felt this device was something that consumers would relate to personally. You could have your whole life in the device. We wanted to make it fun and something that consumers could tap into personally."

Most of Handspring's advertising dollars would be spent exclusively on magazine and outdoor forums. It was a strategy partly dictated by limited financial resources. But Dean says that print ads provided for sufficient national exposure, whereas the billboards served as the platform for more regionally based spots.

But the outdoor ads, which are featured in the company's top 10 markets, provided another benefit. Because Dean says, "Visor is a part of life, we wanted consumers to see it while living their lives, whether they're taking the bus or driving a car."

Handspring outdoor ads are similar to the print versions. The tag line is always present, as is the handheld device and a particular module to pitch. For instance, in one campaign, the Visor is pictured with the VideoPhone, which turns the handheld device into both a phone and a modem for wireless Internet connection.

As Handspring products have gained an identity, the company's advertising is shifting. Marketing in the future will be more promotional as a mechanism to introduce new items and refresh consumer awareness about product benefits. One such product will be the Treo, with phone, Palm OS organizer, e-mail, text messaging, and wireless Web all in one product. Another is the Visor Edge, a slimmer organizer that has proven particularly appealing to women. In one advertising spot, the red Edge is pictured next to a knockoff of a Prada pocketbook.

[LEFT] As the company's brand identity has grown, Visor advertising has moved toward promotions and new product launches.

[BELOW] Handspring sells modules that allow its personal organizers to become telephones and MP3 players and to provide wireless access to the Internet. Its advertising is geared toward showing that distinction among its competitors, and the ads are strategically placed in "recreational" magazines, like *Golf Digest* and *Cooking Light*.

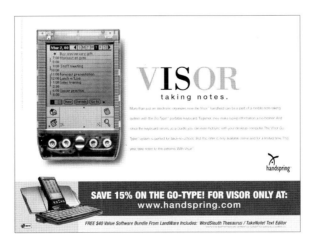

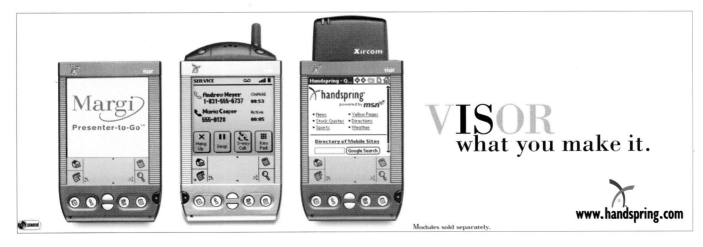

Advertising Agency > TBWA\Chiat\Day, Los Angeles
Production Company > Serial Dreamer, West Hollywood
Editing Company > Rock Paper Scissors, Los Angeles
Music Company > Mit Out Sound, Sausalito
Sound Design Company > Mit Out Sound, Sausalito
Creative Director > Chuck McBride
Copywriter > Scott Wild, and Stephanie Crippen

Art Director > Erick King, Rob Smile, and Scott Wild
Director > Erick Ifergan
Producer > Gerard Cantor, Jennifer Golub, Jill Andresevic,
Eliza Randall, and Ryan Thompson
VFX/Animation Company > Pixel Envy, Santa Monica; and
Method Visual Effects, Santa Monica
2D Design, Motion Graphic Style Board Design > 88 phases

METHOD
Executive Producer > Neysa Horsburgh
Visual Effects Producer > Michael Gibson
Visual Effects Artist > Russell Fell,
and Cedric Nicolas
3-D Designer > Yann Mallard,
Laurent Ledru, and Laurent Briet

PIXEL ENVY
VXF Supervisor > Mat Beck
CG Supervisor > Greg Strause
3-D Supervisor > Colin Strause
CG Artist > Josh Cordis,
and Rena Osamura

> The Task: Launching Future PlayStations

Think of the big rivalries in history and right up there with Coke versus Pepsi and IBM versus Apple is the rivalry between Sony and Nintendo in the computer games arena. When the time came to launch Sony PlayStation 2, which in effect would launch the idea of future PlayStations, the success of the campaign was critical. All fun and games aside, this project would present a serious challenge. Imagine the daunting task at hand: developing an on-air spot that would be so intense and cutting edge that it would win over skeptical gamers—perhaps the most discriminating market when it comes to being wowed by the highest level of creative special-effects imagery.

Sony's San Francisco–based advertising agency TBWA\Chiat\Day developed the concept for the campaign and tapped Erick Ifergan to direct the television commercials; 88 Phases was hired as the graphics team to support the on-air graphics treatment, as well as offline and online finishing of the spot. Sony PlayStation 2 is the product being sold to consumers, but PlayStation 9 is the name of the marketing campaign, which

88 Phases worked with Rock Paper Scissors and director Erick Ifergan to deliver a stylistic approach, as can been seen with this multilayered and effects-intensive spot for PlayStation 9. "We wanted to bring the viewer into the surreal by using color and graphics. Layers and layers of effects were applied to accentuate the world the PlayStation 9 can take you to. It is an unusual journey that you want to travel again and again," says Yu Tsai, designer, 88 Phases.

Courtesy of
Sony PlayStation 2

was targeted to a mixed bag of consumers. The primary target is consumers aged 12 to 28, but there are pocket groups of gamers in various age-groups, so any marketing had to reach a diverse demographic.

TBWA\Chiat\Day had already established the logo and packaging for the product when 88 Phases came on board. The PlayStation 9 on-air commercial branding was for the announcement of PlayStation 2, which was first released as a limited-edition product. The spot's goal was to bring this product to market awareness.

> Take Special Effects and Add the "Cool Factor"

"It was important that the visual graphics were there only to support the film that was shot. This commercial spot was not intended to be a graphics spot. The graphics language and elements were created to accentuate the futuristic theme and the surrealism of time travel. This visual branding was not uncommon from other game-player competitors, but the final execution of the PlayStation 9 spot is so well refined, it set a new standard for this competitive industry," says Yu Tsai, one of the 88 Phases designers on the project.

The style is definitely cutting-edge with exactly the right amount of "cool factor" to appeal to the demographic, which includes gaming enthusiasts as well as the MTV generation and Gen-X and Gen-Y consumers with plenty of disposable income.

"Separation from [the] other game box was the most important factor," explains Tsai. "Other game boxes have created visually driven spots, but none at the time have ever [been] produced with these intense visual and digital effects."

> Overwhelming Demand Tells You It's Working

"Working with editor Angus of Rock Paper Scissors and director Erick Ifergan, we delivered the stylistic approach to this multilayered and effects-intensive spot for PlayStation 9," adds Tsai. "We wanted to bring the viewer into the surreal by using color and graphics. Layers and layers of effects were applied to accentuate the world the PlayStation 9 can take you to. It is an unusual journey that you want to travel again and again."

Station 2

The spot is fast, eclectic, and technology-driven; no slow-motion, crawling spot will do for this market. But put aside all the visual imagery and high-tech motion, and, according to Tsai, the one element most critical to successful graphic design for commercial spots is how well all the shots and elements are integrated. "It is most important that the live action and the graphic elements are not in competition with each other, [but] rather support each other," he says. "And remember never to overdesign. Only add graphic elements to the footage if they add to the spot. In the PlayStation 9 spot, we knew that we achieved a perfect balance where neither live action footage nor graphic treatments can live without each other."

The PlayStation 9 campaign ran for one year, during which time the commercial spot created an overwhelming demand for the Sony PlayStation 2. Waiting lists were as long as six months in the United States to meet the demand of gaming enthusiasts.

"The process was intense and the deadline unreal, but the final result has been widely praised," says Tsai.

∧

> A Hands-On Approach to Buying Consumer Electronics

BACKTO SCHOOL

It's not just pens and pencils anymore™

TempPart # 110113 Expires: 9/1/

Best Buy lures parents
and their children to shop
at the electronics store for
back-to-school supplies
such as computers, print-
ers, and even microwaves
have become common
for students.

Agency > Best Buy Co., Inc.
Group Creative Director > Bill Nordin
Executive Producer > Mollie Weston
Supervising Producer > Tony Purvey

> Creating a Consumer Toyland

In the past 15 years, Best Buy has catapulted to the nation's top consumer electronics specialty retailer as part of the evolution of the big-box store concept. Pack the shelves of converted warehouses with a variety of televisions, computers, and microwaves at discount prices, and consumers will revel in the convenience.

Sounds easy. Borders did it with music and books. Home Depot did it with hardware. Office Depot did it with business supplies, and Linens 'n Things has achieved similar success with housewares.

But as the Internet offers consumers different avenues to purchase electronics, discount stores like Best Buy have had to create a reason for the consumers to walk through its doors. Buying has become less about the price and convenience and more about the experience.

"There was the old kind of retail," says Mike Linton, Best Buy's chief marketing officer and executive vice president. "Manufacturers make it, retailers sell it, and consumers buy it. Now consumers can buy and get information from almost anywhere."

To maintain its market dominance, Best Buy, too, has had to evolve. The Minnesota-based retailer has created a synergy in which it uses its strong brand identity to allow consumers access to the best of both worlds: buying products through either stores or its Web site.

"We are clicks and mortars," Linton says. "We didn't spin off bestbuy.com. It is set up to work as part of the big brand. It turned out to be okay. Consumers don't discriminate by channels. They don't acknowledge the Internet as a separation of business."

In fact, for Best Buy, the store remains at the core of the consumers' shopping experience. Linton likes to compare the company's stores to Nike's shoes. "Nike has great advertising," he says. "But the thing that they have is the shoes. What it means is you have to have great products that consumers can experience and will purchase."

[ABOVE] Initially, Best Buy had limited merchandise available through its Web site. The company eventually created a synergy between the store and its Web site by allowing consumers to research products online and then come into the stores and try them out.

[LEFT] With the growth of e-commerce, Best Buy recognized it must provide an incentive for consumers to enter the stores. Best Buy allows and encourages consumers to touch and play with its computers, video games, and other electronic equipment.

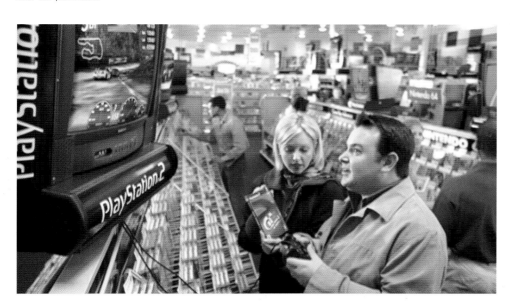

Courtesy of Best Buy

[ABOVE] With its corporate name placed inside of a price tag, the logo delivers a message that the discount retailer offers consumers the lowest prices.

[RIGHT] The ability to experiment with the electronic equipment at Best Buy stores is a constant theme in its marketing campaign, including television and print advertisements.

[BELOW] Best Buy sponsored pop star Sting's free concert in Central Park in September 2000 and promoted a contest through its Web site for prizes that included computers and sound systems.

> Testing Equipment Mandatory

Much of Best Buy's marketing hinges on making the consumers' visits—at least for the time that they spend careering around the aisles—like a brief trip to toyland. Through extensive research, Best Buy discovered that consumers wanted stores to be interactive—touch it, play with it, test it—and no-commission salespeople to take away the pressure to buy.

"There is a lot of energy in the store," Linton says. "You think you want to have fun. We encourage consumers to test out the equipment before buying, because we know it's not an easy decision."

Understanding that back-to-school sales involve purchases of computers, audio systems, and appliances, the company used a clever tag line, *It's not just pens and pencils anymore*, as part of an advertising promotion.

Two years ago, Best Buy set out to make the purchasing decisions easier by allowing consumers to make purchases on its preexisting bestbuy.com Web site. The company realized that it could use its vast distribution channels to provide alternative purchasing methods for its customers.

For example, in its stores Best Buy is only able to carry between 20,000 to 30,000 music titles. Through its Web site, the amount can nearly triple. The only items not available online are appliances. Information about the products is available at the Web site, but purchases must be made at stores. "We believe the two channels work together," Linton says.

Best Buy has moved so far as to bring technology inside the stores. The company has placed kiosks in each store that allow customers to do more research on a product. And if that product isn't in stock, consumers can order it online and either pick it up at the store or have it delivered to their homes.

"Fun can be thought of in a bunch of different ways," Linton says. "It's an individual definition. Fast checkout, playing with the products, getting information online—there's an efficiency and ease to it."

Best Buy tries to convey that experience through its advertising, which ranges from television to newspaper circulars. Most recently, the company's marketing centered on the theme, *Turn on the Fun*. The company, which produces its advertising through an in-house agency called BBY, tested some 20 to 30 ideas before settling on its current campaign.

> Putting a New Twist on Circulars

Turn on the Fun, touches every facet that the retailing giant has created for consumers to purchase products, according to Linton. A key way Best Buy tries to convey that message is through its circulars, which are disseminated by the millions each week to its customers.

For decades, retailers have used circulars to promote their sales for the week, but Best Buy has made significant design changes to improve the production quality of the circulars so that consumers are more inclined to open its pages.

[ABOVE LEFT] **Best Buy's** recent advertising campaign revolves around the theme, *Turn on the Fun*, which encourages consumers to come to its stores and fiddle with the merchandise. In addition, the company has upgraded the circular's design with a table of contents, which helps consumers to quickly locate the products that interest them.

[ABOVE RIGHT] **Best Buy** circulars, which are carried in thousands of newspapers throughout the country every Sunday, remain a critical marketing tool for the company. This ad from 1986 clearly illustrates how far their marketing efforts have come.

Best Buy recently created the Best Buy Fun Zone Technology Truck to embark on a cross-country tour. This fifty-three-foot-long tech home on wheels gives consumers the opportunity to interact with the latest technology and learn how they can easily incorporate it into their lives. Equipped with cutting-edge technology, the truck features a stylish home environment with home integration and satellite connectivity, allowing people to fully experience the "Turn on the Fun" brand.

[TOP] Consumers will find seven televisions including a fifty-five-inch, wide-screen high definition TV and a home video security system in the high-definition home theater.

[BOTTOM LEFT] The integrated home office showcases several computers in different sizes, a printer, and televisions.

A table of contents makes it easier for customers to flip to the products that they're most interested in, and the Web address is consistently placed throughout its pages. "It's [the table of contents] a brand itself if done right," Linton says of the circulars. "It's a constant evolution. You want to make the presentation in such a way that consumers can see what the products will do for them."

Best Buy also tries to build brand awareness through its sponsorship of pop music tours. Two years ago, the company promoted pop artist Sting's Live Concert in Central Park. In ads, the company touted its Web site, and its logo appeared on the enormous video screens around the stage.

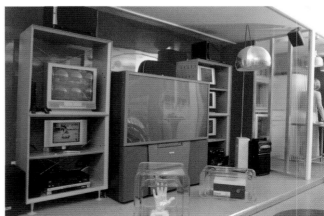

[TOP LEFT] The high-tech kitchen includes a refrigerator with a Web pad for surfing the Net and monitoring the fridge, wine cooler, and under-counter flat screen television.

[TOP RIGHT] The interactive video gaming area outside of the truck features the latest video games and head-to-head gaming station for users of all ages to try.

The company also promoted the broadcast of the rock group U2's live performance from Boston, which was later broadcast on VHI. As part of its advertising, Best Buy offered its customers a DVD of the concert through its stores two weeks before anybody else.

At the live events, Best Buy parks a mobile van equipped with the latest audio components that concert goers are free to test. "We continue to extend the reach of the brand to new spaces," Linton says. "We consider these events additional media in which to enhance our brand identity."

[ABOVE] The familiar yellow Best Buy sales tag logo was prominently displayed throughout the Sting concert on the massive videoscreens that surrounded the stage.

∧

| KitchenAid | > Still Relevant After Eighty-Three Years of Production

UNDERNEATH THE FANCY RIBBONS AND BOWS, I PATIENTLY WAIT.

HARDWORKING, STRONG, AND INTELLIGENT, I AM THE PERFECT CHOICE FOR A LIFETIME OF HAPPINESS.

®® Registered trademark,/TM trademark;/the mixer shape is a trademark of KitchenAid, U.S.A. © 2000. All rights reserved.

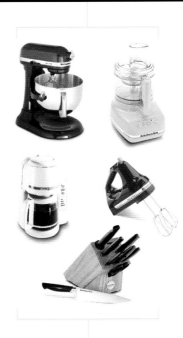

Register for KitchenAid® products and your gifts will always reflect your great taste. The new Ultra Cutlery and the latest and greatest Stand Mixer, the Epicurean. Two essentials for every well-equipped kitchen. Combine these KitchenAid standouts with the 2 hr Fresh™ Coffee Maker, powerful 7 speed Hand Mixer, and ingenious Food Processor, to create a lifetime of memories. To learn more about the KitchenAid Countertop Collection, and to view the entire KitchenAid® line, visit www.KitchenAid.com, or call 1.800.541.6390.

FOR THE WAY IT'S MADE.™

Once KitchenAid reached new consumers with its updated mixers, the company expanded into other product lines such as cutlery, hand mixers, coffee makers, and food processors. The company continues in their efforts to leverage its reputation among consumers for building a quality product.

Firm > N.W. Ayer & Partners
Art director > Alex Spak
Copy Writer > Jesse Potack

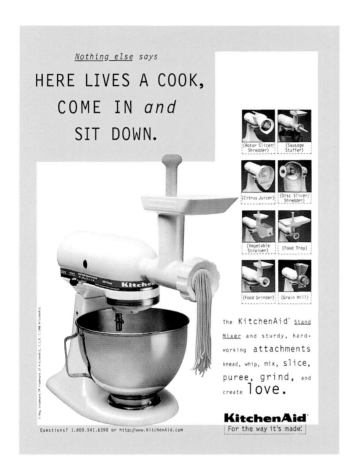

Nothing else says

HERE LIVES A COOK,
COME IN and
SIT DOWN.

(Rotor Slicer/ Shredder) (Sausage Stuffer)

(Citrus Juicer) (Disc Slicer/ Shredder)

(Vegetable Strainer) (Food Tray)

(Food Grinder) (Grain Mill)

The KitchenAid® Stand Mixer and sturdy, hard-working attachments knead, whip, mix, slice, puree, grind, and create love.

Questions? 1.800.541.6390 or http://www.KitchenAid.com

KitchenAid
For the way it's made.

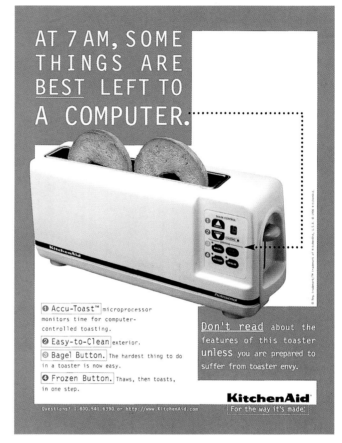

AT 7 AM, SOME THINGS ARE BEST LEFT TO A COMPUTER.

❶ Accu-Toast™ microprocessor monitors time for computer-controlled toasting.

❷ Easy-to-Clean exterior.

❸ Bagel Button. The hardest thing to do in a toaster is now easy.

❹ Frozen Button. Thaws, then toasts, in one step.

Don't read about the features of this toaster unless you are prepared to suffer from toaster envy.

Questions? 1.800.541.6390 or http://www.KitchenAid.com

KitchenAid
For the way it's made.

> KitchenAid Strikes While the Iron is Hot

With the American appetite hungry to bring culinary taste, and the tools to make them, into their homes during the late 1980s, KitchenAid felt the environment was ripe to spur growth in its sixty-five-year-old stand mixer, and expand its portable products line into blenders, toasters, and hand mixers.

"It was the perfect climate," said Brian Maynard, brand director of integrated marketing for Michigan-based KitchenAid home appliances. "We realized we had an incredible opportunity with the combination of this era [in the late 1980s and early 1990s] in which the chef is like a rock star. It was the case of the right product with the right message at the right time. People started to pay attention to the right tools to cook at home. We wanted to make sure that we could get some leverage off it."

The KitchenAid stand mixer had been around for a long time, the first Model H-5 rolled off the assembly line in 1919. The product was revolutionary in that it brought the power and quality of commercial mixers into the home. But the turning point for the recent success in part lies when in 1988 the company designed the Cobalt blue mixer for Williams-Sonoma, a leading retailer of upscale kitchenware that was opening new stores across the country.

[ABOVE LEFT] One feature that distinguishes KitchenAid mixers from its competitors is the knob where attachments are connected to give the machine many uses including a juicer, a grain mill, and a shredder.

[ABOVE RIGHT] In 1996 KitchenAid introduced its toaster. For its launch, the company wanted the message to articulate the technology used to produce it in a clever manner.

Courtesy of KitchenAid

[RIGHT] Here, KitchenAid markets its mixer and oven simultaneously while distinguishing itself from its competitors by using bold colors and subtle humor.

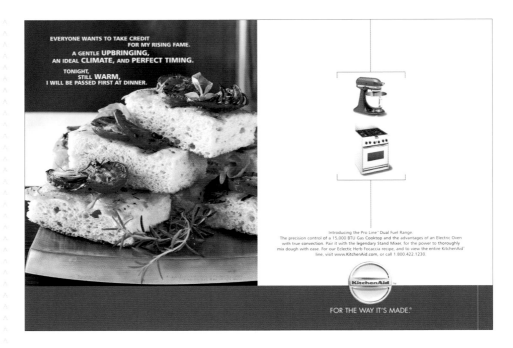

> Cobalt Blue Mixer Creates a Stir

Williams-Sonoma had been carrying KitchenAid mixers since 1959, but the chain's growth provided the display environment in which the product could be introduced to a new and larger generation of cooking enthusiasts. KitchenAid would eventually develop a marketing and advertising campaign in which it would show the mixers as being a product that would enable cooks to be as creative as they wanted to be in preparing meals.

"For our customers, it was about how this product is going to make life better," Maynard said. "Our customers love to cook. They don't view the mixer as the savior. They look at our products as an enabler for them to be creators."

> Mixers Take Center Stage

The moment came seven years ago when KitchenAid decided to change its advertising campaign for its mixers in an effort to stand out from the competition. Until then, the image of the mixer was cast in soft warm lights surrounded by food. The new campaign, developed by KitchenAid's longtime ad agency known then as NW Ayre, was much bolder.

With the development a year earlier of models in empire red, onyx black, and majestic yellow, the mixer became the focal point of the company's print advertising. "It [the advertising] was a little irreverent. It showed no food. The product was the hero," Maynard said.

For instance, one ad showed the KitchenAid mixer pictured in the forefront with the headline: "Nothing else says here lives a cook. So come in and sit down." Another ad introducing a food processor featured the headline: "A tool you don't use is a tool you don't love."

Maynard recalls the meeting in which then KitchenAid President Ken Kaminski saw the new campaign for the first time. He walked around a conference table staring at the new ads as the agency's representatives nervously awaited his response. When one asked what he thought about the campaign, Kaminski replied that the question was irrelevant. What was most important to him was whether the message resonated with consumers and would prompt them to buy mixers.

The agency was confident the new message would work, so much so that they were willing to bet a portion of their fee on it. "In the end, that's wasn't how the contract was written," Maynard said. "Over the course of the three years of that campaign, our awareness on the stand mixer almost doubled."

> Mixers Push Sales Up in Other Appliances

Over the years, the marketing campaign has evolved and changed as its parent company, Whirlpool Corp., has reorganized. In 1999, the company began marketing its small appliances and large appliances in the same ads. The campaign was called "Results." The ads were two-page spreads where one photo would show the food prepared and the other would display the products used to make them. One ad showed focaccia as the result, and the mixer and oven in which they were prepared were featured in bold colors.

The process to grab even more consumers continued this year when KitchenAid tweaked its campaign again. This time, the company's advertising agency developed a one-page campaign called "Steps." The ad campaigns use the steps of a recipe and witticisms to try and convince consumers to purchase its products.

"It tested exceedingly well," Maynard said. "Our approach has always been to raise the bar. We spend a lot of time trying to figure out the consumer, their needs, how they think, and what makes them tick."

[LEFT] KitchenAid has long made refrigerators, but the company started to make small appliances like blenders in the mid-1990s. Through its advertising, the company aimed to illustrate how well its small appliances could work in tandem with their larger appliances as in the case of the Blueberry Velvet Cheesecake Smoothie.

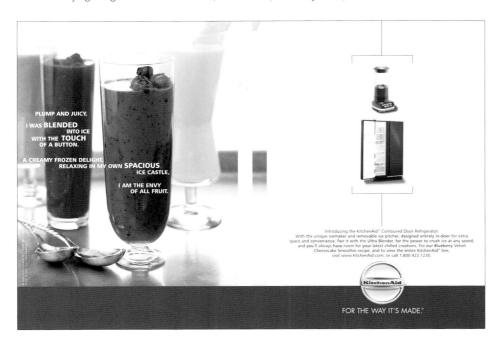

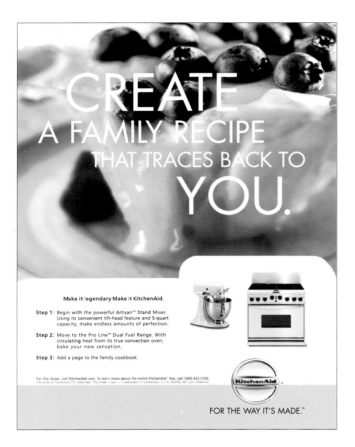

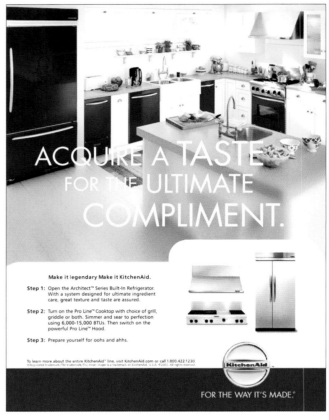

[ABOVE LEFT] The most recent KitchenAid campaign brings back some familiar elements of prior KitchenAid campaigns by incorporating food and the products. In a twist on the old recipe card, each step tells consumers what product was used to create the entree.

[ABOVE RIGHT] The purpose of the KitchenAid "Steps" campaign is to market products from both its small and large appliance lines. The one-page ads allow the company to advertise a greater number of products and reach a number of different consumers.

> Branding Expands to Television and Major Retail Outlets

KitchenAid didn't confine brand awareness to print ads in glossy magazines because the company was trying to build relationships among chefs who had gravitated to food shows on television. The market was exploding as consumers tuned into the experts for advice on preparing gourmet meals inside in their own kitchens.

Research showed that consumers gained knowledge of cooking utensils and brands through cooking shows so KitchenAid began sponsoring *Home Cooking* on PBS. Maynard led a team that was responsible for introducing new products to the likes of food icons such as Julia Child and Martha Stewart in hopes they would use them on their shows.

"You wanted to be able to have them try the products, fall in love with them, and use them on their show." Maynard said. "They would talk about KitchenAid mixers and mention them by brand name. When you look at brand loyalty you're talking about several levels of experience."

KitchenAid also spent quite a bit of time developing the shopping experience for consumers, Maynard said. It built on its early success with Williams-Sonoma in creating an appealing point of purchase where all the company's products were available in one spot. Similar shops were set up in department stores from Macy's to Kohl's.

"Sometimes, we joke about our distribution that there are only a couple of gas stations in Omaha that aren't selling our products," he said. "Brands are what drive consumers. In the past, we operated as a very large manufacturer that happens to market appliances. What we're trying to become is a marketing company that happens build appliances among other things."

Marketing a product that has been around for more than eighty years presents its own unique challenges, but KitchenAid understands its importance. As the competitive market grows, the company has realized that keeping its pulse on consumers needs is the only way to ensure that the legacy of the mixer continues and that its new products continue to grow.

In the past decade, the laurels have been particularly sweet. In 1997, the San Francisco Museum of Modern Art held an exhibition called "Icons: Magnets of Meaning." The curator selected three items considered American Icons: the KitchenAid mixer, the lipstick canister, and blue jeans. In 2001, *Consumer Reports* rated the company's mixer as the number one in its category.

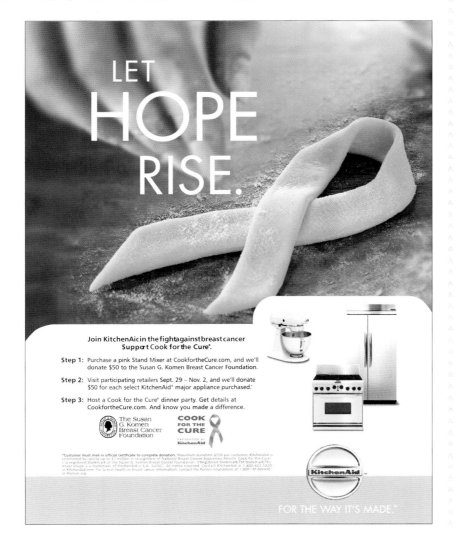

[LEFT] KitchenAid has been known to manufacture specific mixer colors for certain distributors. In this case, the company designed a pink mixer to raise funds for breast cancer research and was able to promote its products at the same time.

Seven Network

> An Identity of
Olympic Proportions

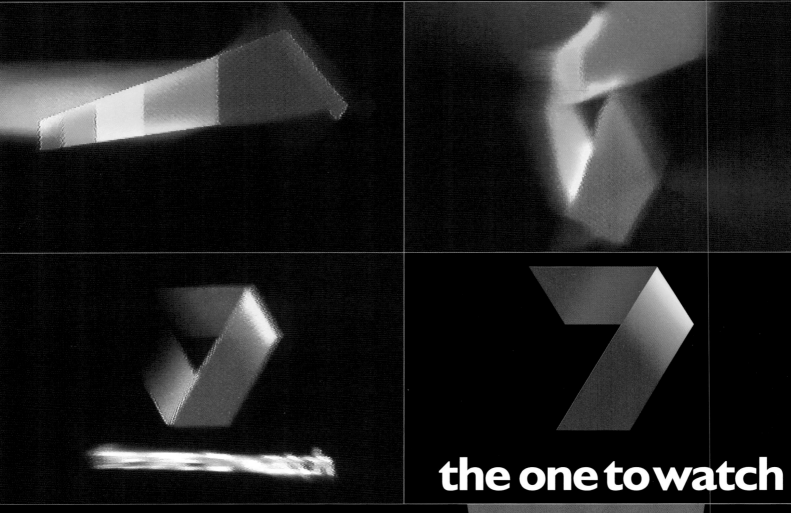

the one to watch

Design Firm > Cato Purnell Partners
Designers > Cato Purnell Partners
Client > Seven Network, Australia
Software > Adobe Illustrator

> A Long-Awaited Makeover

Seven Network's branding had evolved to reflect organizational and programming changes since its inception in 1956. The introduction of color in 1975 prompted Seven Network to integrate a color bar into the logo as a recognizable and positive identity. Through all its logos, the figure *7* was always the constant. Although the number took on many different forms, the most recent was a seven in a bold red circle. It was this identity that needed updating when the broadcaster set its sights on challenging Channel Nine, the longtime number-one station in Australia. To ensure that any new branding would be more than a pretty icon, Channel Seven retained Cato Purnell Partners for the job. Their task? To create a dynamic new look to commemorate the beginning of the millennium and capitalize on the company's position as the official Olympic station in October 2000.

Immediately, Cato Purnell Partners pored over comprehensive research conducted by Seven Network, which gave designers insight into viewer perceptions. "The graphic identity for the number-one brand, Channel Nine, is quite hard edged, arrogant, and authoritarian," say designers at Cato Purnell Partners. "Conversely, Channel Seven was perceived as being comfortable, family oriented, and conservative."

> Speed and Simplicity Were Paramount

With the research in hand, designers had to move fast. They had only six weeks from the initial client briefing to the launch date of January 1, 2000, to brainstorm, design, and execute the new branding, so the redesign had to be easily implemented and it had to work within the confines of designing for television: It had to avoid the outer edges of the screen, especially if the type was going to be read. Type and image had to be placed in the central screen—the "sweet spot" of viewer concentration. Designers had to

[OPPOSITE] The animation sequence of the Seven Network logo begins with the ribbon running through the color spectrum. As it twists and turns, it evolves into a red *7* with the sub-branding statement, *The one to watch,* set in the font Humanist 521, which is derived from Gill Sans. From this, designers developed subidentities such as "7 News" and "7 Sport."

[BELOW] The brand was designed so that it could be easily adapted to everything from business stationery to signage and large vehicles, including Seven Network's news vans.

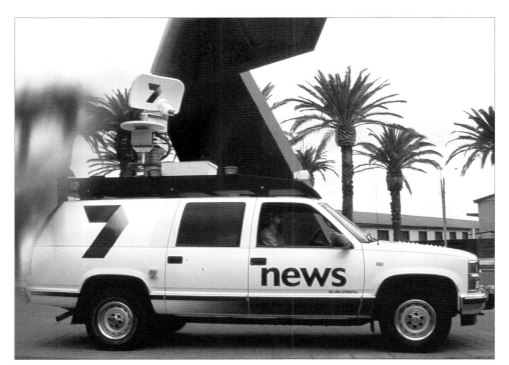

Courtesy of Seven Network

[RIGHT] **Seven Network's Internet entity, i7**, retains characteristics of its parent, while introducing the letter *i*. The numeral *7* is translucent, which is key to the design. When animated, the *i* evolves from the parent *7*, so the two forms appear to work as one.

[BELOW] **The logo for Seven Network's cable station emphasizes the C,** which alternates against a gold and blue background to show alternate sporting channels. It keeps close ties to its parent through the use of the *7* on a red background.

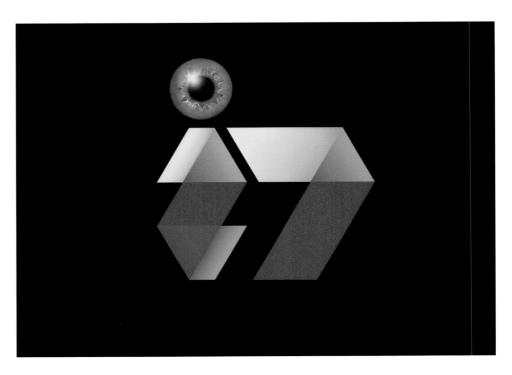

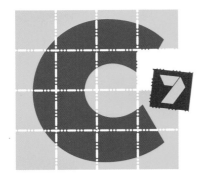

choose an easy-to-read typeface that works with television's low resolution. Fine serif fonts wouldn't work because they would appear blurry or drop out.

Ultimately, designers chose to keep the color bar but enhance and update the image. Because Seven Network was already identified with the color red, it made sense to keep it as the brand's primary color. It also communicated the network's identity as strong, independent, dynamic, fun, and, most important, Australian. This was key, especially to management, which requested that the identity be free-spirited and distinctly different from other television station identities.

The team presented three concepts; the one that won out was a ribbon that glides and folds across the screen through the color spectrum to finally form a red *7*.

"The flexibility offered by the concept and its powerful use of color provide Seven Network with a vibrant and friendly identity that is practical and easily extended to meet future needs," say designers. It could also draw on other colors for use in promotional program breakers and outdoor signage. In short, the logo can change color to suit programming demands—green for environmental programs and so forth.

"Channel Seven's new identity has created an awareness among their audience of what the brand stands for in an extremely effective way. The new identity has created a positioning that is dynamic, fun, approachable, colorful, interactive, and, most important, contemporary and exciting," designers say.

> An I.D. That Speaks the Language

The design is all part of what Cato Purnell Partners call a "broader visual language" that can be applied across all applications of the brand. This visual language involves the animation of the color bar, which

could be extended. "The station now uses this visual language to create fun, approachable, interactive identities, which have been embraced by the Australian public and have elevated the station to currently sit just below the number-one brand with market share increasing incrementally season upon season," say designers.

Besides the television presence, the ribbon graphic has been extended to letterhead, business cards, and envelopes, as well as to large vehicle and building signage systems. Most important, the flexibility of the logo allows it to be easily extended for future needs. It was initially designed for Seven Network, the free television broadcast station. Subsequently, Cato Purnell Partners were called upon to give the same look to the broadcaster's cable television channel, C7, and its Internet presence, i7.

> Extending the Brand

C7, the cable television division of Seven Network Ltd., wanted to be identified in viewers' minds with superior pay television sports programming. Cato Purnell Partners' job was not only to develop a distinct brand that enhanced marketplace recognition of its sporting entertainment offerings but also to provide a flexible platform that would accommodate the company's future broadcast initiatives.

The C7 design concept works on a tear-off grid layout that includes various components that can be individually animated. This graphic device can bind them together, flip them, or divide them to promote content specific to the program of interest. The "tear" furthers the trademark's dynamics and its ability to extend into other forms of communications. The trademark emphasizes the *C*, which alternates in gold

[ABOVE] Since 1956, the figure seven has remained a constant in Seven Network's identity, although it has taken on many different forms. When the station began transmitting in color in 1975, they added the color bar to the logo. Twenty-five years later, Cato Purnell Partners opted to keep the color bar but updated it by adding a ribbon that glides and folds across the screen through the color spectrum to finally form a red *7*. The ribbon draws on the other colors for use in promotional program breakers and outdoor signage.

[LEFT] In addition to television and digital design work, Cato Purnell Partners created Seven Network's annual report.

'Seven's approach to Australian production is inspiring, their commitment to drama unparalleled.'

Our commitment
Austral...

Production

'2000 was Seven's biggest ever year with the Olympic Games. It was marvellous that the powers-that-be at the network let a couple of old boofheads ride along to the gold medal with them.'

[ABOVE] During the Olympics, the company's cable television identity featured the logo on a tear-off grid system that was perfect for a lively animation sequence.

and blue to indicate alternate sporting channels. It ties into its parent network through the use of the broadcaster's identifiable numeral *7* on a red background.

Seven Network's Internet consumer brand, i7, was formed in 1999 as an independent company, which subsequently teamed up with U.S. broadcaster NBC and NBC Internet to create co-branded online and broadband consumer services. Cato Purnell Partners approached i7's identity like the others. The i7 logo has some characteristics of its parent company but conveys its own personality with the introduction of the *i*.

"Retaining the translucency of the *7* was the key design objective," say designers. "In animation, the two forms work as one, exploiting the use of the translucency of the *7*—the *i* evolves from the parent *7*. A deliberate creative strategy was adopted to position i7 as a consumer brand rather than a Web site or portal. i7 provides an envelope network that links niche sites and endows each one with certain characteristics to provide consumers with the best possible user experience within a secure environment," designers say.

The graphic campaign contributed, almost exclusively, to the success of the challenge as it created a personality for the station that then allowed the in-house designers to extend the identity and the broader visual language consistently across all the station's requirements. The creation of a broader visual language has allowed them the freedom to offer a consistent image to their audience.

> The Makeover That Got Everyone Talking—And Watching

The makeover of Seven Network made big news. The story of Channel Seven's resurgence was widely covered in the media, including a six-page cover story in *BRW*, February 16, 2001; a two-page story in *Australian Creative*, Autumn 2001; and a cover story in *The Australian*, March 9–March 15, 2000, which wrote, "Seven has gone from being a broadcaster with some fledgling pay sports channel interests and an

investment in Melbourne's new Colonial Stadium to a company with international alliances in television production, the Internet, and mobile phones."

Moreover, Channel Seven has risen in the Oztam ratings to be almost on a par with Channel Nine. The Seven identity was recently valued by Interbrand in Australia as being worth AU$220 million (*Business Review Weekly*, November 29, 2001).

Because of its success, Seven has nominated Cato Purnell Partners as its preferred supplier on brand management. Channel Nine has not reacted with an identity change so far, according to Cato Purnell Partners, "although we believe that changes may soon be made to position the brand as more 'fun' in order to curtail the phenomenal success of Seven."

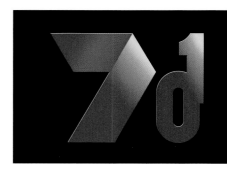

[ABOVE] **Cato Purnell Partners** developed this logo for the company's digital television identity in 2001, so it is no surprise that the *d*, denoting digital, comprises zeroes and ones.

[LEFT] **Seven Network's** ribboned red logo stands proudly outside that station's headquarters in Colonial Stadium, Melbourne.

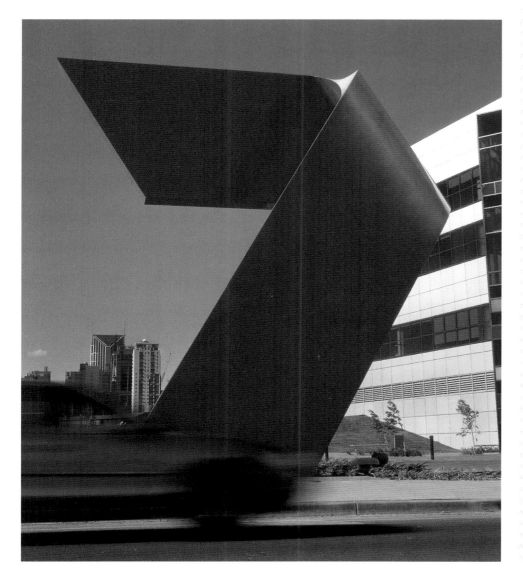

∧

M1 > Challenging Singapore's
Government-Owned Monopoly

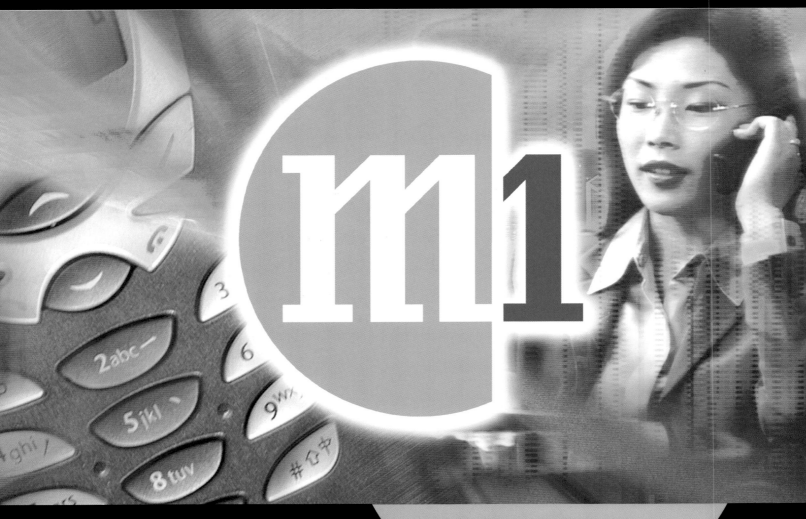

There is a subtle reference
to the corporate entities
behind M1—the four upward
strokes of the M1 reflect
the four-strong consortium
that includes industry
heavyweights such as Cable
& Wireless and Hong Kong
Telecom, as seen in this
mood visual created for
presentation purposes.

Design Firm > The Bonsey Design Partnership
Client > M1 (MobileOne) Pte. Ltd.
Software > Adobe Illustrator, Adobe Photoshop

> Breaking Up a Monopoly

SingTel Mobile, Singapore's government-owned telecommunications company, enjoyed a monopoly—it had no competition. But that was about to change. Enter MobileOne, soon to become Singapore's second telecommunications provider, but at the time, the only independent provider to challenge SingTel Mobile.

"From the beginning, MobileOne was different and was positioned to provide a refreshing alternative to the established, more corporate image of SingTel Mobile," says Jonathan Bonsey, The Bonsey Design Partnership. "It needed a new name—MobileOne was too indistinct—and it needed an identity that would become the badge of the next generation of mobile telephone users who wanted to break from the constraints of the existing service provider."

> What's in a Name?

The name MobileOne defined the company's business, but designers didn't feel it had the zing the new-comer needed to break into a market where consumers were so accustomed to the name SingTel Mobile that it felt like a distant relative—an unknown entity, but nevertheless familiar. Knowing what they were up against, designers opted for an abbreviated form of MobileOne—M1.

"M1 not only stands as a short form of Mobile One, but the *M* represents Me, the individual, and the *1* stands for my choice in mobile telecommunications," Bonsey explains. "The M1 graphics campaign was about providing choice and providing an alternative that, for the first time, reached out to the individual consumer—the man and woman on the street—rather than a corporate entity. The identity is about freedom of choice and freedom to get on with your life."

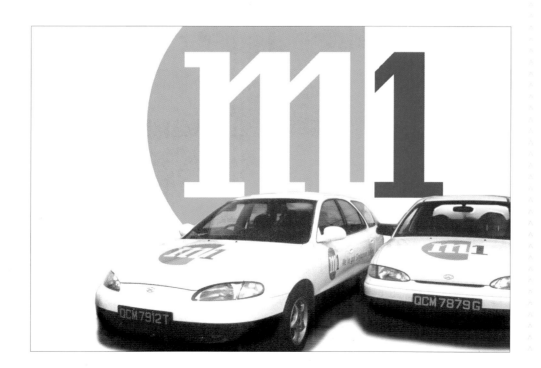

[ABOVE] "From the beginning, M1 needed a new name; MobileOne was too indistinct. Options were explored, along with their visual interpretation, before deciding on M1, which was short, concise, and different," says Bonsey, citing various names and logo treatments designers experimented with in the early stages of the project. The resulting M1 identity represents the four-strong consortium including Cable and Wireless and Hong Kong Telecom.

[LEFT] Because the identity is so simple, yet so powerful, it has attracted a much younger demographic than M1's competitor, SingTel Mobile, which is corporate and staid by comparison.

Courtesy of M1

> Integrating a Mission Statement into the Brand

With the new name at the ready, designers began work on the identity, all the while keeping M1's mission statement in mind, specifically to be Singapore's most responsive, quality-driven personal communications service. Based on this, designers created a symbol that embodies two components key to mobile telecommunication—the caller, represented by the singular numeral, and the world with which he or she communicates.

"The world of M1 is eye-catching and bright, full of hope and ambition," says Bonsey. "The strong, clear-blue *1* contrasts with the orange, complementing the vibrant globe with a steady, reliable stroke. The sharp, clean, and legible letterform of the symbol reflects the technological backbone of the service and the level of innovation that characterizes M1.

"Through this combination of vertical stroke and round globe, M1 communicates the flexible, technically excellent, and customer-focused service that the company will provide."

[TOP] Designers integrated M1's mission statement—*Be Singapore's most responsive, quality-driven personal communications service*—into the logo mark by including the caller, designated by the numeral one, and a sphere, representing the world with which he or she communicates. The mark is the perfect complement to premium items, especially this golf ball.

[BOTTOM LEFT] Although the M1 logo as designed by The Bonsey Design Partnership is fun and playful, there are rules for how it is used. A very simple standards guide, produced as an oversized, full-color, trifold brochure, discusses the dos and don'ts for using the icon.

[BOTTOM RIGHT] The bright orange of the spherical shape, or globe, prevalent throughout the identity materials—referring to the orange "rising sun"—has been the driving element behind M1's "Under the Sun" advertising campaign.

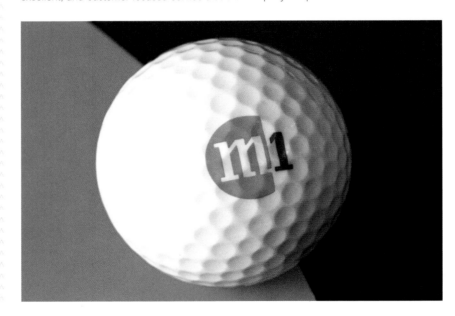

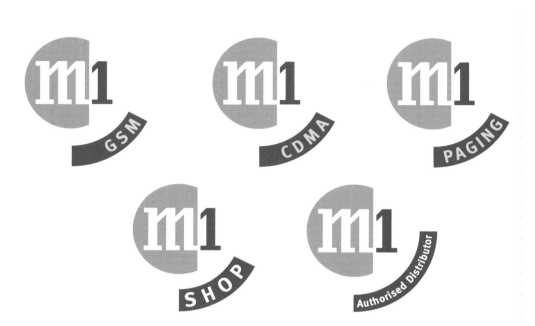

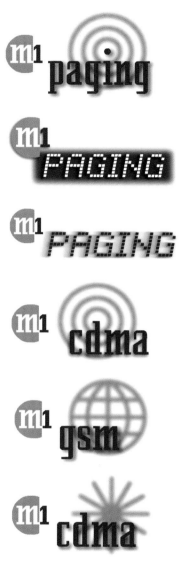

The graphics—so simple, yet so powerful—became a popular sight on everything from retail and vehicle signage, uniforms, and golf balls, to more traditional applications, including printed pieces, corporate letterhead, and identity materials.

> A Welcome Change

By comparison to SingTel Mobile, M1's look is drastically different. For starters, "the identity is compelling and has a huge consumer appeal," says Bonsey. "The graphics appeal to a younger target audience and break with the staid, corporate image projected by the existing provider. They are simple, fresh, and engaging from a consumer viewpoint. The orange 'rising sun' has been the driving element behind the company's 'Under the Sun' advertising campaign. In addition, there is a subtle reference to the corporate entities behind M1—the four upward strokes of M1 reflect the four-strong consortium that includes industry heavyweights such as Cable & Wireless and Hong Kong Telecom."

Moreover, complementing the bold visual element is a strikingly confident slogan, *We've got Singapore talking*, which is promoted everywhere and on everything, including double-decker buses that take the message to the masses.

> The Proof Is in the Numbers

Within the first 30 days of operation, M1 captured 10 percent of the market from incumbent SingTel Mobile. Within six months, M1 secured more than 120,000 customers and within the first year, more than 200,000. Today, it has reached one million against a total population of four million. The company now has 35 percent of the market share and turned its first profit of 7.9 million within 21 months. "Quite an achievement for a nimble start-up," Bonsey adds.

[THIS PAGE] Designers created a variety of concepts for M1's subbrands, retaining the family look of the identity. These subidentities were created for retail outlet and service offer applications.

[TOP RIGHT] M1's slogan *We've Got Singapore Talking* gives an indication of M1's aggressive push into a market that had been the monopoly of SingTel Mobile.

[BELOW] The M1 identity is distinct and works on various applications, including promotional items.

[BOTTOM RIGHT] The bright orange M1 sun was launched to counterattack SingTel's campaign. "M1's sun became the bigger, better, and brighter alternative and supported the highly successful campaign, 'Everywhere under the Sun,'" says Jonathan Bonsey.

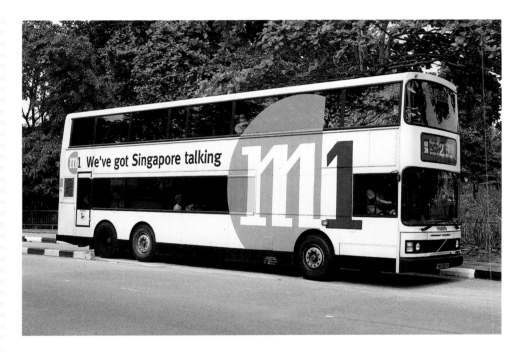

M1 was the first to bundle an SMS (short message service—enabling mobile phone users to send short text messages via their phones) proposition with subscriptions, and the company is still ahead in terms of sales and profitability in an even more crowded and increasingly competitive mobile telecommunications market. "We moved more quickly than the competitors and were first to bundle SMS with subscriptions," says Neil Montefiore, M1's CEO. Singaporeans use SMS more than twice as much as the global average, according to the Bonsey Design Partnership, and M1 is the provider of choice.

> Warning: Don't Get Complacent

So with M1 eating up so much of SingTel's once-solid business, what has been its reaction to the young upstart? "For the first time, the existing SingTel Mobile was faced with competition that challenged its

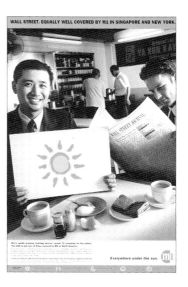

WALL STREET. EQUALLY WELL COVERED BY M1 IN SINGAPORE AND NEW YORK.

monopoly hold on the market, and as a result, it has addressed its position in the market through media campaigns and consumer repositioning. There is nothing like a competitive market to counteract complacency," says Bonsey.

Interestingly, the Bonsey Design Partnership reports that SingTel's graphic identity has remained the same, whereas the advertising campaign has changed undoubtedly as a result of M1's onslaught. "The number-one brand's image of competitive coverage, represented by a red umbrella sheltering users from the rain, has been challenged and beaten by the sunshine and smiles of the M1 brand presentation," Bonsey says.

[ABOVE] This print ad was created to support M1's coverage campaign and illustrate its growing global coverage.

[TOP LEFT] As the M1 service developed, the master brand endorsed a range of new services as an extension of the brand so designers created another set of subbrands to round out the identity.

[BOTTOM LEFT] "The bright orange M1 sun rose as a statement of coverage, and over the three-year campaign it became an expression of M1's service, warmth, and everyday reliability," says Bonsey of this print ad.

[BOTTOM RIGHT] To entice new subscribers, M1 offers packages that include a range of services such as free SMS (short message service). This ad was created to promote this service to Singaporeans, who are one of the highest SMS users in the world.

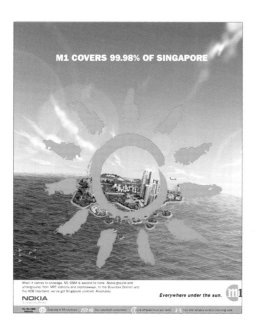

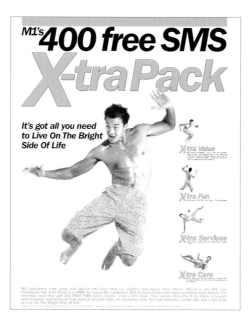

∧

 > Selling Music History

When MTV debuted on cable television, it was out of the ordinary—imagine a television network devoted exclusively to popular music. But the idea took off, and MTV soon became the rage among avid as well as casual music listeners who liked the idea of being able to watch their favorite musicians perform in concerts and in music videos. When VH1—short for "video hits one"—came on the scene, viewers immediately wondered: Can two music networks survive?

Not only did they survive, but VH1 thrived and began nibbling away at MTV's demographic, which targeted 12- to 28-year-olds. In most worlds this would be a good thing, but because MTV Networks owns VH1 and has from its inception, it didn't need VH1 and MTV as rivals—it needed two distinct brands. Each network in the MTV family—Nick Jr., Nickelodeon, Nick at Nite, MTV, VH1, and TNN—are all

A billboard promotes *Rock and Roll Picture Show*, a programming event that showed movies about music such as *Grease*, *A Hard Day's Night*, and *Fame*. The logo used record label logos from the 1960s as its inspiration.

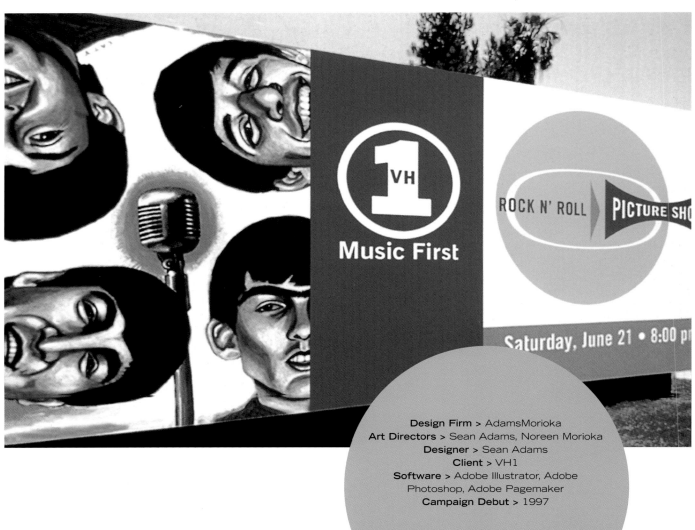

Design Firm > AdamsMorioka
Art Directors > Sean Adams, Noreen Morioka
Designer > Sean Adams
Client > VH1
Software > Adobe Illustrator, Adobe Photoshop, Adobe Pagemaker
Campaign Debut > 1997

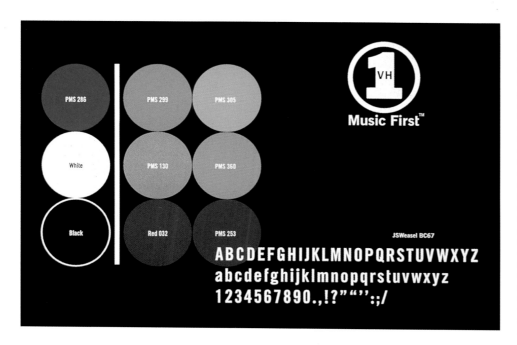

[LEFT] The main color of VH1's color palette is blue. Why? Because when it comes to music history, blue is prevalent—*Blue Suede Shoes*, blue note jazz, and the blues. This color is complemented by six other vibrant colors, including white and black.

[BELOW] The VH1 identity as created by Adams-Morioka illustrates how designers incorporated the words *Music First*—part of VH1's legal name—into the logo to make it impossible for the audience to not know that VH1 is all about music.

independent, with their own ad revenues. Compounding the problem was that VH1 had an image problem; it appeared it was sending the message that it was MTV's little brother.

> When You Have Nothing to Lose...

VH1 needed a new look, so executives invited three large firms in New York, as well as Los Angeles–based AdamsMorioka, to look at redesigning the identity while reestablishing VH1 as a music network and reinforcing its ownership of music history—its niche—to its external and internal audiences. "Thinking that we would not get the job, we told them the truth and tackled broader issues than just the logo. The redesigned logo is very similar to the previous mark. The words *Music First* had been incorporated into VH1's legal name. These words were added to make it impossible not to know that VH1 was about music. The form takes equity from the previous mark, and cleans it up. We gave it a ring for mnemonic reasons and to protect the *1* from party hats," says Sean Adams, AdamsMorioka.

"Previous to the VH1 project," Adams continues, "we had designed systems by making a mark, picking a corporate typeface and color palette, and let it go. This time, we wanted to address the idea of inspiration. How would a designer at VH1 know what to make? As it was, each design was very different. Some looked like David Carson, some looked like Charles Anderson; there was no underpinning concept. So we gave them a source for material. If we want the audience to think about music, what do we show? I, personally, think music notes and lines look like goofy 'jazz' ties and don't really have much resonance. So when we think of music, we think about the visual cues we have been given: the liner notes of a record, the CD covers for the Beach Boys, logos from Verve Records or Capitol Records, Fillmore posters—the list goes on. We suggested that the designers look at these things and use them as starting points, running them through each designer's own filter."

Courtesy of VH1

No one was more surprised than AdamsMorioka when they were awarded the project. The team went on to create VH1's identity, establishing a color palette (using nine colors, the three primary shades of which are blue), a custom font, on-air elements (including screen configurations, bumpers, and so forth), off-air elements, print materials (including letterhead, business cards, and press-release paper), and advertising visuals.

Throughout all the promotional items, designers advocated using colorful illustrations of musicians to give VH1 a distinctive look from other music channels, which rely heavily on photography. By creating original

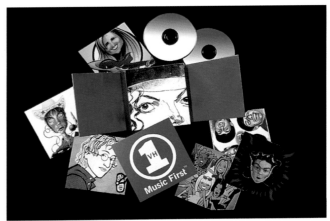

[ABOVE LEFT] The stationery system is innovative, and although the press-release paper is fairly conservative, the letterhead goes all out to have fun. Illustrations of famed musicians are offset-printed on the letterhead, business cards, and other items.

[ABOVE RIGHT] Designers developed various CD jackets for use in VH1 giveaways and promotions.

illustrations, VH1 would build a library of images for subsequent merchandising, including CDs that VH1 could use as giveaways and promotions. "We also suggested VH1 broaden its own CD publishing and book publishing," says Adams.

When the entire project came together, the result was a visual retrospective on music history. "It wasn't just our doing," says Adams. "The change wouldn't have been possible without some great ongoing work from the ad agency and the in-house design department." Adams cites the contributions of Fred Seibert, an AIGA medallist and MTV Networks' creative consultant; Mike Benson, creative vice president at VH1; and John Sykes, president of VH1, as being invaluable.

Within one year, everyone on the team was applauding. VH1's ratings increased by 154 percent, winning viewers not from MTV, but from a previously untapped market—the 18 to 34 age group. Previous to the change, VH1's demographic was less clear. Today, ostensibly VH1 still competes with MTV, which is constantly reinventing itself, but "VH1's repositioning, and identity now work in tandem with MTV," says Adams. "The MTV audience graduates to VH1."

"In our perfect AdamsMorioka world," Adams continues, "each MTV Network graduates its audience to the next MTV Networks-owned channel; Nick Jr. to Nickelodeon to Nick at Nite, and MTV to VH1 and now to TNN. There is obviously overlap in some instances and competition. After the inception of the change with a clearer demographic, ratings increased and surpassed MTV's."

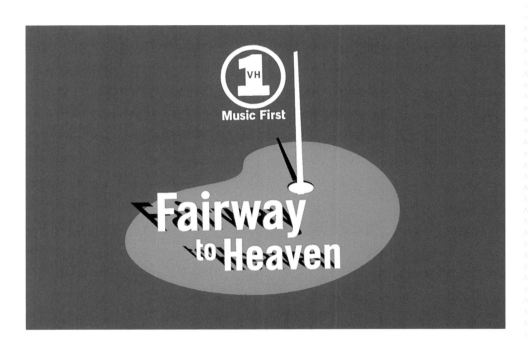

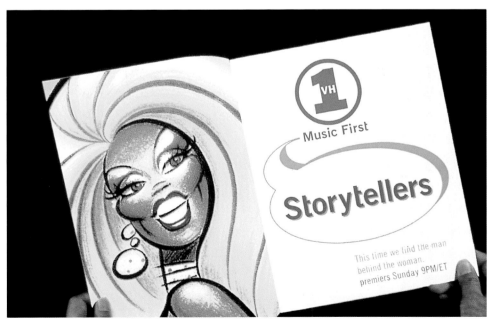

[TOP LEFT] *Fairway to Heaven*, a show featuring golf and music stars together on a golf course in Las Vegas, gets its mark from VH1's typeface, JS Weasel, and VH1 colors.

[BOTTOM LEFT] To promote *Storytellers*, a VH1 show focusing on RuPaul, designers created this trade ad. Designers preferred to use illustrations of celebrities rather than photography to set VH1 apart from other music channels.

Simply Music > A New Theory in Music Education

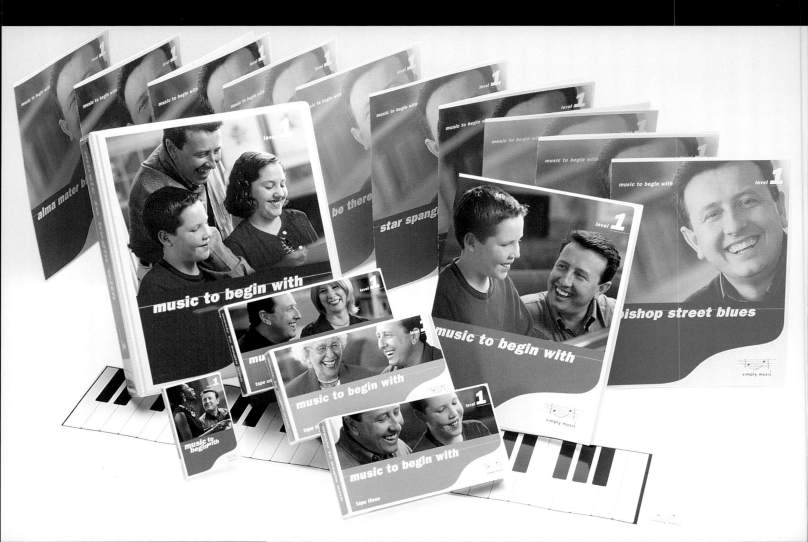

> Taking on Tradition

When you talk music education, people in the know are likely to cite a number of credible and prominent "methods" of instruction, including the likes of Alfred's, Schaumm, and Hal Leonard, among others. "However, in the public eye, the only method that has any recognizable name is Suzuki and Yamaha. Both, in the public's perception, are considered to be a reputable alternative to traditional programs," says Neil Moore, the Australian-born founder of Simply Music.

"Despite the public's perception of Suzuki as being a successful approach—and for that matter, the credibility that all traditional methods enjoy—our stand is that these methods are dated, cumbersome, and inappropriate for most of the population. What is needed is a major overhaul of the entire thinking that embodies music education," adds Moore.

Moore's brainchild, Simply Music, exemplifies the overhaul in music education of which he speaks. It is based on the premise that everyone is naturally musical. Simply Music, a playing-based music education program, draws on and "feeds" the natural sense of music that people possess and teaches students to play the piano by immersing them in the actual process of playing, providing a mix of instruction and discovery. There's no music theory, no music reading—just playing. Students learn by doing.

[ABOVE] Just as intended, the Simply Music logo conveys its playful approach to music education at first glance. What novice musician would be intimidated by two notes forming a smiley face?

[LEFT AND OPPOSITE] Students purchasing the learn-at-home program receive a package of educational materials with the slogan, *Music Made Simple,* which features the smiling faces of satisfied customers and cartoon illustrations.

Courtesy of Simply Music

[ABOVE] The identity system carries off the right blend of whimsy and professionalism, for as fun as the program is, Simply Music is competing with several buttoned-up adversaries that stand by the fact that music education is serious business.

> Learning Can Be Fun

The Aussie-owned company operates its retail sales and tuition services from a base in Australia, but its headquarters is located in Sacramento, California. To launch the company, Moore tapped Australia's Smart Works for the branding, identity system, Web site, and packaging. "The graphic image we present is of extreme importance. Our vision and focus is centered on causing a new era in music education. Our thrust is about an entirely new level of accessibility for all, about music learning being easy, simple, fun, and immediately rewarding," explains Moore, all of which plays to Simply Music's premise—learning to play the piano isn't work; practice doesn't feel like practice.

Smart Works set about the job of creating graphics, including developing the company's corporate name, logo, color scheme, packaging, and individual design elements to communicate warmth, fun, and playfulness at first glance. "We needed to convey a bright, refreshing image that is both substantial and professional, but at the same time, entirely new, inviting, and compelling," says Paul Smith, senior designer at Smart Works.

"Our overall look is profoundly different than any other music education institution. Rather than the look of formality, seriousness, and tradition, we capture a genuine brightness, a newness, a significant departure from tradition, and a playfulness that music rightly deserves and needs," says Moore. "Our graphics

are significantly more contemporary, vivid, rich, and intelligent than our chief competitor's. Traditionally, the graphics, including the logos, of our music education institutions are not typically designed to be communication devices in their own right."

> First Impressions Count

"Our thinking was that if we achieved the right blend of brightness and playfulness, then the design elements themselves would do much of the necessary communication of our vision," adds Smith. This meant that designers had to develop a design that was not only attractive and memorable but also efficient in how it communicated Simply Music's image.

Moore agrees. "Our view is that the message, the sum total of all design, and the method—the breakthrough approach to music education—would be synergistic, interwoven, inseparable, and seamless.

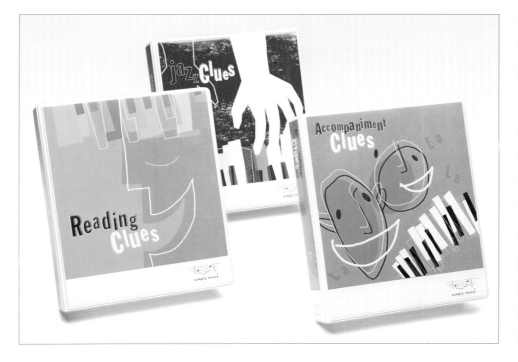

[TOP LEFT] The bold graphic treatment that Simply Music incorporates throughout its visual campaign is reminiscent of early jazz album cover designs with an added youthful twist.

[BOTTOM LEFT] This program includes remarkable shortcuts that teach students how to play along while others sing the well-known songs featured.

[ABOVE] Drop in on Simply Music's Web site, www.simplymusic.net, and you'll be treated to a simple Flash introduction that features brightly colored characters dancing about the music staff. The graphic appeal here, as in all the materials, is clean, uncluttered, crisp, and above all, fun and playful.

"In stark contrast to other institutions and methods, our program is extremely image-based with our thinking being that every aspect of our look must make a significant first impression, and that impression must immediately contribute to the communication of our vision."

To date, the results of the promotional campaign have earned high marks. The Simply Music program was released in 1998, but the official launch didn't come until 2000. Although the music education industry does not track sales as most companies do, Simply Music is proud of its accomplishments since its debut. The Casio Corporation endorsed Simply Music as its education program of choice. The company was acknowledged as an approved educator for various national home-school charters and has been talked up in numerous TV, radio, and newspaper articles focusing on its growth and methodology, including its impact on the inner-city school environment, which was featured on ABC-TV Los Angeles. In addition, the largest per-capita library system in the United States introduced the Simply Music program in all of its branches.

Within 18 months of its launch, PriceWaterhouse's and the *Business Journal's* Annual Awards ranked Simply Music, throughout all commerce categories, as the region's second fastest-growing company. Moore was invited to be on the advisory panel for the proposed Washington, D.C., School of Performing Arts to be funded by the Library of Congress and the Smithsonian Institute.

Spurred on by the enthusiastic reception Simply Music has generated to date, the team is now gearing up for a sustained five-year program after the initial promotional campaign that listed a short six months.

"Our commitment to achieve this was immediately measurable. This was reflected in the growth of our school system, which went from approximately 500 students attending lessons, growing to over 10,000 students within 120 days of the campaign's launch," says Moore.

[BELOW AND OPPOSITE BOTTOM] **The Web site is easy to navigate. The worst mistake designers could have made would be to create an overly complex site to promote an easy piano instruction program. Instead, the site is easy to read and is enjoyable to peruse. Furthermore, as soon as a visitor learns about the program, it is even easier to buy into it.**

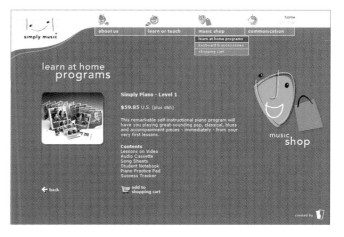

∧

> Charging Against the Bull

burn™
energy to begin.

'burn' is a trade mark.

Design Firm > Asprey Di Donato
Strategic Direction > Graham Ritchie (nonstop partners)
Art Director > Tony Di Donato
Designer > Peter Asprey
Illustrator > Sergio Medina
Client > Coca-Cola South Pacific
Software > Adobe Illustrator

[OPPOSITE; ABOVE AND BELOW] Artwork for the Burn straw dispenser, wobbler, and refrigerator sticker feature the slogan, *energy to begin*. The slogan is not unlike Nike's tag line, *Just Do It*, which talks to young people directly like a motivational speaker. In Burn's case, the slogan ties back into their product—an energy drink; drink it and it will give you the energy you need to take on the world.

[TOP LEFT] Burn was targeted to the "out and about" 18-plus club and bar market that knows what they want—innovative, different products that appeal specifically to their age-group. The look it presents is the opposite of that of its chief competitor, Red Bull.

> Energy to Burn

Burn, a new energy drink designed for the 18-plus club and bar market, was poised for release into the Australian market when it tapped the counsel of Sydney-based intellectual property company nonstop partners, Melbourne-based design agency Asprey Di Donato Design, and beverage distributors, Atlantic Industries, to help with the launch. Burn, a product of Coca-Cola South Pacific, needed all the help it could get because it was going up against market leader Red Bull.

"The proposition behind Burn was based on the consumer insight that energy can mean many things to this audience. Burn is the first of a range of four drinks, each aimed at a specific energy 'need state' through the course of a typical night," says Tony Di Donato, art director. "We expressed each of these need states through the four basic elements—fire, air, water, and earth. This approach speaks directly to a youth audience that is looking for a more specific product offering that speaks to their energy needs on their terms—energy to burn—a drink for the beginning of the night."

> A Flame Ignites the Campaign

Designers were able to integrate all of these elements visually via a flame—an icon that they used as the mark—and translated it onto everything from packaging to point-of-sale items, including straw dispensers, wobblers, and refrigerator stickers. Most important, the flame takes prominence over the product name, which is secondary in the overall design. The resulting packaging—arguably the cornerstone of the product campaign—is a sleek, black can emblazoned with a flame that clearly sets Burn apart from the competition. "Burn is squarely aimed at the 'out and about' young adult crowd," adds Di Donato. "It breaks with tradition by underplaying the role of the retail brand. The lead brand identity is the flame not the name."

Besides appearing especially trendy and eye-catching, the identity communicates something more—an intangible quality that subliminally claims that this product has sex appeal. "Burn is designed to look confident and potent. As a nightclub drink, it communicates through the symbol more than the brand name—a

Courtesy of the "Burn"
Collective

fact not lost on the brand-weary market. The strength and simplicity of the packaging alone creates a stark contrast to the silver, blue, and red shades and loud animation dominating the market," says Di Donato.

The look is indeed potent—and most of all, unusual. This is no ordinary flame against a black background. To make it stand out, designers specified that the flame be printed with UV inks, which enhanced the visual, particularly in a club environment. "This helped to attract attention, emphasize uniqueness, and encourage trial," explains Di Donato.

> Going for the Opinion Leaders

In order to obtain a fashionable status among a market with little brand loyalty, the campaign sought to reach buyers by targeting opinion leaders for the first three months of the rollout. "The deliberate subtly of both the marketing and the on-pack branding were crucial in building credibility into this brand. As a newcomer directed at a highly skeptical audience, it was important to avoid the 'me too' trap," Di Donato explains. Subsequently, the campaign targeted 18-plus club and bar patrons in a mass-market promotion.

As the "Burn myth" grew, more creative companies got on board. Under the direction of marketing agency nonstop partners and known as the Burn Collective, the group launched an amorphous creative

[OPPOSITE LEFT] Interestingly, the flame icon developed as the mark for Burn is the predominant element in the product packaging. The name of the product is secondary.

[OPPOSITE RIGHT] Posters were an important part of the campaign, as seen here in this A3 poster featuring three variations of the flame icon—the multicolored flame on the package itself, the red and white icon next to the Burn name, and the two-tone flame that makes up the poster's background. Artwork was printed with UV inks to make the imagery stand out in a nightclub setting and further distinguish it from its competitor, Red Bull.

[LEFT] The slogan, *energy to begin*, was reinforced with *Begin*—the book, CD, and video. These items, packaged in a sleek, black, gusseted envelope, were sent to opinion leaders, creating a groundswell of word-of-mouth publicity.

[THIS PAGE AND OPPOSITE] *Begin*, a promotional book, video, and CD series publicized young talent (and in turn, the 18-plus market) by featuring works by up-and-coming painters, sculptors, textile students, fashion designers, architects, computer artists, graffiti artists, and multimedia specialists.

package, comprised of a music CD, video, and book, which was sent to market opinion leaders as part of Burn's launch. The theme of the work is *begin*—and *burn* is the starting point.

> Begin with Word-of-Mouth Advertising

Begin—the book, CD, and video—salutes young talent (and in turn, the 18-plus market) by featuring works by up-and-coming painters, sculptors, textile students, fashion designers, architects, computer artists, graffiti artists, and multimedia specialists. Packaged in a sleek, black, gusseted envelope, the book, CD, and video were sent to opinion leaders. "This material reinforced Burn's relevance to this audience—having been created by their peers—and created a groundswell of word-of-mouth publicity. The work produced for the launch package was then supported by point-of-sale promotions, posters, and print ads," adds Di Donato.

Did the campaign make Red Bull do a slow burn? Perhaps. According to Asprey Di Donato, other entrants to the market imitated Red Bull's graphics. Designers at Asprey Di Donato chose to take the opposite approach, using contrasting colors and an unusual illustrative style compared to that of the competition. "We wanted to look different; we wanted to portray a different personality to everyone else," Di Donato admits.

Sales figures are unavailable, but based on Coca-Cola South Pacific's expansion plans, Burn performed well against Red Bull. Burn was originally proposed for the South Pacific area only. However, it was received so well in Australia that Coca-Cola South Pacific decided to launch the product in the United Kingdom, as well as in the United States—beginning with the most skeptical of all markets, New York City.

∧

SoBe > Energy Drinks with a
Grassroots Approach

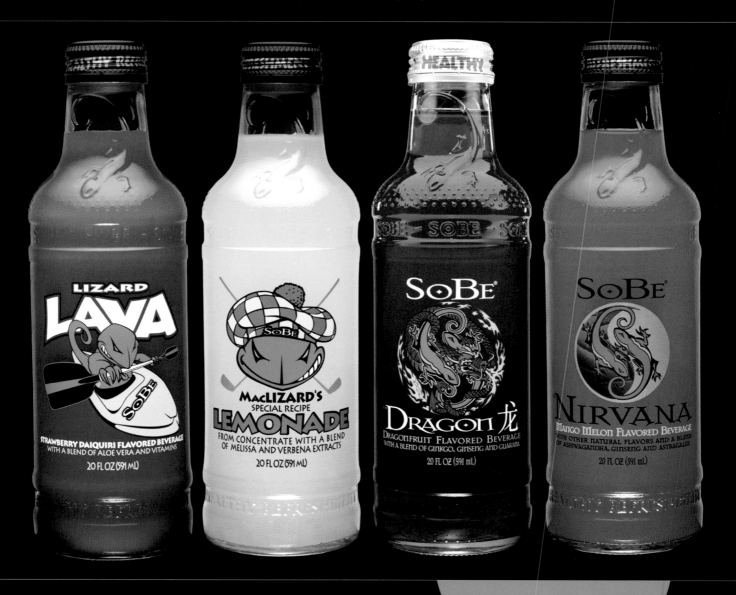

Bello is fond of saying that
SoBe's marketing plan is in
the bottle. The company
spared no expense in devel-
oping bottles that are
embossed with the "dueling
lizards" logo and SoBe name.

Agency > SoBe
Senior Art Director > Rob Mallon
Art Director > Kevin Smith

> Entering the Juice Wars

Since these fruit-flavored energy drinks fortified with ginseng and other vitamins first appeared on store shelves just six years ago, SoBe has become the beverage company that competitors are having difficulty catching. The Norwalk, Connecticut–based company is now leading the New Age beverage market and riding the wave of a highly successful grassroots marketing campaign.

SoBe has never shot a television commercial and has run only a handful of magazine ads and radio spots since it began selling the beverages in 1996. Instead, the company has attracted customers—ranging from teenagers to business executives—through a variety of highly unusual alliances, ranging from Wal-Mart to the sponsorship of extreme athletes and teams, including a motocross racing team called SoBe Suzuki. It opts to hand out samples from its school bus, armored truck, and bread truck at sporting events and concerts throughout the United States.

And don't forget the packaging: glass bottles embossed with its dueling lizards logo.

Like many challenger brands with little resources for advertising, SoBe was forced to raise consumer awareness with an innovative grassroots approach. So far, the strategy has worked. The result: SoBe sales have exploded from $13.1 million in 1997 to $300 million in 2001.

When SoBe began selling its product, the New Age market was still in its infancy. Today, it's a bona fide category within the beverage industry, with other powerhouse companies' drinks, like Coca-Cola's ginseng-laden KMX and Snapple's Elements line.

[ABOVE] To make its products more widely available, SoBe has developed containers—which resemble juice boxes—in which its products are sold.

[LEFT] SoBe drives one of its fleet, which includes a school bus, an armored truck, and a bread truck, to festivals throughout the United States where employees hand out samples. The vehicles, which are all painted with the company's logo, are a magnet for potential consumers.

Courtesy of SoBe

[ABOVE] Much of the design of the SoBe logo revolves around drawing the consumers' eyes to a particular product on the shelf. Founder John Bello sought a design that would be, "fun, cool, and eye-catching."

[RIGHT] SoBe has run few radio or magazine ads for its products. However, the company did produce this piece to promote its Adrenaline Rush beverage. The high-energy drink is a natural for the Gen-X crowd that is looking for something healthy, but with a kick.

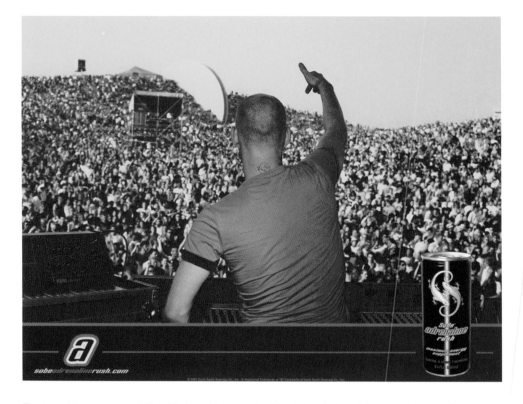

The brand has grown, and PepsiCo bought an equity stake in South Beach Beverage Co. in a $370-million deal two years ago, but founder and CEO John Bello still eschews a national advertising campaign for fear of alienating the diverse consumer base the fruit-drink maker has already successfully attracted.

"Our marketing is in and on the bottle," Bello says. "SoBe products have a great packaging that's different from everyone else's in the market. It's fun, it's cool, and it's eye-catching."

> Unleashing the Dueling Lizards

The core SoBe 20-oz. glass packaging is clear with the embossed lizards—known as the dueling lizards—on the bottleneck. The lizard design was developed after Bello spied it on the facade of a building in South Beach and had designers create sketches to be incorporated into a logo for the company's products.

Although the labeling varies by product flavor, there is always a lizard-based graphic on the bottle. For instance, the strawberry-daiquiri-flavored Lava Lizard has a caricature of a lizard paddling a kayak with a SoBe monogram, and the Lizard line of dairy-based products features the lizard in cartoon form.

Creative packaging, according to Bello, is essential in the beverage industry to stand out from the other products lining supermarket shelves. In addition, edgy packaging can serve as one of several negotiating tools that distributors can use to get better shelf space from storeowners.

"When you're a marketer in this type of category, you've got to work quickly and be on the cutting edge," Bello says. "Marketing campaigns must be fun, and they must have impact, because you're constantly

competing for the consumer's attention. Reaching your consumers at launch with effective marketing helps build consumer brand loyalty."

SoBe, which is named after the trendy Miami neighborhood of South Beach, developed 11-oz. Lizpacks—an octagonal prism that is a spin on the idea of juice boxes—for its teas and juices. The packaging allowed SoBe to expand its demographic markets to teenagers.

Another way SoBe has used its packaging to entice consumers is through the product's bottle caps. Consumers can turn over the top to find slogans such as *Drain the Lizard*, *No Drain No Gain*, *Put a Lizard in Your Gizzard*, and *SoBe or Get Off the Pot*.

"It [the lizard] has evolved into our icon," Bello says. "It is a representation of who we are as a brand and the attitude that we have. We stand for healthy refreshment, and I think the lizard logo stands for both those things."

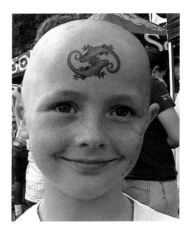

[ABOVE] The simplicity of the SoBe marketing plan is the relationship the company develops with its consumers. Face painters often are hired to recreate the "dueling lizards" logo on the faces of children at festivals where samples are handed out.

[LEFT] SoBe Founder John Bello has been the mastermind behind the creation of the company's beverage line and its marketing. The company's vast line of drinks—including SoBe Black Tea, SoBe Tsunami, and SoBe Energy—all yield their own unique packaging, yet maintain the undeniable SoBe look and feel.

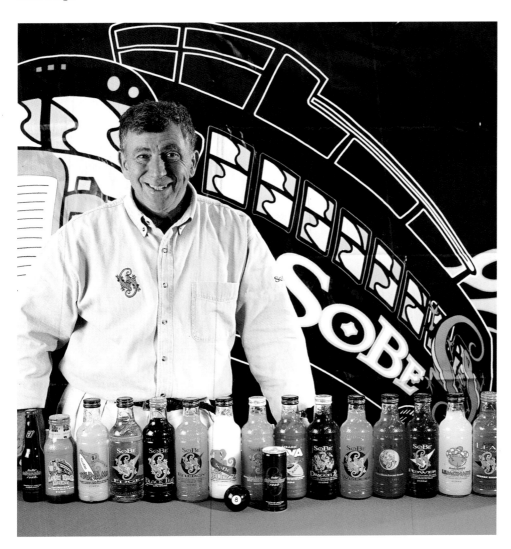

[RIGHT] Some consumers have developed a cultlike affection for SoBe beverages and revel in the arrival of the company's armored truck at festivals so they can sport the latest decals and other promotional items.

[BELOW] SoBe often runs promotions with celebrities, as in this contest to win the bag carried on the professional tour by golfer John Daly.

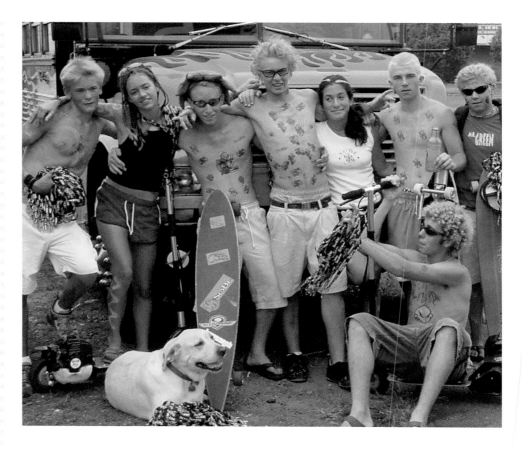

> Grassroots Marketing

Part of SoBe's attitude has manifested itself in the way the company has chosen to promote its products. The company has tried to develop a personal relationship with its customers by unleashing a fleet of buses filled with SoBe employees to outdoor concerts, festivals, and other events throughout the United States. Each vehicle, including a 1970s Partridge Family–style bus, a 1980s armored truck, and a 1949 milk truck, is painted black and emblazoned with the green lizard logo.

Employees travel from April to November in the trucks, which are set up at events to hand out free samples to consumers. SoBe believes that once consumers try the products, they'll buy them, so sampling is a huge part of these tours. The company will often hire artists to offer free face-painting to children.

SoBe also has run promotions with retailers, including Publix Super Markets, Schnuck Markets, Albert's, and Basha's Markets. As part of a $9-million tie-in radio promotion, the company promoted its dairy-based drink called Tsunami with regional radio spots to tell listeners which supermarkets were carrying the SoBe line.

SoBe provided the retailers with promotional in-store point-of-purchase displays and used its SoBe traveling bus to offer free samples in the parking lots outside certain retail chains. The promotion provided SoBe with yet another opportunity to expand its customer base.

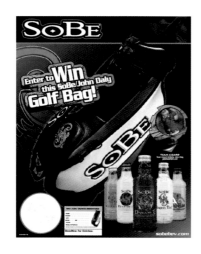

> Unusual Celebrity Endorsements

Bello said the company also has drawn some attention with its athletic sponsorships, which include events like the X-Games, the professional lacrosse league, and NORBA mountain biking. It even sponsors a motocross racing team. SoBe also has landed endorsement deals with an eclectic array of individual athletes, ranging from professional golfer John Daly and beach volleyball star Gabrielle Reese, to U.S. downhill skier Bode Miller and hammer thrower Anna Norgren.

John Daly, who emerged on the PGA Tour as one of golf's longest hitters, has been one of the game's unique celebrities. After battling alcoholism on the tour, Daly was dropped as an endorser of many sporting goods companies. However, Bello decided that Daly's edgy personality reflected in brand's attitude. The SoBe logo appears now on Daly's apparel, umbrella, and golf bag.

"What we have done as a company is build a very dedicated following through grassroots marketing," Bello says. "The challenge we face in the future is expanding into other markets and determining the best way to do that. I still believe our approach will work, but there may come a point in which we need to make changes based on how the market is reacting. You have to remain on the cutting edge in the beverage industry, and we're always thinking of ways in which to do that. At the same time, it's important that we don't lose the spirit that has come to define us."

[LEFT] U.S. downhill skier Bode Miller is one of several celebrities that SoBe sponsors. Bode, whose helmet features the SoBe logo, appeals to a younger generation of consumers, which represents a core growth segment for the beverage company.

[BELOW] SoBe chose to sponsor John Daly, who has battled alcoholism, because he likes to joke with the gallery and keeps the game interesting for fans.

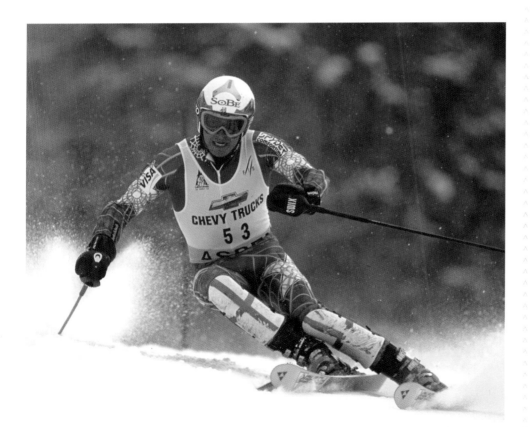

∧

Osborne > The Birth of a Cultural Icon

[BELOW AND OPPOSITE BOTTOM] **The bull was painted black and, as the years went on, was devoid of advertising. However, its silhouette against the countryside communicated more than any advertising copy ever could.**

For many, the Osborne bull is as much a pop culture icon as Mickey Mouse. Whereas Mickey was born of the entertainment industry, however, the Osborne bull came about as an advertising campaign for Osborne Brandy. The Osborne family has had a long, rich tradition in Spain as a maker of wines, brandies, and sherries since 1772. But it wasn't until 1956 that the company changed history by retaining Manolo Prieto Benítez, a painter and poster designer, to help with their advertising. He went to work creating a 13 foot (4 m) tall bull, made of wood and painted completely black, as billboard advertising. On its flank was an illustration of a glass of brandy with the words *Veterano Osborne*.

Design Firm > Tau Diseño
Art Director > Emilio Gil
Designers > Jorge Garcia and Emilio Gil
Client > Osborne/España Abierta
Campaign Debut > 1956

Osborne's competitors at the time were Fundador and SoBerano, brandies manufactured by companies like Domecq or Terry. All these, including Veterano, were not considered luxury brandies, but they were popular ones.

By 1957, 16 bulls were scattered on the busiest roadways in Spain. Four years later, the bull had grown to 23 feet (7 m) high and was made of metal sheeting. Subsequently, the wording on the bull changed when *Veterano Osborne* was replaced with *Osborne Sherry & Brandy*. Next, it became even larger, standing 46 feet (14 m) high and was supported by four small metal pylons. In 1989, new regulations on advertising required that the wording on the bull's flank be removed. "Their fame grew such that after time, the name of the brand disappeared completely, leaving the bull free of any advertising message," says Jorge Garcia, designer at Tau Diseño. Legislators may have silenced the advertising message, but the visual of the bull standing on Spanish hillsides spoke volumes to Spaniards and foreigners to the point that the Osborne bull is largely credited with why bulls have become a symbol of Spain.

[ABOVE] **The Osborne bull obtained mythical proportions and became an icon that defined Spanish style.**

Toro de El Bruch, Barcelona

Toro de Alfajarín, Zaragoza

Courtesy of Osborne

[RIGHT] Famed photographers Richard Avedon, Herb Ritts, Annie Liebovitz, and Helmut Newton all worked with the bull.

Richard Avedon, 1992.

UN POCO MACHO UN POCO ÁNGEL. BRANDY OSBORNE VETERANO

In order to introduce its black bull to the public, Osborne kept its sights firmly fixed on perfection, searching out the best hilltops and plains and the most strategic bends in the rivers of Spain from which to launch its protegy. The bull, eternal companion to the name Osborne, became the best-known man-made image that I, after four decades working in advertising, have seen anywhere in the world.

The Osborne Bull is a giant dream machine, a vehicle for the expression of emotion and feeling. Its outline is that of a creature which has transcended the purely commercial in order to become one of, if not the, best depictions of modern-day Spain and its roots for any observer, from any country in the world.

As someone whose business is communication, I am acutely aware that in this case I am not exaggerating. In fact, it is precisely because, I am a communicator that I can affirm that, as a visual image, the bull is as strong for Spain as is, for example, the maple leaf for Canada, the red spot for Japan, or the white cross for Switzerland.

Today, skimming back over the past, it is easy to come away with the impression that the bull itself was created almost by chance, and that its subsequent success happened by accident.

But it is difficult to believe only in chance or accidents when there is a company in the background, indicating that there were decisions involved, decisions taken jointly by many at the beginning, and upheld

for decades. When this kind of process is followed, with this kind of input, it can only be explained as entrepreneurial talent.

Later, with a view to making the Bull internationally famous, Osborne went to New York, to the four best photographers in the world, Richard Avedon, Annie Liebovitz, Herb Ritts and Helmut Newton. The idea was that these four, having been given the very clear brief of bringing together bull and woman, should let their artistic imaginations run wild. The results were photographs which surpassed their original commercial function to take their rightful place in the world of art.

Above: the top photograph is by Herb Ritts, 1994.
Below it is the image created by Annie Liebovitz, 1993.

Left: the work of Helmut Newton, 1995.

> Logo Turned Global Corporate Symbol

"With the combination of their successful design and the perfection of their placement on the most well-traveled highways, generally on the top of a hill, they [the bulls] soon became hugely popular," says Garcia. "The bull was first a promotional element in outdoor advertising, but then it was later used in the brandy's print and television advertising campaigns until, in an uncommon case in the history of corporate images, it became the symbol of the Osborne bodegas. From promotional element, it evolved into the symbol of the company."

Its popularity isn't limited to Spain. The bull is a popular icon throughout Europe and has been used by many visual artists, photographers, and graphic designers in their work. British designer Neville Brody

Portada de la revista británica
Hot Graphics International,
especializada en diseño gráfico.
1992

Fotografía RGA

La actuación del
colectivo Obra-Abre
en proceso

Cartel de
Neville Brody
para la película
de Bigas Luna

[TOP LEFT] British designer Neville Brody included the Osborne bull in the poster for the movie *Jamón Jamón*.

[BOTTOM LEFT] The *New York Times Magazine* even featured the Osborne bull on its cover.

Decir que el Toro nos pertenece un poco a todos, que España entera es su accionista, puede ser una figura poética, que algunos interpretan literalmente.

Toro Abierto fue el resultado de un trabajo, consistente en pintar de rosa uno de los ejemplares, sustituyendo la palabra OSBORNE por ABIERTA. Sucedía un 26 de mayo en el kilómetro 54 de la nacional Madrid-Valencia, a cargo de un grupo llamado OBRA-ABRE. "El Toro, publicaba la revista Foto Profesional, "es uno de los emblemas nacionales por excelencia; una figura que ha dominado no sólo el paisaje de las carreteras, sino también nuestro paisaje íntimo desde la infancia, por eso creemos tener derecho a la acción-réplica sobre un icono científicamente dirigido a reclamar nuestro interés o, cuando menos, nuestro sexo. El toro pintado de rosa en su resultado final goza de una gran belleza, por eso OBRA-ABRE aboga por la máxima divulgación de este acontecimiento y asume la polémica que se pueda crear como una parte más del trabajo que dará nuevos sentidos al mismo".

Un sábado, a las siete horas de una fría madrugada, los tres artistas y tres amigas más, se dispusieron a travestir al animal. Extravagancia habitual en los trabajos plásticos de este colectivo, autor de la colocación de un

televisor, en un nicho del cementerio de San Fernando de Henares, o la crucifixión de Jesús en una columna de monitores de vídeo.

Elogiaron al Toro, "fachada, muralla negra que revienta contra el cielo. Maravilloso mito seductor". Midieron su altura, subidos a lo alto de una de las torres, y lanzando una cuerda desde allí. 13 metros de alto, 11,5 de ancho, 100 metros cuadrados de superficie. Demasiado cuerpo para poderlo dominar con una simple escalera. Contra el viento y la lluvia espesa, al final, en cuatro horas, seis pares de manos y una grúa verde, pintaron de rosa al Toro negro.

Igual que una vara de picador; pero sin daño, al menos físico. La solicitud de algún permiso fue intencionadamente olvidada. Allí se quedó el Toro, esperando una limpieza, sin encabritarse, pero sabiendo que los colores que más le favorecen son el negro de su piel de acero, al azul del cielo, algún terracota anaranjado y crepuscular, el verde de la pradera o campo repleto de reventones mirabeles.

No es
una valla
cualquiera

The New York Times Magazine

El Toro de El Cuadrejón, colocado en la Autopista Sevilla-Cádiz, en las cercanías del Aeropuerto de Jerez, sirve para que los pilotos no aterricen como puedan, sino al verle aparecer. Los aviadores le han compuesto hasta una cantinela, "El Toro de OSBORNE, ponte a 400 pies y tíratе a tierra, aunque haya niebla", apostillan naturalmente en broma. Es el mismo tono de chanza, que le dedicaron a la casa una fotografía, solicitando que pintaran de rojo la cara posterior del animal, para señalizar mejor el momento de entrar en pista.

Pero retroexclamen, ¿Cuál era entonces la competencia?, ¿quién le plantaba cara al Toro? OSBORNE no desprecia el impacto de algunos otros anuncios, como el conductor blanco y tullido de Michelin, las vallas de Anís del Mono, o dos brillantes ideas de Donnecy: un maletilla a los pies de una valla saltada por un toro; y un león furioso, rompiendo con sus fauces la botella de Fundador.

A lo largo de su historia, al Toro le han salido muchos novios, mecenas, ofertas de trabajo, museos lo bastante irritados como para retirarle de su sitio, la intemperie. Con el garbo de una *top model*, ha posado ante las cámaras y rodado portadas a las más elegantes

rnuniques en revistas de prestigio, dentro y fuera de España, como ocurría en 1972 con el New York Times Magazine. La marca Volkswagen lo utilizó como portada de un almanaque en 1985 y lo volvía a reproducir en su interior. Doce meses, los doce mejores símbolos de cada país. Los tulipanes de Holanda. De Italia, la Torre de Pisa, y el Toro de Altipartín; a diez kilómetros de Zaragoza, quedaba como símbolo español. El siete de mayo de 1987, 100 fotógrafos españoles y extranjeros, pasan un día entero retratando escenas de nuestro país. Anthony Luke, redactor del proyecto, se dirige en estos términos a Don José Antonio Osborne Vázquez.

"Una de las 130.000 fotografías realizadas en ese nuevo día es previamente una fotografía de vuestro anuncio del Toro. Si está usted de acuerdo en su publicación, me gustaría complementar la fotografía con un pie informativo explicando un poco lo que significan, sus orígenes, el impacto, etc."

El Toro figuraba para siempre en un magnífico volumen, titulado "Un día en la vida de España", editado por el grupo Planeta y Collins Publishers. Sexta entrega de la serie. "Un día en la vida de...", enriquecido en esta ocasión por una magnífica foto de los Reyes de España y sus dos hijas, realizada por Rick Smolan.

El Toro ha sido carta de presentación para escritores, cuyos libros lo hacen en portada. "España eterna. El Paisaje Rural Español", de Alastair Reid. "El Kitsch Español", de Antonio Sánchez Casado. "Monsignor Quixote", de Graham Greene. "Horas de España", de Leonardo Sciascia, y un considerable etcétera.

El Toro pintado

Algunos artistas lo utilizan conscientemente y sin permiso. Es el caso del americano Keith Haring, que decora un torito de tres metros de altura, fabricado en los talleres Tejada de El Puerto de Santa María, para la exposición "La Imagen del Animal. Arte prehistórico y Arte contemporáneo", diciembre 1983, enero 1984, patrocinado por la caja de Ahorros y Monte de Piedad de Madrid, en la Casa del Abeto. Plaza de San Martín número 1 de Madrid. El Toro pintado por Haring se expuso en la galería Toni Shafrazi de Nueva York, alcanzando un precio de 10 millones de pesetas.

Otros son artistas espontáneos, que le toman como lienzo, decorándole sin orden ni estética, sin ton ni son, saltándose las normas previsamente a la torera. Cuando la gente se pone a hacer el indio, el resultado sólo se puede llamar Toro pintado.

CALIDAD

included it in the poster for the movie *Jamón Jamón*, Ralph Steadman included it in a portfolio about Spain and its wines, and it was on the cover of the *New York Times*, and other major global publications. Photographers such as Richard Avedon, Herb Ritts, Annie Liebovitz, and Helmut Newton have also worked on campaigns about the bull, according to designers at Tau Diseño.

> A Chance to Work with the Bull

Tau Diseño's work for Osborne began in 1994 with a book entitled *Un Toro negro y enorme* (A Bull, Black and Enormous). The title was taken from a poem by the Spanish poet José Bergamin, who dedicated his poem to the Osborne bull.

"All Spanish graphic designers, as well as those designers from outside Spain who know it, have or have had the temptation to work with the bull and pay it homage in some way," says Garcia. "It was a privilege for Tau Diseño to do this book and be given the opportunity to do something with the mythical bull, as well as a privilege to take on the whole concept in and of itself. España Abierta and Osborne did not hire us to design a book, but rather to conceive a book homage to the bull of Manolo Prieto, give it content, choose the contributors, and think it through in its entirety."

"Being able to define the contents gave rise to a work process in which we simultaneously thought about the section or the subject, how to graphically resolve it, and how to treat those aspects in its publishing," Garcia explains.

[BELOW] **The Osborne bull has become a celebrity in its own right, so much so that it was written up in numerous newspaper and magazine articles and was the subject of many works by noteworthy illustrators.**

un toro negro y enorme

El Toro Osborne: marca, símbolo, tótem, imagen universal.

[LEFT] Tau Diseño didn't create the Osborne bull, but they got the chance to pay homage to the bull and its creator, Manolo Prieto Benítez, when, in 1994, they designed a book tracking its history: *Un Toro negro y enorme* (A Bull, Black and Enormous).

[ABOVE] Tau Diseño also designed this book for Osborne, which traces the history of the bodegas from 1772 until the end of the 20th century.

Designers specified three different paper stocks for the book—one for the flyleaves, a textured paper for what they refer to as more textural sections, and a stucco-type paper for the reproduction of photographs and designs. "In short, the book was thought out like a mosaic, and this approach is reflected in the materials on which the images and texts were printed," explains Garcia.

> Homage to the Bull

"The book is an homage to the highway billboard from the Spanish cultural world. The most important writers, journalists, publicists, painters, photographers, cartoonists, and graphic designers in Spain all participated in it," says Garcia.

To date, the book on the Osborne bull has received almost as much acclaim as the bull itself. It has been awarded various Spanish and international awards, such as the TCD's Certificate of Excellence, the Donside 1994 special award in Great Britain, and the gold Laus (the most important Spanish graphic design award) in the category of Editorial Design.

∧

Krispy Kreme > Fresh Doughnuts Served
with Nostalgic Flavor

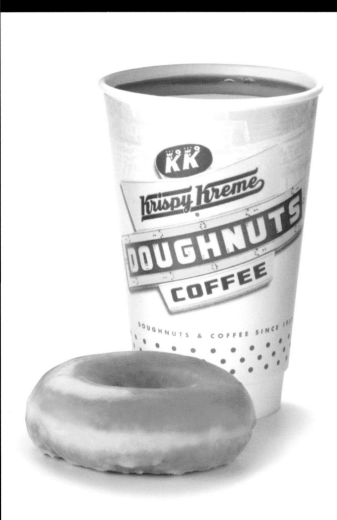

Agency > Krispy Kreme

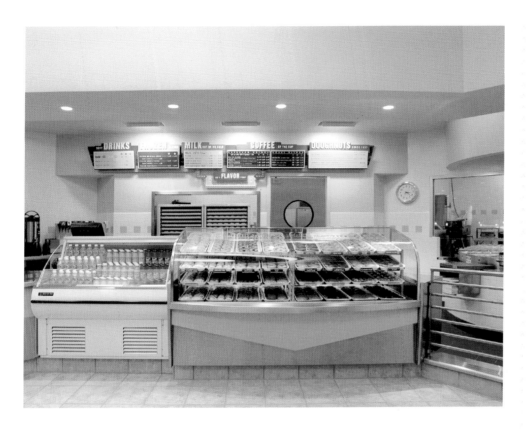

Courtesy of Krispy Kreme

[OPPOSITE; LEFT]
Although the design has been modernized, the cup's exterior has consisted of the bow tie Krispy Kreme logo since its founding. Several decades ago, the company added *doughnuts* to the logo as part of its expansion for better consumer awareness.

[OPPOSITE; RIGHT]
Krispy Kreme has launched an aggressive expansion of its retail outlets throughout the United States. Much of the brand awareness the company tries to create is through the design of its stores. Despite a modernization of the display, customers still get a peek at the actual production of the doughnuts.

[LEFT] The updated store design offers consumers an unencumbered view of the Krispy Kreme products, as well as the opportunity to watch employees make the doughnuts.

> Stepping Out from the Warehouse

For more than six decades, Krispy Kreme Doughnuts had established itself as one of the South's leading doughnut wholesalers. But that all changed in April 2000, when the Winston-Salem, North Carolina–based company launched an initial public offering to finance the expansion of its retail operations nationwide.

Until then, the retail availability of Krispy Kreme products was largely confined to small cities through the South. This new direction would require the 64-year-old doughnut company to compete against rival Dunkin' Donuts and embark on a national brand-awareness campaign to win the needed market share.

Management took on the project like it had done with many others in the past, trusting its in-house marketing division to create a brand identity that would touch a chord among new customers and deliver a message that didn't stray too far from its heritage.

"We do most of our marketing internally," says Stan Parker, senior vice president of marketing. "We think we have developed a good understanding of the brand that outside firms don't always have."

Krispy Kreme executives settled on a marketing campaign focused solely around the baking of the doughnuts. The company learned from its current stores that consumers remained loyal to the brand because of the freshness of the doughnuts.

[RIGHT] As a wholesaler several decades ago, Krispy Kreme had small retail outlets connected to its warehouses. The trademark feature of the store was an illuminated red "Hot Now" sign that when lit up let consumers know that fresh doughnuts had just emerged from the oven.

[BELOW] The Krispy Kreme doughnut box is a distinctive package that is meant to catch not only the eyes of consumers in supermarkets but also those of passersby at street festivals where the product is sold by churches, schools, and other community groups for fund-raising.

> Designing a Store Identity

"It all starts with the product," says Parker. "The store serves as a multisensory experience for the consumers. There is the emotion conjured up when they smell fresh doughnuts being made. But then the loyalty to the product grows because they can actually see the process as well."

The design of the stores served as the centerpiece to Krispy Kreme's efforts to establish brand identity in new markets. The stores reflect an updated version of a concept developed in the late 1920s, when the company used to have small retail outlets connected to its factories.

Because many of its stores are stand-alone units, Krispy Kreme management determined that the signage would need to provide a strong draw for consumers. Each store would have a sign in the shape of a bow tie emblazoned with the Krispy Kreme Doughnuts name, topped off with a circular shape with the word *Hot* in the middle. The company added the word *doughnuts* in the late 1980s, as the company expanded nationwide and into Canada.

The "Hot" sign harks back to a time when store owners would light up the sign to make consumers aware that a new batch of glazed doughnuts had just been removed from the oven. Today, "Hot" signs

[LEFT] The interior seating area has been modernized, but still reflects the style of the 1950s, with a bar with stools. In each store hangs a mural depicting Krispy Kreme logos of the past.

are illuminated once in the morning and once in the evening at the 205 stores in 32 states to let con-sumers know that fresh doughnuts are available.

The interior design of the stores features a retro style to conjure up the feeling of being inside the original stores, which were connected to the factories. The color scheme is a combination of red, green, and white. The seating area has been expanded to include a countertop with bar stools. The walls are filled with photographic reproductions highlighting the company's history.

[RIGHT] **Krispy Kreme** used to deliver its products in a 1938 Chevrolet truck. Now the company uses the truck at grand openings and sells replicas as part of its collectible items.

> Memorabilia for the Road

"The story of Krispy Kreme spreads so much by word of mouth," Parker says. "Someone will go to a shop and have a good experience and then relay it to friends. It's amazing how when we open new stores in some parts of the country, lines start forming the night before with people who are just so excited about our arrival. It [the word of mouth] creates incredible awareness."

Customers can also purchase sweatshirts, caps, and mugs in the stores, which further helps to spread Krispy Kreme's identity. For instance, the black baseball cap features the "Hot Now" sign in red

embroidery, and collectors can pick up a replica of the 1938 Krispy Kreme delivery truck painted in red, green, and white.

The expansion of stores has also provided a marketing boost for a sizable chunk of Krispy Kreme fund-raising efforts. Thousands of schools, churches, and community organizations purchase Krispy Kreme doughnuts annually to sell and raise money. Each store can provide consumers with a packet outlining the details of their fund-raising program.

The biggest challenge for Krispy Kreme is making sure its franchisees use the brand's identity in a consistent manner in their stores, as well as in their promotions. The company put together a graphic standards manual detailing how and where the logo should be placed in advertising and on other marketing materials.

"We're very mindful of wanting to be a local doughnut store," notes Parker. "A lot of people associate Krispy Kreme with good times and warm memories. It's important that the message is conveyed in the locations in which we choose to put stores and in fund-raising efforts we get behind. We talk a lot about what Krispy Kreme is and isn't."

[BELOW] Krispy Kreme relies on word of mouth in an effort to increase its doughnut sales. It has found one of the best methods is through the sale of its collectible items, including sweatshirts, caps, travel mugs, and boxer shorts.

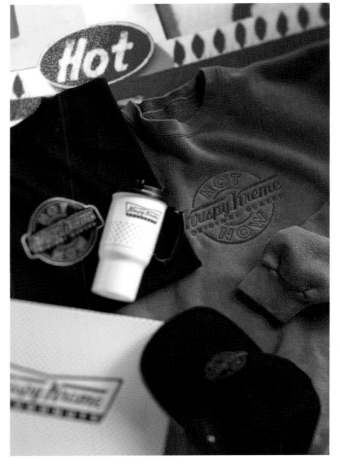

∧

| britart.com | > Stuffy Galleries Beware

Pavement 1962

concrete slabs, cement, shoe prints,
dog excrement, chewing gum.
8000 x 15050 x 10cm

*Regimented mosaic.
Companion piece to road by the same artist.*

art you can buy **britart.com**

Wall 1946

mixed media installation: bricks,
tiling, wood, insulation, nails.
2256 x 425cm

Bridge 1977

bricks, steel, railway line.
60545 x 1025cm

Bridge 1977

bricks, steel, railway line.
60545 x 1025cm

Lamp Post

steel pole (hollow), glass,
dog urine.
200 x 10 x 10cm

By adorning everyday
objects with two-color
stickers that described
them as if they were high-
brow art, the initial cam-
paign, which lasted several
months, succeeded in build-
ing britart.com's reputation
and establishing its colorful
and accessible personality.

Design Firm > Mother
Client > britart.com

> Challenging Tradition

When you think of European art galleries, the traditional impression is of a conservative, white-walled show-place, just one notch down from a museum, that appeals to properly attired, serious art aficionados—intimidating the rest of us. Seeing an opportunity to sell art to consumers who might simply like a painting because it matches their decor, britart.com was born. britart.com is an art gallery selling original art—painted works, prints, photography, sculpture, installation, and so forth, from emerging artists based in the United Kingdom—to consumers and businesses, both online and offline.

When britart.com came on the scene, it was totally different from the traditional galleries consumers were accustomed to, and by its very difference it challenged such galleries as White Cube, Rhodes + Mann, Davies and Tooth, Vertigo, and Danielle Arnaud Contemporary Art.

"There are hundreds of art galleries in the U.K.," says Victoria Powell, business development executive at britart.com. "We are different from every one in the 'down to earth' approach and the sales methods—online, business-to-business, gallery—that we take. None of the galleries are market leaders or have brands as such; we are the first truly branded art gallery."

"britart.com, and this campaign in general, is focused on the traditional art market. In this market, the gallery system has been the primary sales channel. In addition to the limited hours of operation and the

[BELOW] Posters like this one, street fly posters, were britart.com's primary advertising vehicle, in addition to some newspaper and magazine advertisements. They were placed on ordinary, everyday objects all around London.

geographical challenges, the gallery channel is perceived as being intimidating. It is often difficult for the novice art buyer to feel comfortable in a gallery surrounding and with gallery curators and sales staff who are often extremely arrogant and condescending," says Powell.

> Poking Fun at the Absurd

Taking the opposite tack, britart.com's goal is to make art buying easy. britart.com sells on the Internet and in its own gallery, but wherever it makes a sale, it does so with its quirky, humorous, offbeat personality

Courtesy of britart.com

[RIGHT] britart.com's Preview Specs is a kit that helps consumers choose the right art for their home and office. There is no art history test here. Simply don the paper glasses, choose a piece of preview art from the sheet provided, attach it to the glasses' stem, wear the glasses in the your living room or office, and you be the judge. How does it look?

[BELOW] Two-color stickers would be placed on ordinary objects, providing the date of origin and dimensions, along with a highbrow, tongue-in-cheek narrative such as: *Chair—mixed media: wood, aluminum, comfy cushion. Upholstered by artist, 1 of 6.*

that is fresh and—for consumers—accessible. When it began, it faced an overwhelmingly tough challenge—how to differentiate itself with minimal funds.

The initial campaign, which lasted several months, succeeded in building britart.com's reputation and establishing its personality, yet it cost very little. It consisted primarily of adorning everyday objects with two-color stickers that described them as if they were high-brow art. The idea and design is something that britart.com still uses in everything from advertisements to gallery invitations. "We feel that the

campaign is generalizable enough to be used in a variety of situations through time and that it is effective at conveying the company's strategic direction and corporate personality," says Powell.

"This campaign is particularly effective because it reminds people of the absurdity of some of the pedantic and condescending conversation that often fills the art world. To begin with, the labeling and graphics are reminiscent of what one expects to see on a piece of art. The juxtaposition of that established form with words that convey a sense of humor lets the consumer see that britart.com believes that even quality art need not be taken too seriously.

> Keep It Simple

The placement of stickers on everyday objects across London reached thousands of consumers and, above all, was memorable and made britart.com instantly recognizable. In fact, according to Powell, the brand was one of the 20 most recognizable, even though the company's expense to run the campaign would not have ranked in the top several hundred. "Beyond that, the style of the campaign created a

[ABOVE] A pack of "artalizers" shows how you can turn your office into an art gallery with one-color labels that describe common office supplies in a new light.

[LEFT AND BELOW] britart.com's goal is to make art buying easy, so they've created a quirky, humorous, offbeat tone that carries over to their Web site. The casual feel of the design is welcoming and easy without pretension.

strong affinity with the brand that went beyond simple recognition," adds Powell. "Many people who had been uncertain or intimidated by the thought of buying art felt that britart.com was speaking to them. The strength of this campaign is in its simplicity. Visually simple and reminiscent of art signage in general, the campaign is easily recognizable. Furthermore, the style lends itself to a wide range of uses, and this allows constant reinforcement of the brand identity."

> The Art of Selling

In short order, britart.com had positioned itself as a force to be reckoned with, having become a recognizable and established name in a market where branding was previously nonexistent. The company went from very few hits on its Web site before to the campaign to more than 500,000 hits per month after the

[THIS PAGE] The generous and consistent white space and linear layout gives users the feeling of viewing art on a gallery wall while providing an easy-to-use format.

campaign launch. Two years later, the Web site is recording one million hits per month. The campaign also won the gold award at the AD&D awards, and brand recognition created by the campaign has led to a continuing stream of public relations placements.

"The market has been interesting and strong. When britart.com began in 1999, the art establishment—represented by many galleries and their curators—believed that it would be impossible to sell art online and that britart.com would quickly fail," admits Powell "[Now], many of these galleries have approached britart.com, seeking partnerships of various sorts, whereas others have attempted to develop Web sites of their own."

[ABOVE] This art voucher allows recipients to transform the "combination of paper and text into original art" when they visit www.britart.com to browse and buy paintings, prints, photographs, and sculptures.

[LEFT] Educating users about what's going on in the art world helps both to create a sense of community and to make them feel more confident when purchasing works.

Home | Browse art | Search | Exhibitions | **Magazine** | My Britart | Mailing list

britart.com

artwords, July 2001

what's on

Eidetic
Britart Gallery, 60-62 Commercial St, London E1. Until 10/02/02.

A selection of work by artists from the Britart.com website. To browse online click here.

Video Show
Anthony Wilkinson Gallery, 242 Cambridge Heath Rd, London E2, 10/01/02 - 10/02/02.
David Claerbout, Christian Janjowski and Kenny MaCloed.

Inventory
The Approach, 1st Floor, 47 Approach Rd, E2, 31/01/02 - 03/03/02.
Requiem for the Empty chamber.

Borders - Koen van den Broek
White Cube, 44 Duke Street, St James's, London SW11, until 12/01/02.

Large scale pantings by the Belgian artist, that employ flat, unmodulated areas of colour which veer between figuration and abstraction.

Reflections: 100 years of Sydication International
Focus Gallery, 43 Museum St, London WC1A , until 16/02/02.
Historical pictures from the archives of Syndication International dating

ART2002 - The London Art Fair
Business Design Centre, Islington, London N1, 16/01/02 - 20/01/02.
Over 100 selected galleries from the UK, including Britart.com!.

Margarita Gluzberg
Platform, 3 Wilkes St, London E1, until 06/01/02.
Drawings.

Roman Signer
Camden Arts Centre, Arkwright Rd, London NW3, until 03/03/02.
New 'sculptural events' & video.

Richard Artschwager
Serpentine gallery, Kensington Gdns, London W2, until 10/02/02.

The first in-depth exhibition in a public gallery in Britain of the work of one of the key artistic figures of post-war American art.

By Hand
Hales Gallery, 70 Deptford High St, London SE8, 12/01/02 - 01/03/02.
Group show that takes drawing to its limits.

Sam Taylor Wood - Mute
White Cube 2, 48 Hoxton Square, London N1 , until 12/01/02.

Silent films, a series of new single-subject photographs and new sculptural works by the British artist.

Audrey - photographs by Bob Willoughby
Proud Camden Moss, 10 Greenland St, London NW1. Until 31/03/02.

One of the greatest icons of the silver screen as photographed over many years by one of Hollywood's most famous photographers.

Goya: The Family of the Infante Don Luis
The National Gallery, Trafalgar Square, London WC2N, until 3/03/02.

Paul Klee
Hayward Gallery, Belvedere Rd, London SE1, 17/01/02 - 01/04/02.
The Nature of Creation.

Mirror Mirror: Self Portraits by Women Artists
National Portrait Gallery, St. Martin's Place, London WC2, until 10/02/02.
Work spanning four centuries, includes Barbara Hepworth.

Robert Maplethorpe
Asprey Jacques, 4 Clifford St, London W1, until 21/12/01.
'Robert, Patti and Sam'. Rare photographs.

A Pause for Breath
Frith Street, 59-60 Frith St, London W1, until 11/01/02.
A collection of work by artists that include Cornelia Parker and Giuseppe Penone.

Elina Brotherus
The Wapping Project, Wapping Pump House, Wapping Wall, London E1, until 13/01/02.
Video work and installation by the young Finnish artist.

Minna Haukka
The Showroom, 44 Bonner Road, London E2 , until 20/ 01/02.
Drawings, collages and poems by inmates of Belfast prisons.

Turner Prize 2001
Tate Britain, Millbank, London SW1, until 20/01/02.
Work by the shortlisted artists Martin Creed, Mike Nelson, Isaac Julien and Richard Billingham.

Re: Mote
Photographers' Gallery, 5 & 8 Great Newport St, London WC2, until 19/01/02.
Artists explore the relationship between nature and technology.

High Society?
Proud Central, 5 Buckingham Street, London WC2N, until 27/01/02.

Exhibition of photography by Dafydd Jones.

Keith Tyson
South London Gallery, 65 Peckham Rd, London SE5, until 17/03/02.

New sculptural works using unexpected materials.

Britart for your mobile
Britart and Vodafone have teamed up to bring 8 specially comissioned artworks that can be downloaded directly onto your mobile. For more details, click here.

If you have a show, event or other art-related activity that you'd like to suggest for inclusion in the 'What's On' section, please let us know by e-mail: artwords@britart.com

regional shows

∧

Christie's > Going, Going, Gone

Christie's signature red is boldly displayed on banners alongside oversized graphics that promote super sales in windows running almost 100 feet (30.5 meters) in length.

Christie's is the world's oldest and most distinguished fine arts auctioneer with a rich history that spans 250 years, many of which it battled for the number-one market position against its rival, Sotheby's. In 1998, the auction house relocated its headquarters to its new home in New York's Rockefeller Center, a move so important that it called for a new worldwide corporate identity and architectural graphics program. Christie's tapped Carbone Smolan Agency (CSA) for the job. The objectives were clear: develop a brand platform that would differentiate Christie's from its rival, commemorate its move to Rockefeller Center, and give

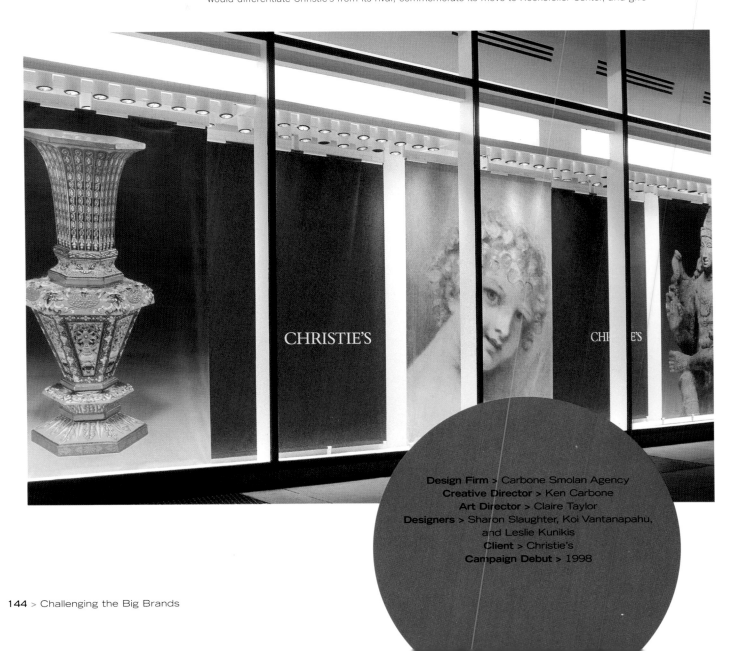

Design Firm > Carbone Smolan Agency
Creative Director > Ken Carbone
Art Director > Claire Taylor
Designers > Sharon Slaughter, Koi Vantanapahu, and Leslie Kunikis
Client > Christie's
Campaign Debut > 1998

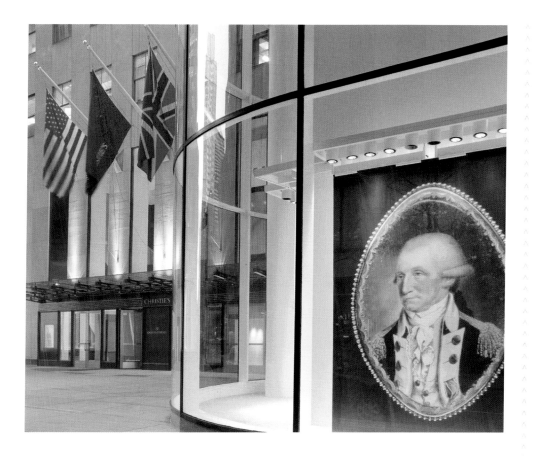

[LEFT] A portrait of James Christie, the founder of the famed auction house, had been used as an emblem decades ago. It was resurrected for the new identity, to be used in conjunction with other graphics and as a stand-alone element.

[BELOW] Christie's signature color, a vibrant red formulated from proprietary Pantone ink, is complemented by a neutral palette of ecru, black, and silver, which provides a sophisticated backdrop for a wide array of components from stationery to packaging.

Courtesy of Christie's

Christie's a contemporary image that would resonate with new generations of buyers and sellers and an expanding international audience. Finally, the new image, whatever that might be, had to respect the heritage of the brand while injecting a spirit of innovation.

> Blending the Old with the New

Carbone Smolan Agency tackled the job by putting Christie's through Brandscaping, CSA's proprietary strategic process. "The exercise established the necessary organizational consensus and support among senior management in New York and London to successfully define a compelling framework of visual cues and verbal attributes for Christie's future brand image," says Ken Carbone, creative director. "The outcome of several sessions told CSA that Christie's envisioned a more accessible, modern brand that respected its history. CSA approached this new positioning from the inside out. Rather than impose a new aesthetic, our strategy was to identify and evolve core elements of the existing brand in a fresh, bold manner that would propel the brand from the 18th to the 21st century."

As a salute to Christie's heritage, CSA chose to make a portrait of James Christie, the company's founder, an integral component of the brand. Christie's portrait had been used decades ago in a company emblem; resurrecting it required updating the image to meet the demands of today's media. Designers also repositioned Christie so that he faces right, a discrete adjustment that designers say orients him toward the

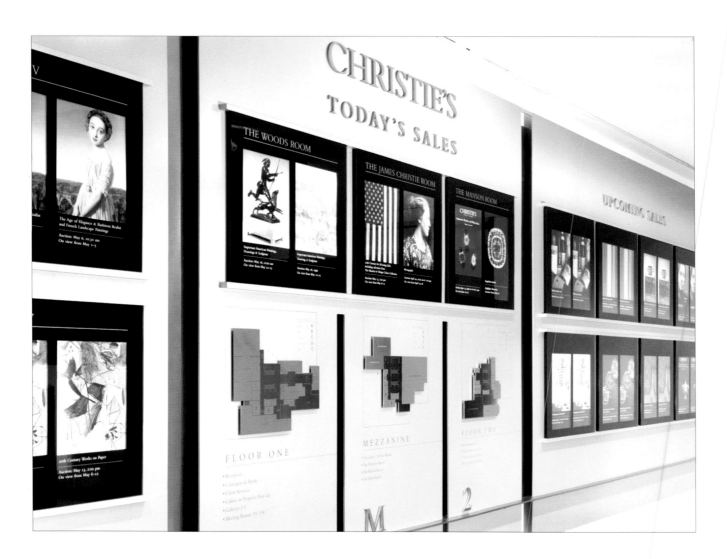

future. However, perhaps the most distinguished aspect of the identity program is Christie's signature color, developed by CSA—a vibrant red formulated from proprietary Pantone ink. "The color appears in several gradations throughout the program—as a bold splash or as a whisper of understatement," Carbone says. Accenting the primary color scheme is a neutral palette of ecru, black, and silver, which provides a sophisticated backdrop for a wide array of components, from stationery to packaging.

Next up, CSA developed an integrated architectural graphics program that complemented the interiors of Christie's new home at Rockefeller Center. Designers used stainless steel and rich, earthy neutrals—a palette inspired by the architectural finishes in the building. Outside, CSA designed an intricate display system for show windows running almost 100 feet (30.5 meters) in length.

> Taking the Message to the Street

"The framework supports supersized graphic banners, which promote blockbuster sales with enormous imagery and text. The prominence and scale of these displays instantaneously established Christie's new headquarters as a cornerstone of the Rockefeller Center complex," says Carbone. "Christie's Rockefeller Center location demanded a strong street presence, in contrast to the subtle palette and quiet authority of the interior way-finding system." The architectural graphics program was later expanded to give facelifts to the Christie's showrooms in Paris and Berlin.

[LEFT AND OPPOSITE] Designers used stainless steel and rich, earthy neutrals—a palette inspired by the architectural finishes accenting the interiors of the Rockefeller Center space, which was designed by Gensler Architects. The architectural graphics and way-finding system are simple and elegant.

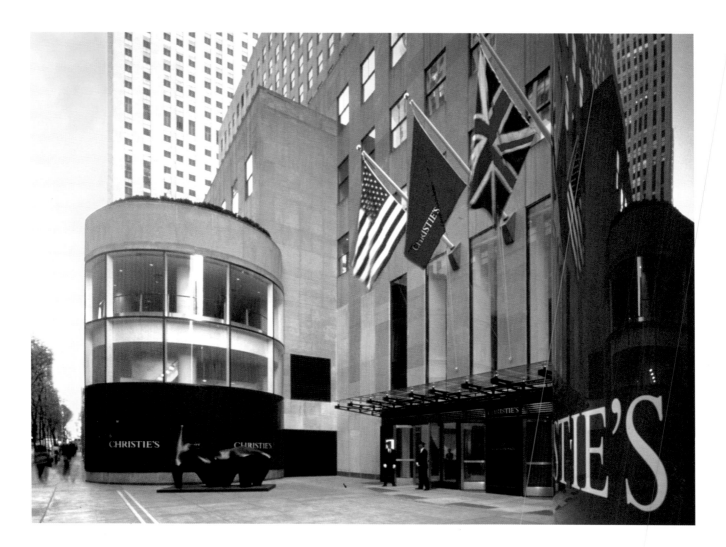

[ABOVE] **The main entrance to Christie's home at New York's Rockefeller Center was treated to a magnificent display of Christie's unmistakable bold, red signage.**

One of the last elements created by CSA was a detailed standards manual that helps Christie's maintain the identity system. Anticipating future needs, designers deliberately created stand-alone versions of the wordmark and James Christie's portrait so that these components could be easily adapted to new applications without limiting creativity, yet provided the guideposts needed to maintain the integrity of the core system. The manual is a bible to designers who have produced hundreds of elements to date using the components in all of Christie's 117 offices and showrooms worldwide.

> And the Winning Bidder Is?

"Christie's continues to break records and make headlines, eclipsing its rival Sotheby's," says Carbone. "The combination of a rejuvenated brand, world-class location, and a high level of consistency in its visual and verbal image have strengthened its brand equity."

CHRISTI

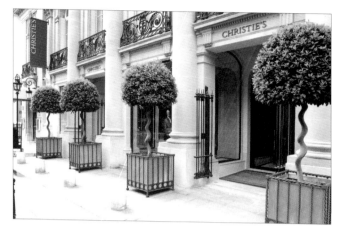

[TOP LEFT] The exterior of Christie's Paris location also received new graphics, including red Christie's banners featuring the portrait of James Christie.

[MIDDLE AND BOTTOM LEFT] Interiors of Christie's Paris showroom feature way-finding signage similar to that in the New York headquarters, which is characterized by its simplicity and elegance.

∧

| Big Yellow | > Self-Storage Gains an Identity in the United Kingdom

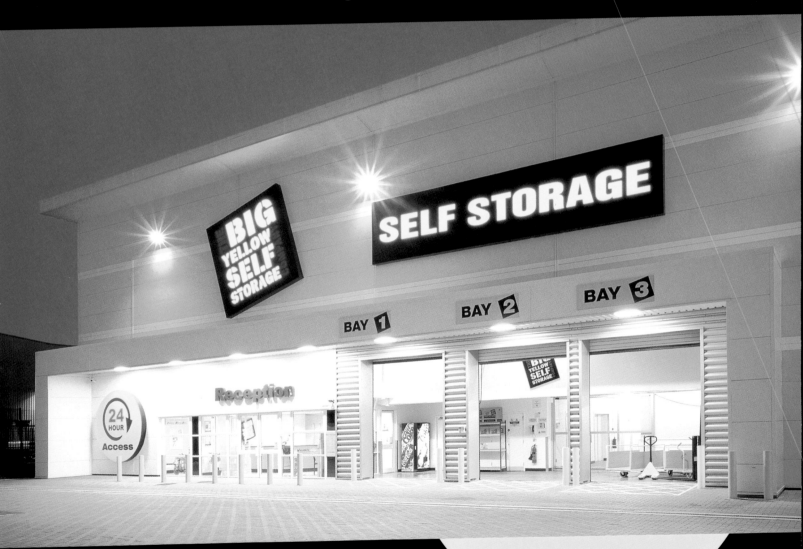

[ABOVE AND OPPOSITE TOP LEFT] **The design of the Big Yellow warehouses, with illuminated signs that can be seen from the road-side, allows the company to use the exterior as a marketing tool.**

Agency > Tableau Group, Ltd.
Creative Director > Lawrence Salisbury

> Bringing Consistency to the U.K. Storage Industry

In the United States, self-storage warehouses dot suburban and urban landscapes, but in the United Kingdom, it's a different story. Before Big Yellow opened its doors in 1998, the industry comprised a cornucopia of independently owned companies with no recognized market leader.

With its brightly designed warehouses along main thoroughfares, Big Yellow is trying to change the way self-storage is perceived in the United Kingdom. In many respects, the buildings themselves have served as the company's premier marketing mechanism as the company has grown into one of the leading self-storage companies over the past four years.

"Awareness levels of self-storage were and, although improving, remain low with consumers having little understanding of self-storage as a service, especially outside of London," says Stephen Homer, Big Yellow's marketing director.

The United States has 30,000 self-storage facilities, compared to about 250 in the United Kingdom. But Londoners are beginning to catch on to the concept. Nearly three-quarters of Big Yellow's customers are domestic, meaning that they need more space to store possessions because they are moving, getting divorced, or having a new baby. The company also provides student lockers for the school breaks at various times of the year.

In London, self-storage is becoming increasingly popular with apartment owners who need space for skis and bikes, as well as beds, tables, and chairs. Many homeowners also are converting what were traditional storage areas, like the attic, into extra bedrooms and office space, making it necessary to store items not in use.

[ABOVE RIGHT] After extensive research of the self-storage market in the United States, Big Yellow replicated many American features in its stores as a way to distinguish itself from a hodgepodge of independent companies in the United Kingdom.

Courtesy of Big Yellow

[RIGHT] Most of Big Yellow's current customers learn about the store through its building signs, which include a company telephone number and Web address.

[BELOW] Big Yellow's research indicated that consumers wanted clean, secure, and well-lit facilities in which to store their valuables, and the company prominently displays this in all its advertising.

"The market was fragmented with no recognized brand or market leader," Homer adds. He describes an industry in which companies converted buildings in industrials parks rather than constructing new facilities built with the technology and security to house personal property. Even worse, customer service was entirely nonexistent.

Big Yellow executives sensed the opportunity to make a challenge and even possibly become the market leader. "By bringing the principles of retailing into the market—strong branding, excellent customer service, visible and accessible locations, and clean, attractive store environments—Big Yellow has quickly differentiated itself, says Homer."

> Location, Location, Location

One clear advantage for the Big Yellow management team is its access to prime real estate on which it could build self-storage warehouses. Several of the executives have extensive development experience, including retail projects. Today, Big Yellow operates 19 stores that serve some 7,000 customers. The company has nine other properties under development and expects to develop 50 stores in the southern part of the country within the next two years.

By constructing Big Yellow warehouses in highly visible and accessible locations, the company is able to use the buildings themselves as an advertisement. The Big Yellow Self-Storage Company sign allows for consumers to see it from various points along the roadside. The signs, a black background with yellow and red letters, sit slightly askew on the buildings. In addition, there are signs with the warehouse's phone number and the company's Web address so consumers have several ways to get further information about rental space.

Homer says the signs and banners hanging on the warehouses generate nearly 40 percent of customers. "They're all at major intersections, so a lot of people get to see them," he says. "We paint all the buildings bright yellow, so everywhere you go you see large yellow boxes."

But the company also needed to do some advertising. With the opening of new warehouses, Big Yellow management realized its marketing plan would have to serve the dual role of educating consumers about self-storage and convincing them to give it a try with their company.

[LEFT AND ABOVE] **Big Yellow often advertises its services to college students. The company offers them lockers as a safe and secure way to protect their valuables when away for breaks.**

The company launched a series of radio commercials with television personality Lloyd Grossman, whose oversized voice and personality is reminiscent of the celebrity interviewer Robin Leach. The commercials use humor to subtly convey to listeners that Big Yellow storage can be used for a variety of reasons.

For instance, one ad is dedicated to bubble wrap. Grossman intones, "But when you actually need it… when you're moving house, for example, can you find it? No. You've popped it all. At the Big Yellow Storage Company, they understand. Which is why they don't just have the space you need for moving, they also have the stuff you need." Another spot highlighted the ease with which consumers can rent self-storage space.

Grossman says, "When did you last have a long chat about the joys of self-storage? Frankly, I hope you never have. And so do the people at the Big Yellow Storage Company, whose aim is to make self-storage so simple, you never have to think about it."

The use of a celebrity, Homer says, "gave us instant credibility in a new segment in the United Kindom. It helped convey what self-storage was with a little humor to get the message across without sounding boring."

Newspaper advertising serves a similar purpose in educating the consumer. Homer says the ads try to convey what the consumer is going to get when they rent from Big Yellow—safety, security, and accessibility 24 hours a day, seven days a week. "The expectation is totally different than the reality," Homer says. "People are expecting something like a lockbox or garage. Our offer is very different from that. What we're trying to show is our efforts."

[ABOVE] **Big Yellow** uses its large signs, which are large enough to be seen from the roadway, as another form of advertising.

[RIGHT] **Big Yellow** touts the security, accessibility, and reasonable fees in its advertisements because these qualities differentiate them from competitors.

> Marketing Alliances with a Purpose

Over time, Big Yellow has developed a marketing strategy that relies heavily on targeted advertising within 3 to 5 miles (5 to 8 km) of its stores. Homer says the company's approach has been refined over the years after extensive consumer feedback.

"People use self-storage as part of their house," Homer said in a recent newspaper article. "At our Croydon store, a man comes to play his guitar every day. We have people who keep bikes in our stores and use them daily. It's a lot cheaper than moving."

That's why Big Yellow's marketing alliances with moving companies are integral to its success. The management at each location distributes brochures and car stickers that these companies then give away to their customers. Big Yellow also developed a "privilege card," or credit card, that moving companies give to customers so they can receive a discount for self-storage. In return, Big Yellow allows the moving companies to advertise on their Web site.

At some of its locations, Big Yellow targets students attending universities to use their facilities to store their belongings while traveling on winter and summer breaks, and the company allows students to rent units as a group. To promote the service, Big Yellow plasters posters all across campus billboards and periodically advertises in the travel section of student magazines.

Now, after Big Yellow has raised more capital for expansion through an initial public offering, the company is seeking to hire an advertising agency to further develop its brand identity. The company realizes that its initial success could be elusive as the self-storage concept gains more acceptance in the country and new competitors enter the market. So far, the company has positioned itself to take advantage of the growing British appetite for self-storage.

[LEFT] Because many Great Britons are unfamiliar with self-storage, Big Yellow has used its advertising to educate consumers about the industry and the circumstances in which the service could benefit them.

[BELOW] Big Yellow attempts to maximize its advertising spending by promoting several facilities in a single placement.

> Priceline.com

> A Futuristic Approach to Travel

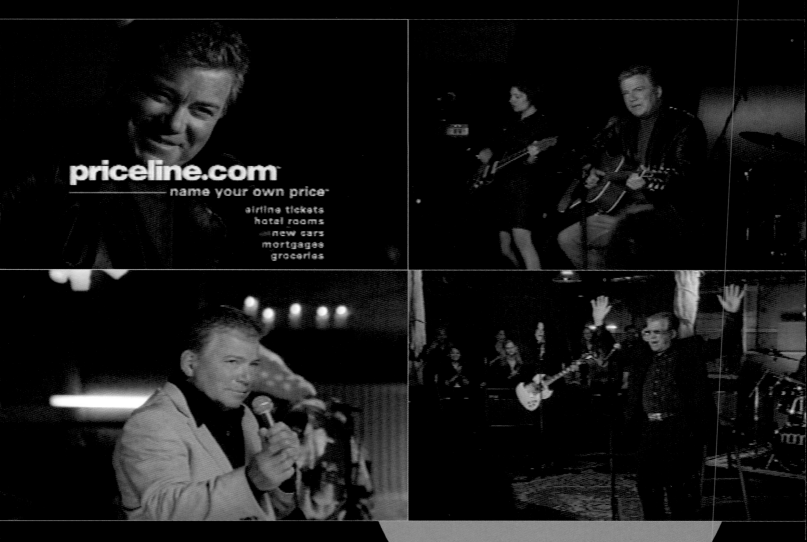

Agency > Hill Holiday
Creative Director > David Wecal
Art Director and Copywriter > Ernest Lupinacci

> A Revolution in E-Commerce

Nothing about selling cheap airline tickets, hotel rooms, and cruises online was a sure bet when Jay Walker founded Priceline.com in 1997. The clear-eyed truth was that the "name your own price" business model remained unproven in the travel industry, as well as in the grocery, long-distance telephone, and mortgage loan industries that Priceline.com would later enter.

But after just 16 months, market research studies showed that more than half of all U.S. adults had heard of Priceline.com, making it the second most recognized e-commerce brand behind Amazon.com. In many respects, the success of the cyberspace venture is easily traceable to a marketing campaign steeped in the use of the old-fashioned television.

William Shatner of *Star Trek* fame burned the name of the online buying service into the consciousness of Americans in a series of quirky television spots in various incarnations as rock star, rapper, and beat poet. The ads have lured consumers to the start-up company's Web site and, in the process, changed the way Americans buy goods and services.

"It was the height of the Internet craze, and there were a few brands that were starting to break out," says David Wecal, president and executive creative director for Hill Holliday in New York, the creator of the spots. "They [Priceline.com] had aspirations to be the top Internet commerce brand. It is very difficult to get people taking about a radio or print campaign. The way to become part of the culture and part of people's lives is to expand to TV. It delivers the quickest and most effective impact."

[OPPOSITE: TOP ROW] Hill Holliday set out to make Priceline.com one of the top e-commerce brands with its television advertising campaign "Age of Aquarius." The advertising agency chose to expand the role of actor William Shatner, who had been a Priceline.com spokesman in radio ads.

[OPPOSITE: BOTTOM LEFT] William Shatner spoofs rap artists in this "Bust a Move" ad in which he challenges consumers to take advantage of the savings Priceline.com offers on airlines, mortgages, hotels, and other services.

[OPPOSITE: BOTTOM RIGHT] William Shatner once again takes on the rock-star persona to tout the low prices consumers can pay for "fly" rental cars and "dope" airfares.

> Script: Age of Aquarius

Open on a soundstage, William Shatner and a small band are in the middle of the set; they are surrounded by a small audience.

[MUSIC] The band is playing "Age of Aquarius."

[SHATNER] When the moon is in the seventh house
 And Jupiter aligns with Mars
 Peace will guide the planets
 And love will steer the stars...

[MUSIC] Music goes to refrain.

[SHATNER] It's a whole new age of consumer power.
 With Priceline.com millions of beautiful people have named their own
 price and saved a load of bread on the things they want and need.
 Can you dig it?

[MUSIC] The music swells.

[SHATNER] Age of Aquarius!
 Aquarius!

Courtesy of Priceline.com

> Linking the Future to the Past

Priceline.com had been using Shatner as a pitchman in radio and newspaper spots. But Wecal says those ads didn't take full advantage of the actor's personality or past celebrity as Captain Kirk on one of America's kitschy television series.

Walker originally picked Shatner because he was a *Star Trek* fan, and because the show's storyline of conquering the unknown in outer space mirrored what he was trying to achieve with his new company. "Here they had a cultural icon," Wecal recalls. "We were one of the few companies that said, 'Keep him and have fun with him.'"

Copywriter Ernest Lupinacci, a self-professed Shatner fanatic, got the idea for the television spots from the actor's own 1968 record album *Transformed Man*. An underground cult classic, the album features Shatner reciting poetry and covering classic rock songs like "Lucy in the Sky with Diamonds." "You've got Captain Kirk and William Shatner who had done some horrible singing," Wecal says. "Well, it's obvious to put those two things together."

The result is a memorable campaign of 10 TV spots in which Shatner engages in a bit of over-the-top acting as a washed-up lounge singer, delivering a message to consumers about the virtues of saving money. Hill Holliday went so far as to hire a crew from VH1's *Storytellers* to make the club scenes that set the underlying mood in many of the spots. No pop tune from the 1960s and 1970s is safe from

[BELOW LEFT] William Shatner's parody of Peter Townsend smashing his guitar on stage was so well received by TV viewers that it got national coverage on the talk shows.

[BELOW RIGHT] After the dot-com crash in 2000, Priceline.com streamlined its business by eliminating some of its services and focusing once again on its niche market of travel deals. Hill Holliday created an animated campaign in which it used celebrity voice-overs to tout travel to certain destinations.

being reworked into a Priceline.com message. Hence, Shatner singing the theme from *Mahogany*, "Do you know... how much I saved using Priceline?," as he stares at the piano player. "Do you know?" Dressed in a taupe suit, he lampoons rap by singing about "fly" rental cars and "dope" airfares. Staring straight into the camera, he asks consumers, "You want some of this? Bust a move." In "Age of Aquarius," he sits on a stool strumming the guitar and asks the audience if they can "dig" saving through Priceline.com.

He puts forth his best Pete Townsend imitation, grabbing a guitar from one of his bandmates and smashing it as the crowd goes wild. "If saving money is wrong, I don't want to be right," he utters. "It's a

[LEFT] Actor/director Quentin Tarantino provided the voice-over for this spot encouraging families to consider taking a trip to Orlando by using Priceline.com to book hotel, airfare, and car rentals.

balance of an absurd moment and delivering a message," Wecal says of the campaign. "You either really like it or really hate it. It was really polarizing and got people talking about it [Priceline.com]."

The ads generated an estimated $40 million in free publicity from various media profiles on *Today* and *Entertainment Tonight* and, of course, a parody on *Saturday Night Live*. More important, Priceline.com increased sales as a result of the spots. The number of unique visitors rose to 5.3 million in the first quarter of 2000, from 3.8 million in 1993. The number of airline tickets sold rose to 1.25 million in the first quarter of 2000, up from 707,000 in the fourth quarter of 1999.

Then came the dot-com crash in 2000, and Priceline.com, like many e-commerce companies, was forced to retrench as the industry lost favor on Wall Street. Generating additional money from investors became tougher. Priceline.com closed its grocery and gasoline services and focused on its niche as a travel company.

> Evolving the Brand with New TV Spots

The redirection of focus meant that Priceline.com's marketing campaign would have to evolve. Hill Holliday came up with advertising that reflected more of the benefits of its services, rather than solely its value in cutting costs for consumers.

"We needed to make a radical shift," Wecal says. "We needed to become a lot more approachable. If we were going to be the lead travel site on the Internet, the advertising had to reflect the benefits of going to really cool places for a little money. We consciously focused more on the destination and the joy of travel."

After Shatner, Hill Holliday executives faced the challenge of coming up with ads that were equally as fresh and unexpected. They turned to animation and the use of celebrity voice-overs to extol the virtues

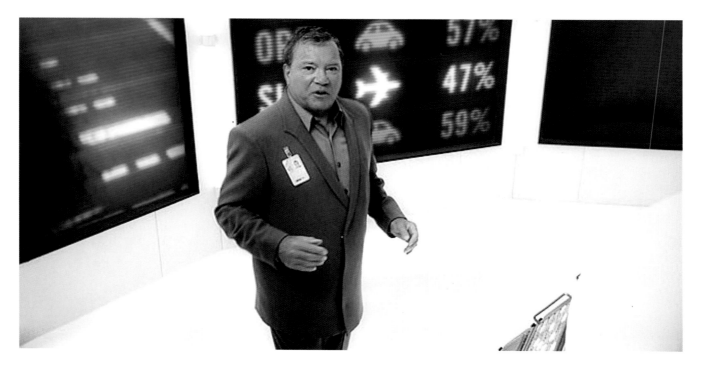

[ABOVE AND OPPOSITE]
William Shatner burned the name of the online buying service into the consciousness of Americans. In just 16 months, market research studies showed that more than half of all U.S. adults had heard of Priceline.com.

of discount travel in a series of three 30-second spots. Quentin Tarantino, director of *Pulp Fiction*, is heard encouraging families to travel as an animated rollercoaster travels along the tracks to a destination labeled Orlando.

"He's like a kid at heart," Wecal says. "It made him right for the twisted view of Disneyland. It was a great reason for consumers to think about traveling to Orlando—the fun and adventure."

Rock star Billy Idol, who was just about to release a greatest hits album, did the voice-over for a spot about London. Tony Randall, the actor from the *Odd Couple*, and Sarah Jessica Parker of HBO's *Sex in the City* are among other celebrities tapped for destination-style ads.

Another spot, dubbed "Live Like a Movie Star," plays out the fantasy of flying to Los Angeles for a few days to live the life of a glamorous movie star. What the traveler saves on discount airfare can be parlayed into a shopping spree, a professional makeover, or day at the spa.

Hill Holliday set out to make Priceline.com a household name through a celebrity-driven campaign saturated with humor. It allowed Priceline.com, one of the original travel sites on the Internet, to extend its identity. Yet, even when Priceline.com returned focus to its travel business, the agency perceptively maintained the company's image with another series of ads that celebrates its distinctiveness.

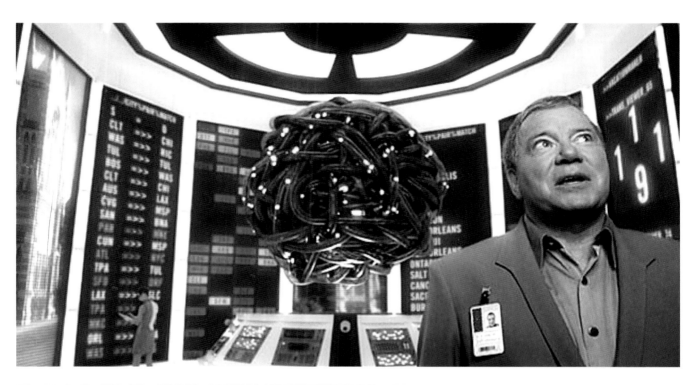

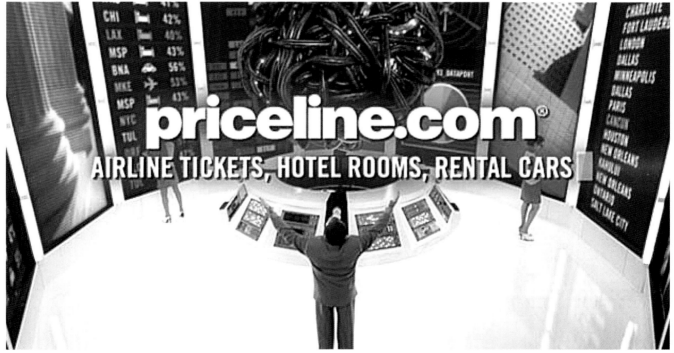

priceline.com®

AIRLINE TICKETS, HOTEL ROOMS, RENTAL CARS

^

Ameritrade

> Moving Stock Trading from
Wall Street to the Web

Open an account today and get 25 COMMISSION-FREE TRADES

WHAT'S A FEW PENNIES PER SHARE
TO A BIG SHOT LIKE YOU?

You're a savvy investor. You know what you're looking for,
and when you see something you like, bam, you go for it.
You're in control. Unfortunately, once you place your order,
someone else is in control. And if they don't shop for the best
price (some sell from their own portfolios), it could cost you.
That's why we provide you with a proprietary routing system
that routes trade orders to multiple market centers, giving
you a better shot at the best available price. Not to mention
a trading edge. Remember, you may not care about a few
pennies per share. But the other guys are banking on it.

For 25 free trades call 888.344.0097 or go to www.AMERITRADE.com (offer code RKU)

25 Commission-Free Internet Equity Trades	
$8 Internet Trades' — 10 Second "Guarantee"	
24-Hour Client Service — Level II Quotes	**Ameritrade**

Ameritrade touts the
savings that savvy
investors can expect
by using the discount
brokerage company and
cutting out the commis-
sions of the middleman.

Agency > OgilvyOne

> Navigating Online Trading

Ameritrade Holding Corp. founder J. Joe Ricketts has always been something of a trailblazer. In 1975, as the brokerage industry was undergoing deregulation, Ricketts and his partners started to offer consumers negotiated commissions, later known as discount brokerage.

So, with the emergence of the Internet and the technology to allow online buying, it was no surprise that the Omaha, Nebraska–based financial services company emerged as one of the leading e-commerce brands to provide customers with the ability to buy and trade stocks via the Internet.

Since 1994, through various incarnations, Ameritrade has been one of the pioneers in the competitive online brokerage business. But the company's breakthrough to mainstream American investors came in 1997, when it launched a multimedia marketing campaign featuring its $8-per-trade promotion and technology that enabled fast, inexpensive trades.

Today, even as the bear market is causing fewer trades, Ameritrade continues to promote itself aggressively. The company has recently shifted its advertising strategy to focus more on attracting professional traders with new products that provide more timely investment information.

"Joe Ricketts saw the opportunity to provide online brokerage services to those self-directed investors with a terrific price point of $8 per trade," says Anne L. Nelson, chief marketing officer for Ameritrade.

[BOTTOM LEFT] This print campaign uses green lights to show that if consumers use its service for online trading, they should expect no surprises in their financial portfolios.

[BOTTOM RIGHT] Ameritrade often uses print advertisement often to promote specials that will entice new investors to try online trading.

Courtesy of OgilvyOne

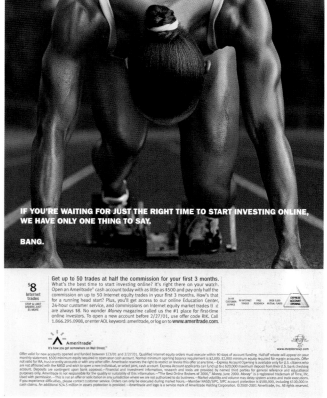

EXPLORE THE AMAZON FOR 8 BUCKS.

You're quite at home in the trading world. You figure out where you want to go, and then call your broker to execute your trades. He gets a hefty commission, yet you do the majority of the work. That's why it's time to explore another way to trade. It's time to start trading on the Internet with Ameritrade. ■ At Ameritrade, Internet market orders are just $8. No matter how many shares of Amazon.com you buy or sell. And limit and stop orders are only $5 more. ■ All the research tools you need to explore the market are at your fingertips. And Ameritrade is fast, easy, and as safe as can be. ■ Take a tour of our website or give us a call to open an Ameritrade account today. There's a whole new world of trading to explore. And you're going to love it.

$8 Internet trades	Free real-time quotes*
Broker-assisted trades $18	Over 7,000 mutual funds
Limit and stop orders are only $5 more	Free charts and research

Ameritrade
THE WAY TO TRADE. PERIOD.

Call 1-800-728-8620, visit us at www.ameritrade.com or AOL keyword: Ameritrade

*Upon opening an Ameritrade account, you will receive 100 free real-time quotes and 100 more real-time quotes for every Internet order filled. Market volatility and volume may delay system access and trade executions. Member NASD/SIPC. $2000 minimum equity required to open your account. SIPC account protection is $500,000 including $100,000 cash claims. An additional $245 million in securities protection is provided. ©1999 Ameritrade. Amazon.com is a registered trademark of Amazon.com, Inc.

"I don't want to just beat the market. I want to wrestle its scrawny little body to the ground and make it beg for mercy."

$8 **INTERNET TRADE** UNLIMITED SHARES Ready to take on the stock market? Ameritrade makes it simple to trade. Not to mention inexpensive. Commissions for Internet equity market orders are only $8, no matter how many shares you buy or sell. Or trade with a broker for $18. Limit and stop orders are just $5 more. And with Ameritrade, you get the same research tools that many professionals use. So call or visit our Web site today and open your account. The sooner you do, the sooner you can show that weak-kneed, lily-livered stock market who's boss.

Special offer: Get three commission-free equity trades to use in your first 90 days as a customer when you open your account between 9/1/99–12/20/99. Call 1.800.326.7271 and mention offer code REC.

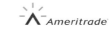

Ameritrade
Believe in yourself

Visit www.ameritrade.com. AOL keyword: ameritrade

*Not valid with any other offer. Not available for IRA accounts. Market volatility or volume may delay system access and trade executions. Member NASD/SIPC. $2,000 minimum equity required to open your account. SIPC account protection is $500,000, including $100,000 cash claims. An additional $245 million in securities protection is provided. ©1999 Ameritrade.

[ABOVE LEFT] **In one of its earlier print ads, Ameritrade set itself apart from its competitors by offering consumers trades through the Internet for just $8 per order.**

[ABOVE RIGHT] **The growth in Internet technology has allowed Ameritrade to make online trading simple, and the company uses copy, such as that featured in this spot, to establish brand identity among consumers.**

"The whole positioning of the company was bringing Wall Street to Main Street. It was almost the greatest leveler in the investment business."

In October of 1997, Ameritrade sought to distinguish itself from a myriad of discount brokers with the launch of its $8-per-trade national campaign. At the time, the $8 commission for online trading was the lowest price among deep discount and traditional brokerage firms.

> A Defining Identity

Education and low trading costs served as the theme for Ameritrade's initial print, television, and radio advertising campaign. Yet, Ameritrade wanted its message to be interesting and, in some ways, reflect the company's rural Midwestern roots. "We are very straightforward in what we say and how we say it," Nelson says.

But OgilvyOne, who developed the campaign, manages to intersperse subtle humor, too. So, in big block letters, one of its ads exhorts, *Explore the Amazon for 8 bucks.* Then, the copy went on to assure savvy investors that Ameritrade could allow them to trade stocks without paying a big commission to their brokers.

In developing the campaign, Nelson says OgilvyOne faced a challenge in conveying that $8 per trade "wasn't a gimmick" in ads. "It was the business model, because we had the technology to provide that kind of value on an ongoing basis," she says. "We never introduced it as a limited-time offer."

Two years later, as has been Ameritrade's style, the company continued to look for ways to break from competitors—such as Schwab, Fidelity, and E*TRADE—through its advertising. With educating consumers still paramount, Ameritrade launched the charming television spots featuring the wild-haired slacker hero Stuart, who taught his boss to trade online.

> Honing the Message

The ad debuted in March 1999, opened with Stuart photocopying his face for party invitations, when his boss, Mr. P., orders him into his office. The stuffy boss looks to the 20-something Stuart for help in buying stocks online. Stuart says, "Let's light this candle."

"That really was a kind of breakthrough spot," Nelson says. "It was highly memorable, and people really liked it. It was something that Ameritrade was known for, for quite a long time."

[ABOVE] The company touts it routing system as among the best for online trading so that consumers can execute orders quickly.

[LEFT] In one television spot, Ameritrade showed that consumers who sit around and wait to invest using the Internet would be left behind once retirement arrives.

Money magazine said we've got "the magic formula."

That's a real-time quote we're proud of.

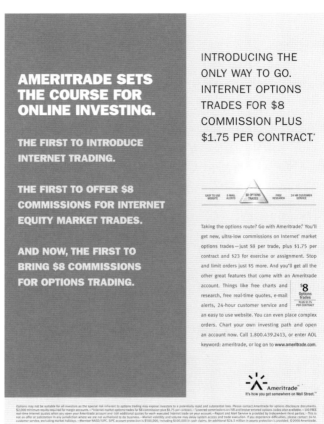

INTRODUCING THE ONLY WAY TO GO. INTERNET OPTIONS TRADES FOR $8 COMMISSION PLUS $1.75 PER CONTRACT.

AMERITRADE SETS THE COURSE FOR ONLINE INVESTING.

THE FIRST TO INTRODUCE INTERNET TRADING.

THE FIRST TO OFFER $8 COMMISSIONS FOR INTERNET EQUITY MARKET TRADES.

AND NOW, THE FIRST TO BRING $8 COMMISSIONS FOR OPTIONS TRADING.

[ABOVE LEFT] **When** *Money* **magazine rated Ameritrade as one of the best online brokers, the company quickly leveraged the honor to capture more consumers.**

[ABOVE RIGHT] **This Ameritrade print ad touts the company's ability to allow consumers to do more than simply make equity trades.**

The other spot in the campaign featured Dave, a successful family man. Dave's done well: He has a boat, a house with land, a loving (and educated) family, and an antique car in his garage. Although the ad doesn't proclaim that Dave traded his way online to riches, the suggestion is quite strong.

Even though the company had become a household word with its wildly popular TV campaign featuring Stuart, Ameritrade realized that its future ads needed to focus more on its services, such as research tools, and the availability of advice from its investment professionals via the telephone.

Much of the change reflected a consumer slowdown, in which investors have been making fewer trades. But the role of Stuart as a pitchman also was clouded by the Screen Actors Guild strike in July 2000.

"People were now aware of online investing. The challenge right now is convincing people that Ameritrade is the right partner for online investing," Nelson says, whose company was named one of the best online brokers in 2000 by *Money* magazine.

In fall 2000, Ameritrade switched gears to a new effort that assumed consumers were comfortable with the medium and tried to convince them that Ameritrade was the firm with which they wanted to do business. One print ad featured a female track athlete in the starting blocks with the words, *If you're waiting for just the right time to start investing online, we have only one thing to say. Bang.*

Ameritrade also used the series to promote its computer systems, which have allowed investors to make quicker and cheaper trades. For instance, one ad focuses on the company's routing system that allows investors to get the best price on a stock through the use of various market centers.

One print ad touts the company's Advantage package, which includes access to Ameritrade's comprehensive trading tools. The ad features a woman sitting in a shoe shop surrounded by several pairs she has tried on. The headline reads, *We don't have the slightest idea what you should do with your money. Refreshing, isn't it?* The copy explains that the company doesn't make investment decisions, but rather gives investors the tools to help them do it.

"That [ad] really emphasized that we were staffed and ready to handle our clients' questions and help them through anything that they needed help with," Nelson says.

Ameritrade has been equally active and aggressive in advertising on the Internet. The company is constantly testing messages, offers, and banner sizes to tailor messages to sites. "What is exciting about the Internet is that as broadband becomes more prolific, you can reduce the more costly channels," Nelson says.

[TOP ROW LEFT] **A series of Ameritrade ads featured the character Stu demonstrating the ease of online trading to his boss.**

[TOP ROW RIGHT] **Ameritrade constantly boasts about the ability for investors to make trades quickly, not only to save money but also to get the best price.**

[BOTTOM ROW] **Ameritrade shows that in spite of being an online brokerage company, it does develop relationships with consumers, as in this spot in which the investor talks about the benefits of using the service.**

Ameritrade®

[ABOVE] A rising sun illu-
minated over the *A* of
Ameritrade signifies in part
the ability consumers have
to control their financial
portfolio through use of
the discount brokerage's
online services.

[RIGHT] Ameritrade doesn't
pretend to be a full-servive
brokerage company that
advises consumers about
investing. Instead, the com-
pany offers investors the
tools to make decisions
through its Ameritrade
Advantage packages.

Yet, Ameritrade is now committed to nearly all marketing methods. At the same time, the company is
highly disciplined about its advertising placements. "We measure and track everything," Nelson says.
"We track [advertising] costs per account and compare it to our competitors. A lot of marketing is very
analytical and lot of it is intuitive. Whatever we do has to resonate with the brand."

Open an account today and get 25 COMMISSION-FREE TRADES

WE DON'T HAVE THE SLIGHTEST IDEA WHAT YOU SHOULD DO WITH YOUR MONEY. REFRESHING, ISN'T IT?

You're not looking for financial advice.
We don't offer it. So far so good? What we
do offer you is a full range of investment
products: stocks, IRAs, options and more
mutual funds than just about any other
brokerage. And because you want to make
more informed investment decisions, our
Ameritrade Advantage™ package includes
some of the most sophisticated and

comprehensive trading tools available. We also have an easy-to-navigate web
site. And real people to answer questions about all of the above, 24/7 (excludes
market holidays). It all adds up to giving you a trading edge. The way we look at
it, what you do with your money is your business. Making it easier is ours.

For 25 free trades call 800.513.3998 or go to www.AMERITRADE.com (offer code RKU)

25 Commission-Free Internet Equity Trades
Screening/Charting Tools—10-Second Guarantee"
24-Hour Client Service—$8 Internet Trades'

Ameritrade™

'Fees apply. Market volatility and volume may delay system access and trade executions. New account offer valid for new
individual and joint accounts opened with a minimum of $1,000 between 1/2/02 and 4/30/02. Additional limitations apply.
"10-second guarantee offer valid through 3/29/02. Limitations apply. Go to www.ameritrade.com for complete details. This is not
an offer or solicitation in any jurisdiction where we are not authorized to do business. '$8 Internet equity market orders. Stop and
limit orders $5 more.—Ameritrade, Division of Ameritrade, Inc., member NASD/SIPC. Ameritrade Advantage, Ameritrade and logo
are trademarks of Ameritrade IP Company, Inc. ©2002 Ameritrade IP Company, Inc. All rights reserved. Used with permission.

[TOP LEFT] In this television spot, Ameritrade tries to make consumers aware of one of the main benefits of using an online brokerage company: no waits on the telephone to get in touch with your broker.

[BOTTOM LEFT] Ameritrade's brand identity revolves around the ability to get into online trading with little hassle, as shown in this television spot in which a colleague watches another after the experience of investing with the brokerage company.

first direct

> The Difference Is Black and White

In one television spot called "Stuffed Cat Choice," Reeves challenges people to make a choice between a thin stuffed cat and a fat one, actually stuffed with £30,000. Making the obvious choice would save somebody £30,000 on a first direct smartmortgage. The point is that people don't always make the obvious choice.

Design Firms > Scope Creative Marketing, Ltd., and OneAgency, Finepoint, WCRS
Client > first direct
Campaign Debut > 2001

[TOP LEFT] A page from first direct's Web site is uncluttered, easy to navigate, and features unexpected visuals.

[BOTTOM LEFT] Although other, more conservative banks might feature their data processing center to demonstrate their operational efficiency, first direct takes a simpler approach and pictures a handy rack that holds toast as its model of efficiency.

> Different from the Beginning...

first direct, a financial institution with three locations in the United Kingdom, was launched in 1989, and from its inception, it was different. Although it went up against traditional banks, lending institutions, and other financial organizations offering mortgages and investment plans, including Royal Bank of Scotland, Barclays, Lloyds TSB, among others, it did so by being unconventional. "first direct has always been known for its quirky, off-the-wall advertising, about as far removed from traditional bank advertising as you could get!" says Matthew Higgins, communications manager at first direct.

"first direct is a trusted challenger brand," says company documentation. "We challenge accepted norms in banking and attitudes to money and continually innovate our services and products to reflect the changing needs of our customers."

Courtesy of first direct

Member HSBC Group

[TOP RIGHT] *Choose Your Bird* asks consumers to make the choice between the huge golden egg of an ostrich and a tiny egg of a canary. Which would you choose in terms of being better off?

[MIDDLE AND BOTTOM RIGHT] The last spot, called the "Frying Pan Challenge," gives people the choice of being warned before they're hit over the head with a frying pan so they can duck or receive no warning and get a sharp blow to the temples. The message? first direct can text your balance to your mobile phone so that you can be warned before you are overdrawn. Again, the choice, first direct insists, is so black and white.

[LEFT] The *Robotic Voice Choice* features people in a restaurant able to choose Alan, a smartly dressed, efficient waiter, or Agent Huckleberry, a well-meaning but totally inept robot that succeeds in causing absolute chaos. The message? Choose the bank with real people, not one with recorded messages on the phone.

[BELOW] A somewhat overweight fairy godmother with tennis shoes? That kind of imagery is what gets consumer attention and is currently winning customers for first direct.

> Talk Direct to the Customer

Among the company's areas of differentiation is that it designed its operations around its customers. Although other banks make the same claim, first direct may be the only bank to deliver on its promise. For starters, the bank has removed all the financial jargon from its advertising and, instead, it talks to customers with humor, using layman's terms—and it's not shy about speaking up. In fact, as part of the 2001 campaign, first direct targeted 8.9 million buyers via direct mailings, 1.8 million through electronic messages, 20 million via low-cost statement inserts, and 20 million through Web site sales banners, in addition to an aggressive television advertising campaign.

Helping pull this massive undertaking together were four advertising firms—Scope Creative Marketing and OneAgency both developed brochures for the bank; Finepoint was the principal designer of first direct's Web site; and WCRS, first direct's agency of record since 1995, produced its television campaign.

finale

First Direct is recommended every 4 seconds

[ABOVE] On February 1, 2002, first direct's new ad campaign debuted. That same day they also launched a joint venture with yahoo.co.uk by taking over the yahoo.co.uk home page to promote its new television advertising campaign.

> Yahoo! Helps Build Exposure

Although all the marketing elements are innovative and totally "unbanklike," the company's television advertisements are groundbreaking. The subject matter is traditional: one ad depicts first direct's smart-mortgage product, an "offset" mortgage that allows customers to link their mortgage to their current account and savings, thereby saving a substantial amount of money and reducing their mortgage term. Another promotes first direct SMS (short message service). Both ads feature Vic Reeves, a British comedian who is currently starring in his own TV show, which, according to Higgins, is very "off the wall."

The new ad campaign debuted February 1, 2002, the same day that first direct also launched a joint venture with yahoo.co.uk. On that day, first direct took over the yahoo.co.uk home page to promote its new television advertising campaign. "The TV campaign confirms first direct as a challenger brand with the strategy of first direct being the obvious choice: Choose first direct—it's so black and white," says Higgins, referring to the campaign's slogan, which is highlighted in multiple ways throughout the campaign.

> Move Over Benny Hill and Monty Python

There are four television spots in the campaign, and they all feature Reeves as the master of ceremonies along with a cast of characters one would never expect to see in a commercial for a bank, including

stuffed cats, frying pans, a giant ostrich, and a robot trying to be a waiter in a restaurant. The cast is more likely to be found on an offbeat British situation comedy in the tradition of *Benny Hill* or *Monty Python's Flying Circus*.

"The whole idea is to illustrate that choosing first direct is the obvious choice. In fact, as we say, 'Choose first direct—it's so black and white'," reiterates Higgins.

Peruse first direct's archive of past television ads and one finds that they are all equally as eccentric, featuring everything from a man in a pink suit dancing in the streets, a bucket of fish, a wrestling match, Bob Mortimer—Vic Reeves' comedy partner—and a little animated man in a white suit musing on why cheese and onion crisps (potato chips) should be in green packets rather than blue. Where are the ads talking compounded interest, zero closing points, and no-fee checking accounts?

You're not likely to find anything boring with even the hint of being heavily financial in first direct's promotional program, and not surprisingly, it is paying off with big dividends. "This type of maverick marketing goes down really well with our target market, generally people between ages 25 and 45, who are busy, professional people concentrated in and around London," adds Higgins, pointing to consumer feedback that reads like a five-star movie review:

> Campaign Ranks High with Consumers

"As a parody of call-center mentality, Vic Reeves offered customers in a restaurant the option of having either a regular human waiter or a comedy robot. The robot was chosen and proved to be incompetent, clearly trying to get across to the potential customer the message that first direct is keen on customer care and, therefore, after a better service. The advert works really well...."

"Funny, modern....a bit of a poke at the technology that's taking over our lives."

"It made me smile and laugh along with the people in the restaurant when the robot went wrong."

"Everything black and white is very memorable. Vic Reeves is funny in a madcap way. It looked very enjoyable to take part in."

"It was short, sharp, and humorous and gave you enough information to get you interested if you're looking to change your mortgage, but enjoyable even if you're not."

The latter comment perhaps best exemplifies first direct's success; it is hitting consumers ready for change and making a memorable impression on those who may be looking for a new bank in the future. It all bodes well for the newcomer, which has as its immediate goal increasing its customer base from 1 million to 1.1 million by the end of 2002, selling 30,000 smartmortgages, and increasing its base of long-term investors.

Where are these new customers coming from? Traditional banking institutions, says first direct, and it's the company's promotional campaign that is changing people's minds about banking. The campaign, according to the company's literature, "continues to position first direct as the bank most unlike a traditional bank in the U.K. and is already driving increased acquisition among like-minded people."

About the Authors

Judith Evans is a sports reporter for the *Washington Post*, where she recently won third place in sports writing from the National Association of Black Journalists. She has also been a financial reporter at the *Washington Post*, covering real estate and the hospitality industry.

Cheryl Dangel Cullen is a writer and public relations consultant specializing in the graphic arts industry. She is the author of more than 13 books from Rockport Publishers, Inc., including: *Promotional Design That Works*, *The Best of Annual Report Design*, *Direct Response Graphics*, *Global Graphics: Color*, *Global Graphics: Symbols*, *The Best of Brochure Design 6*, and *Then Is Now*. Cullen writes from her home near Chicago and has contributed articles to *HOW* magazine, *Step-by-Step Graphics*, *Graphic Arts Monthly*, *American Printer*, *Printing Impressions*, and *Package Printing & Converting*, among others.

Cullen Communications, a public relations firm founded by Cheryl Dangel Cullen in 1993, provides public relations programs for clients in the graphic arts, printing, paper, and other business-to-business and consumer industries.

HAVERING COLLEGE OF F & H E

162772

WITHDRAWN